THE MESSAGE BEHIND THE MOVIE— REBOOT

DOUGLAS M. BEAUMONT

The Message Behind the Movie— Reboot

Engaging Film without Disengaging Faith

Foreword by Carl E. Olson

IGNATIUS PRESS SAN FRANCISCO

First edition printed by
Moody Publishers, Chicago
© 2009 by Douglas M. Beaumont
All rights reserved

Cover photo © Denise Jans/Unsplash

Cover design by Enrique J. Aguilar

Published in 2022 by Ignatius Press, San Francisco
© 2022 by Douglas M. Beaumont
Foreword © 2022 by Ignatius Press
All rights reserved
ISBN 978-1-62164-287-9 (PB)
ISBN 978-1-64229-232-9 (eBook)
Library of Congress Control Number 2020946496
Printed in the United States of America ∞

This book is dedicated to my wife, Elaine.
Thank you for your trust in God,
your belief in me,
your commitment to us,
your example of excellence,
your sacrificial love,
your hard work,
and the gifts of
Michael, Ember, Dante, and Jacob.

CONTENTS

ACT THREE
APPLAUDING OR AVOIDING

FOREWORD

In my twenties, I was the creative director of a regional department store chain. Granted, the term "creative" in that context was a non-creative stretch. But I occasionally went beyond product description and price points, and I once had a brief "part" in a thirty-second commercial for an event called "Power Sale!" (I also wrote the gripping verbiage, which consisted of about eight words.) Thankfully, no known footage exists.

Although that commercial is my only experience with filmmaking, like you, I've watched a lot of movies. To be entirely honest, I've watched far too many bad movies (mostly in my youth) and not a few lousy television shows.

But it hasn't been all bad. I have a soft spot for movies such as *The Matrix*—discussed most insightfully in this book by Douglas M. Beaumont—*Memento*, *The Usual Suspects*, *Loopers*, and *Inception*, all of which take up themes that have long fascinated me: identity, the nature of reality, time, memory, sin, and salvation. (My favorite movie is probably *The Princess Bride*, which I first saw the same evening I first met Heather, my wife; we have watched it together countless times.)

But rather than bore you with my cinematic likes and dislikes, I'll reflect for a moment on a deceptively simple statement made in the book you are holding—a book that is, if you'll forgive the obvious play on words, rather cinematic in scope: "Any movie worth watching will include some features of truth."

Now, this is also true of books, music, and the visual arts. It is something I first began (emphasis on *began*) to comprehend when I discovered the poetry of T. S. Eliot at the age of thirteen. For whatever reason, I didn't really read Eliot's post-conversion, Christian poetry until I was in college; I instead began with "The Love Song of J. Alfred Prufrock" and "The Hollow Men". (Oddly enough, I was rarely invited to parties while I was in high school!)

Why did those poems capture my imagination? There are several reasons (the strong images and the gripping style, for example), but one is key: they expressed truth in ways that challenged and interested me. Truths about human nature, existence, and reality. The Big Stuff!

As noted, I watched a flood of lousy movies when I was younger, quite of few of them lacking any interest in truth, never mind demonstrating any "features of truth". (It brings to mind Eliot's comment in his essay "Religion and Literature": "Whether there *is* such a thing as a harmless book, I am not sure: but there very likely are books so utterly unreadable as to be incapable of injuring anybody.")

But films such as *Out of Africa, Ghandi, Once Upon a Time in America,* and *Dead Poets Society*—to name a few that come to mind immediately—did make a much better impression. They made me think a bit. Or even quite a bit. They lingered. And I saw features of truth in them, even as I was working through various questions and riding the sort of emotional rollercoasters so common to teenagers and young adults.

After some time at art school, I ended up—providentially, I'm convinced—attending an Evangelical Bible college for two years. There I was introduced to the concept of "worldview", which is taken up in chapter 5 by Beaumont:

The way the term is often used, "worldview" describes a collection of beliefs one has concerning important aspects of reality—one's "underlying principle and concept of life". Worldview is thus deeper and more comprehensive than one's political positions, philosophical commitments, or religious affiliation—even though any of these can strongly influence the resulting set of beliefs one holds in the other areas. It functions as a backdrop against which our life is experienced and interpreted.

Thirty years later, I remain thankful for the many conversations I had with professors and fellow students about worldviews. Those conversations, which included plenty of discussions about literature, music, painting, and movies, challenged me both intellectually and spiritually (and paved a path that led to—and into—the Catholic Church). Beaumont captures well one of the main streams of discussion and debate that I experienced in my own life during that formative time:

Disagreement over movies is in many ways a contemporary version of a debate about the influence of art that has raged since long before the first moving picture was ever conceived. Two noteworthy positions regarding the purpose of art and the proper way to judge its worth originated with the philosophers Plato and Aristotle. The differences between them help explain why Christians disagree about the value of film.

I won't give any more spoilers here. But I will say, without hesitation, that I wish I had this five-star book thirty years ago! It's wonderful for all ages, but I see it as especially helpful for young people who are trying to navigate a world sinking in screens. Beaumont covers so much ground with such engaging ease, adroitly handling the art

xii THE MESSAGE BEHIND THE MOVIE—REBOOT

of movie making *and* movie watching, theology, philosophy, apologetics, and evangelization. He handles all of the varied topics and themes like a masterful film director.

The sections on story and storytelling are worth the price of admission alone. The world is hungry for good stories, but people too often settle for dull, shallow, or sensational rot. Christians, who know The Greatest Story Ever Told and who are disciples of the Greatest Storyteller of All, should better understand the ins-and-outs of stories and how their cinematic expression impacts and influences viewers. There's more to the story, as the saying goes, and Beaumont presents it without ever resorting to special effects or Al Pacino–like yelling.

Movies, writes Beaumont, "act as vehicles for messages. When a movie is written, it says something about the world—and that is open to evaluation as much as its artistic merit or entertainment value. This is why a proper understanding of the message behind the movie is important to accurate evaluation."

This echoes what Eliot wrote almost a century ago about reading fiction: "The good critic—and we should all try to be critics, and not leave criticism to the fellows who write reviews in the papers—is the man who, to a keen and abiding sensibility, joins wise and increasingly discriminating reading."

So, be a good critic and thus become an even better Christian.

Happy reading—and discriminating viewing!

Carl E. Olson
Editor, *Catholic World Report*

PREFACE TO REVISED EDITION

What's the Story?

I am not an actor, screenwriter, or director; nor am I a gaffer or key grip. Although I have spent a fair amount of time in front of the silver screen, I am no cinephile (the fancy term for "movie geek") or professional film critic. What I am is a movie lover educated in the fields of psychology, apologetics, and theology who came to believe that these interests often have significant overlap.

The idea for this book came to me back when I was in seminary ...

DISSOLVE TO:

INT. CLASSROOM—NIGHT

 DOUG, a seminary student, has just delivered his first class sermon. It did not go well.

... where I found myself struggling in what I assumed would be an easy class: Homiletics (Greek for "Preachin!"). While I could hold my own when it came to explicating Scripture, I didn't have a gift for crafting forty-five-minute sermons from single passages.[1] I was told that one thing I lacked was an appreciation for how storytelling could

[1] This is one thing I appreciate about being Catholic: fifteen-minute homilies!

support a message. My wise professor suggested I study Hollywood screenwriting. That certainly sounded more interesting than the assigned textbooks, so I dove into the subject. In doing so, I learned of a storytelling system well known among professional screenwriters—one that was invaluable for conveying messages through movies. (I also earned an A on my next sermon!)

I had always been frustrated with many Christian movie evaluations that could not seem to get much beyond counting bad words or nude scenes, and many pious reviewers seemed to overreact to particular film elements without considering their overall context. I thought Christians owed filmmakers the same kind of informed, objective analysis that they expected of others when they criticized our faith. I came to believe that becoming familiar with the art and science of screenwriting would help us all better understand films on their own terms. To that end, I created the *Message behind the Movie* seminar, and after sharing it coast to coast over the next couple years, I set it down in book form.

The rest was history ... until Ignatius Press contacted me about revising the book.

I'll admit, I was hesitant at first. Like many movie lovers, I am not a big fan of reboots. Bad movies should not be rebooted, and good movies do not need to be. Although revising the book would be a great opportunity to reflect my current thinking and restore some content that ended up on the cutting room floor the first time around, I didn't want to alter the original in unnecessary and possibly disappointing ways.[2] I eventually decided that the potential benefits outweighed the dangers and, not wishing to reinvent the reel, agreed to write a "rebooted" edition.

[2] Han shot first!

A lot has happened in my life since the book's first publication. My family has increased in number, I completed a Ph.D. in theology, and we moved across the country. Perhaps most significantly to readers, I entered into full communion with the Catholic Church.[3] Although none of these events need affect the book's essential content, I was eager to revisit the material.

So there I was, ten years after sitting down to write my first book, sitting down to write it again. It is doubly appropriate that I began on April 1, 2018—for if anyone had told me that I would be rewriting *The Message Behind the Movie* a decade after completing it the first time, I would have certainly thought it was a joke! More importantly, though, it was Easter (Resurrection) Sunday!

The basic structure of the book remains the same. The first part, Act One, explains how to engage movies actively rather than merely watching them passively, and evaluate their messages objectively. Act Two looks at topics particularly important to Christianity, such as the knowability of truth, proofs of God's existence, and discovering true religion. Then it considers how what movies say about these topics can affect evangelism (proclaiming the faith) and apologetics (defending the faith). Act Three wraps it all up with some practical guidelines concerning which movies to watch. As with the original, many chapters include portions of an ongoing story illustrating the principles discussed in the chapter.

Additions to this "reboot" include the following: a new argument for the existence of God, a brief look at the argument from beauty, a discussion of the problem of evil, a historical understanding of the Church, and a

[3] That story is recounted in another book (*Evangelical Exodus*, Ignatius Press, 2016), so I will not go into it here.

discussion of desensitization. Finally, I added a chapter titled "Denouement", which includes a sample analysis of one of my favorite films.

I close, once again, with gratefulness to those who made this book possible. In this endeavor, I frankly admit to standing on the shoulders of giants from both movie and ministry worlds. It is said that stealing from one source is plagiarism but stealing from several sources is research. There is more truth to this joke than many would like to admit, but in the attempt to advance a subject, it is wise to begin with the work of others rather than start from square one. Of particular influence on my thinking concerning the subjects included in this book are Brian Godawa, Syd Field, Robert McKee, Christopher Vogler, Barbara Nicolosi, Barry Leventhal, Richard Howe, Thomas Howe, Norman Geisler, Aristotle, and Thomas Aquinas.

Special thanks go to my dad for introducing me to Monty Python and explaining the principle of Chekhov's Gun before we even knew it was a thing; my mom for letting me stay up and watch scary movies when I was probably too young for them and for her input on this edition; my most excellent movie-watching crews throughout the years; Nathan Pierce for his valuable research and suggestions on the first edition of this book; and Matthew Graham for his work on this one. I appreciate Moody Press for publishing the first edition, and I applaud Mark Brumley for suggesting this reboot. I also must humbly express much gratitude to Ignatius Press' editorial team (Vivian Dudro, Abigail Tardiff, and Kate Adams) for covering a multitude of sins.

Finally, my ongoing gratitude goes out to the creators of my favorite films and to my wife, whom I got to know while watching many of them.

—Douglas M. Beaumont, Ph.D.

ACT ONE

WATCHING AND
UNDERSTANDING

Chapter 1

Can Anything Good Come Out of Hollywood?

Coffee Shop Talk: A Non-Date at Café Veritas

Mike Schonberg and Nita Wellborn were definitely not on a date as they found chairs next to a window overlooking the parking lot of Café Veritas. Outside, everything was taking on a reddish glow as the sun dropped below the skyline, silhouetting the ornate tower of the old movie theater across the street. This was their first "hangout", and although both insisted that it was not a date, friends in their college group teased them mercilessly (as good friends seem obligated to do). Mike was glad they had settled on an after-school visit to the café—it was cozy and private at this time of day. As they settled into their overstuffed chairs, Mike racked his brain for something to talk about. Why did his mind sometimes seem to derail in the presence of an attractive girl? He gazed across the parking lot and spied the movie theater. Perfect!

"Seen any good movies lately?" he asked, at once proud of himself for preventing an awkward silence and embarrassed for having to resort to a cliché.

"I don't watch many movies," Nita answered casually. When she saw Mike's look of surprise, she felt the need to explain. "I just think there is too much sex and violence,

3

and for what? They hardly ever have anything good to say." She tried to read Mike's expression, then went on. "It just seems like Christians should have better things to do with their time." Nita saw Mike grimace slightly and immediately wished she hadn't added that last part. What if Mike was a movie nut? This was their first "hangout", and she had probably just insulted him!

For his part, Mike was not completely surprised by this response. He had heard it before and was ready with an answer. "Well, everyone takes time out for entertainment. I know there is a lot of bad stuff in movies, but I'm able to filter it out pretty well. If a movie is really bad, I can always get up and leave."

"Have you ever actually done that?" Nita asked, some-what defensively.

Mike thought about it. "Well, no—not really." He noticed a slightly triumphant gleam in Nita's eye.

She continued her interrogation. "So, you're telling me you have never watched a movie so awful that you had to leave? What's the worst movie you ever sat through?"

Now Mike was in a bind. He knew he had seen some pretty bad stuff. So, he decided to dodge. "Well, most of the time I'm with friends and don't want to embarrass them." That sounded pretty good. But Nita was one step ahead of him.

"Why would your friends be embarrassed by your walking out of a bad movie?"

Mike was mentally sweating now, but Nita's question gave him an idea—a change of tactic. "I find that movies are a way to find common ground with my nonbelieving friends. Don't you think we need to be able to interact with the culture?" There! He had turned the conversa-tion around.

Nita only looked confused. "What do you mean? Should Christians involve themselves in sin just so they

can be buddies with nonbelievers? How is that showing Christ to the world?"

This was going poorly. What was the big deal? Mike thought. Didn't everyone like at least a few movies? "Are there any movies you have liked, Nita?" He hoped this would get them on the same side.

Nita looked suspicious but thought for a minute and managed to come up with something. "This is probably going to sound stupid to you, but I did like ..." she trailed off.

Mike jumped at the opportunity to get this conversation back on friendly ground. "No, please tell me!"

Nita eyed him for a moment and then said, "*The Wizard of Oz*. I liked it when I was a kid, and I guess I still do." She looked back and grinned sheepishly. "Happy?"

Mike smiled. Although he would never admit it in front of his friends, he had loved that movie when he was a kid, too. He breathed a sigh of relief and was about to remark on the coincidence when a thought occurred to him. Against his better judgment, he offered Nita a challenge of his own: "Doesn't *The Wizard of Oz* have violence and witchcraft in it?" He grinned as he said it, hoping she would not take his question too seriously. It sort of worked.

"Oh, come on," Nita laughed, "you can't compare *The Wizard of Oz* to the junk in movie theaters today. It's a classic kid's story!"

Mike saw an opportunity to have some fun and hopefully regain some of his lost moral ground. "A minute ago you said that you didn't like movies because of violence and evil. So how come you have no problem with those things in a movie that you do like?"

Nita opened her mouth to speak and then abruptly shut it.

Ha! Mike thought. I've got her! He was just leaning back to take a triumphant sip of coffee when Nita answered,

"*The Wizard of Oz* doesn't have cussing or nudity, and it certainly does not promote evil. That's what makes it different."

Mike agreed, but he was not about to let her off that easy. "Well, *The Wizard of Oz* is violent, though, right? The scarecrow catches fire, the dog bites that lady, the witch melts—which freaked me out when I was a kid! Not to mention the witch herself. She was scary!"

Nita paused, bit her lip, and then answered, "Well, the violence was pretty tame compared to movies today ... and the witch was supposed to be scary because she was evil!"

"So, if a movie has some violence and witchcraft, it's OK as long as the witch is clearly evil?"

"Yes," Nita replied more confidently than she felt.

Mike reflected for a moment and then added, "But wasn't there also a good witch?"

Nita's eyes focused past him for a few moments. She had thought her last response was going to be the end of the conversation. Now what? How could she defend her favorite movie's portrayal of witchcraft as a good thing?

Mike was looking at her with a smirk growing on his lips. Nita shot him with her straw wrapper, and they changed the subject.

Hooray for Hollywood?

Do you sympathize more with Mike or Nita? The fact that you are reading this book suggests that you perceive some value in movies. But perhaps, like many Christians, you are uncertain how to think about movies as they relate to your Christian faith and morals. Both had good reasons for their perspectives on the subject of movies, but who was right? When it comes to Christian opinions of Hollywood,

there is no shortage of simple answers. Although individuals will likely hold to more nuanced positions, some general categories can be identified.

Some Christians choose *abstinence*. Like Nita, some Christians choose to abstain from the theater and simply dismiss nearly everything that comes out of Hollywood as pure evil.[1] Many watch very few movies and are extremely critical when they do watch them, often focusing on the style components of the movies more than anything else. While this position may not be difficult to sympathize with given the content of many movies these days, it does have negative consequences. As author Stephen Lawhead once wrote, "Those who reject popular culture wholly or in part tend to see the devil as extremely active in the world, so terrible in his power and influence that the best defense is retreat."[2] If Christians abandon Hollywood, we can't really complain about it being *non-* or even *anti-*Christian. The same goes for the culture that is being influenced by Hollywood. By avoiding movies altogether, abstainers may be unaware of shifts in current popular thinking, limit their ability to interact well with the people around them, and simply miss out on a lot of positive experiences.

Other Christians celebrate their *affinity* for film. Representing the other end of the spectrum from the abstainers are those who have an almost careless love for movies. These folks are primarily concerned with entertainment, believing movies are just for fun. They likely think they are not being affected by the films they watch—although if they weren't, they probably would not spend so much time and money on them! Because of these attitudes, these

[1] For the purposes of this discussion, I will refer to "Hollywood" and "the film industry" as one, although this is certainly an oversimplification.
[2] Stephen Lawhead, *Turn Back the Night* (Westchester, IL: Crossway Books-Good News Publishers, 1985), 8.

people often view films uncritically and ignore offensive style aspects so long as they are entertained.

Then we have the movie *advocates*. These are more theologically and culturally sophisticated Christians who recognize the artistry and the importance of movies and often commend them to others. Although this may seem to be the perfect *via media*, there are dangers in this stance as well.[3] In their desire to see movies used for spiritual purposes, Christian movie advocates are often inclined to emphasize any positive spiritual theme in a movie (whether real or imagined) even when there are no overtly Christian elements. Unfortunately, some film advocates fail to see the actual message of a movie and mistakenly vilify or champion a film for a message it doesn't actually communicate.[4]

As you can see, there is a delicate balance between over-zealous avoidance, careless affinity, and unfounded advocacy. While these extremes are pretty easy to identify and have some fairly obvious flaws, mediating positions can be a challenge to discern and articulate. How can Christians appreciate movies for what they are and engage them without disengaging their faith?

Christianity's Platonic Relationship with Film

This debate is nothing new. Disagreement over movies is in many ways a contemporary version of a debate about the influence of art that has raged since long before the first moving picture was ever conceived. Two noteworthy positions regarding the purpose of art and the proper way

[3] "Via media" pun intended.

[4] This problem occurs with "Christian films" as well. The celebrated *Facing the Giants* (2006) had a decidedly misleading message about the "power of prayer" that most Christians would reject, yet this was rarely noticed.

to judge its worth originated with the philosophers Plato and Aristotle. The differences between them help explain why Christians disagree about the value of film.[5]

Plato viewed art as sometimes useless and oftentimes harmful. This assessment was based on the philosopher's understanding of virtue and goodness. Plato believed that to be virtuous, a person must have true knowledge. If art only imitates truth—but is not actually true—it cannot make a person truly virtuous. He also believed that the highest good is also the most *real*. Because all art is essentially an imitation of reality (and often a faulty imitation), it is not morally neutral but is actually bad.[6] Finally, Plato believed art can be dangerous, because it is emotionally provocative. When the emotions are aroused, the soul's balance is disrupted and a person becomes irrational. Therefore, said Plato, people should be exposed to only that art which strongly and clearly communicates ultimate truths.

Plato's student Aristotle thought of art differently. While he agreed that art imitates reality, Aristotle did not necessarily consider this a problem. For one thing, artistic imitation is one way humans distinguish themselves from the lower animals, which seems to indicate that doing so is good for us because it is part of what we are made to do. Art is also useful for learning, even when it depicts immoral behavior. For example, a comedy depicting fools and their folly is useful because it can teach us to avoid foolishness (which is good) without our having to make foolish decisions (which is bad). Aristotle also noted that art has cathartic value—experiencing emotions can help release pent-up feelings, which helps

[5] The Church has generally followed one or the other. Augustine and Aquinas, for example, were strongly influenced by Plato and Aristotle, respectively.

[6] Actually, because the physical world is seen by Plato as a shadow of the higher World of the Forms, art is a representation of a representation!

us achieve the balance Plato thought was lost when the passions are inflamed.

Finally, Aristotle recognized that art is good at communicating profound truths precisely because it is not bound by mundane reality. As we all know, examples of virtue are sometimes hard to find in the real world. The virtue of courage, for instance, can often be more easily taught by watching a movie from *The Lord of the Rings* trilogy than by watching politicians on CNN.

When it comes to movies, it appears that many Christians have sided with Plato. They want films that communicate truth clearly without displaying anything false or bad—movies that have strong, easily discernable moral messages but do not arouse the "lower" passions. So, when a film comes along that presents the dark side of life, asks more questions than it answers, portrays sinfulness realistically, or overly excites the emotions, they may judge it as immoral even if it communicates messages that are true and good.

Plato got a lot right, but Christians would do well to recognize the merits of Aristotle's perspective as well. An Aristotelian approach to movies needn't condone sinfulness; it can recognize how central storytelling is to human experience and seek to critique accurately the messages that stories in films are communicating. It can also recognize the value of accurate presentations of reality without condoning what is being presented. Imagine, for example, if movies were made of every book in the Bible. Some of these films would include portrayals or at least mentions of murder, incest, rape, adultery, idolatry, betrayal, total war, and cruelty in order to remain faithful to the text. Are these behaviors in the Good Book off limits for a good film? This question brings us to our next point.

Why Do You Call It "Good"?

If you read many movie reviews, you will quickly discover that there is disagreement on what makes a movie "good". Some reviewers look for artistic styling, acting quality, edginess, adherence to time-honored filmmaking conventions, storytelling, special effects, musical score, and so on. Virtually any combination of movie attributes can be chosen for evaluation, and this results in varying critical opinions. Christians often focus on potentially objectionable style elements or the lack of an uplifting message. This leads to reviews that are often far afield of secular norms.[7] Is there any way to evaluate a movie without our personal preferences overshadowing our objectivity?

I think that Aristotle can help us here as well. The philosopher said that a thing was to be considered good according to how well it attained its purpose.[8] So, for example, because a knife's purpose is to cut, a sharp knife is good, and a dull knife is bad. Unlike a knife, a sharp pillow would be a bad pillow. Thus, when we call something good, we can easily be confused if we don't know what purpose (or purposes) a thing has.

If the most common motivation for movie watching is any indication of a movie's purpose, then it seems movies are made to provide an *emotionally moving experience*. Some of the emotions a movie evokes, such as excitement and awe, yield what is often referred to as "entertainment", but even serious or frightening films can function in this capacity.

Whatever term we choose to describe the phenomenon, people simply enjoy watching movies—even sad

[7] Compare religious versus secular movie review ratings on the Movie Review Query Engine (MRQE), www.mrqe.com.

[8] Aristotle, *Nicomachean Ethics* 1.7.

or disturbing ones. Of course, movies should provide more than mere escapist thrills, and many rightly balk at judging a movie good or bad merely on the basis of its "entertainment value". However, ask a line full of people in front of a theater why they are there, and few will likely answer that they came to be educated or enlightened. There is a reason people will pay good money to sit through a two-hour movie but get antsy when a free sermon exceeds twenty minutes! The primary purpose of a sermon is *exhortation*, not *entertainment* (although many judge sermons by the latter standard).

A movie is generally considered good if it provides an entertaining, moving experience. Since telling a good story while providing a worthwhile vicarious experience is the first task of the moviemaker, assessing a movie begins with an evaluation of those things. But that's not all there is to consider. Film is an art form, and craftsmanship is an important part of any art form. Who would watch pro sports if the athletes were not good at their game? The craft of filmmaking will not be explored in detail in this book, because it does not necessarily need to be. Most people can intuitively recognize the difference in quality between a classic Hollywood blockbuster and a direct-to-video hack job. However, Christians who are interested in the messages of movies, both as producers and consumers of films, sometimes need to be reminded that no one but your family members and closest friends will listen to you sing a song if you can't carry a tune. And even they might ridicule you for a rotten performance.

Movies also act as vehicles for messages. When a movie is written, it says something about the world—and that is open to evaluation as much as its artistic merit or entertainment value. This is why a proper understanding of the message behind the movie is important to accurate evaluation.

In light of these considerations, we need to keep in mind that "good" can be said of things in many ways, and it does not always indicate a *moral* goodness. Calling a movie "good" might mean that it is artistically well made or that it discusses some important truth or simply that it is enjoyable. As you can imagine, misunderstandings over which kind of goodness is being spoken of can cause problems. *The Exorcist* (1973), for example, is a very good movie artistically and one that has a positive message concerning faith and the triumph of good over evil. Yet the film's depictions of evil are so horrific that many do not find them worth enduring. *And that is fine!* Just because a film is good in one (or many) ways does not mean that it deserves blanket approval.

(Heavenly) Parental Guidance Suggested

In Act Three I will present principles that can help readers make informed movie-watching decisions, but there are a lot of gray areas that must be judged according to personal preferences and individual characteristics. We need not explain why we don't want to watch a film in which blatant evil is being glorified or stylistic matters are a serious affront to one's sensibilities. We need to be careful, however, that we do not judge a film solely on its style or declare that no one should see it just because we prefer not to. Sometimes a strong portrayal of good requires an equally strong depiction of evil. As Saint John Paul II said, "Even when they explore the darkest depths of the soul or the most unsettling aspects of evil, artists give voice in a way to the universal desire for redemption."[9]

[9] John Paul II, Letter to Artists (April 4, 1999), no. 10.

Sometimes, even dark movies can shed light on important topics. A good example of such a movie is *The Decalogue*, a series of ten short dramatic films produced in the late 1980s for Polish television. Each film tells a story about how one of the Ten Commandments is being violated or fulfilled by people living in twentieth-century Warsaw. The series won numerous awards and is on the list of films recommended by the Vatican, yet its portrayal of evil is at times too vivid and disturbing for some viewers.

While it is not necessarily evil to view evil, we need to avoid entertaining ourselves with indulgence in our own disordered appetites. There is no justification for pornography, for example, because its only purpose is to cause sexual arousal and satisfaction through the depiction of sexual acts. It's a substitute for a prostitute, to which the word *porneia* can refer in Greek, and the "actors" in these movies are, in fact, "sex workers". But there are lots of films that while not technically pornographic include sensual scenes that could have an injurious effect on some people. That's why there are now movie "cleansing" companies that provide film recordings with the objectionable content removed for the more sensitive viewer. The point is, apart from actual pornography, which no one should watch, the films a person should or should not watch are matters of conscience that require a discerning mind and heart.

Further, those who are affirmed in their conscience with respect to certain movies need to show care for those who are not. Saint Paul speaks to this issue in 1 Corinthians 8 and 10, where he deals with what to do when a tough decision becomes a stumbling block for someone with a weak conscience or someone whose conscience forbids him from watching something that although not harmful to us would be harmful to him (see chapter 11, "What

Should We Then Watch?" for more on this topic). At all times we should act in love toward those around us and not seek to elevate our preferences above their well-being.

Deep Impact

As early as the 1930s, one theater critic wrote, "Theaters are the new Church of the Masses—where people sit huddled in the dark listening to people in the light tell them what it is to be human."[10] Because movies encourage community by creating shared experiences that unite people as they try to make sense of the world, they can therefore shape the way we think about the world.

This should be a concern, because the views of the world being offered by the media might be false or at least woefully incomplete. The more we are influenced by them, the further from the truth we may find our thinking (and therefore acting). This level of influence becomes a bigger concern as media becomes ubiquitous—and today we are virtually surrounded by it.

But media can also offer an honest portrayal of reality, which can be a good thing. To echo Aristotle's observations about art in general, movies can serve as a vicarious means of experiencing life. We can encounter things through movies that we might not otherwise have a chance to explore. Such an encounter goes beyond mere entertainment. Movies provide a way to experience myriad situations with a measure of detachment that is impossible in real life. Rather than being shocked and ill-equipped to deal with these situations when they arise, we can safely

[10] From Barbara Nicolosi's weblog, Church of the Masses, churchofthemasses.blogspot.com.

explore these issues through cinema before being faced with them in real life.

Finally, even if a certain movie isn't as good as it could or should be—for instance, it's ambiguous about some of the evils it portrays—it can sometimes be used for good. God brings good even out of evil (Rom 8:28) because his truth and goodness continue even when they are distorted or rejected; so while we must avoid joining in evil (2 Cor 6:14), Christians can appreciate and learn from such movies as they are, even when they are not what we might like them to be. One way to do this is to see in movie messages a way to explore the truth with others.

Cinevangelism

Any relationship requires common ground, whether that is speaking the same language, living in the same neighborhood, or sharing a work environment or common interests. Sometimes common ground has to be cultivated. The best evangelists know that finding common ground means meeting people where they are. In Acts 2, for example, Peter spoke to the Jewish crowd using Old Testament prophecies to show that Christ was their Messiah. But in Acts 17, when Saint Paul was at Mars Hill, he used philosophical arguments from creation to lead the pagan Greeks to Christianity. In both cases, the method of evangelism was directly related to the speaker's ability to make use of cultural connections. Because movies explore issues central to human experience, they can provide an excellent means of engaging people in conversation about what the Christian faith has to say about being a human being.

More often than not, good cultural connections can be found in a culture's stories. Ursula K. LeGuin wrote that

stories are "one of the basic tools invented by the mind of man, for the purpose of gaining understanding. There have been great societies that did not use the wheel, but there are no societies that did not tell stories."[11] In the same way that anthropologists investigate ancient cultures through their myths, we can learn much about our own culture through films. Like tales spun around the campfires of our forefathers, movies draw us together via common stories. At a time when religion is distrusted as a source for ultimate truth, movies allow us to reflect collectively on our own stories and share our reflections with others.

Sometimes, though, even those who acknowledge the possible positive benefit of cultural interaction through movies still wonder whether Christians should involve themselves with the products of non-Christian culture. Of course, at the time of the apostles, there was no Christian culture! Their missionary efforts required them to engage with the pagan culture around them. Not only did the apostles not introduce "Christian" versions of everything enjoyed by pagan culture, they used even anti-Christian cultural materials in the service of Christ. Consider the following verses found in the letters of Saint Paul:

"Food is meant for the stomach and the stomach for food" (1 Cor 6:13).
"Let us eat and drink, for tomorrow we die" (1 Cor 15:32).
"Bad company ruins good morals" (1 Cor 15:33).
"Cretans are always liars" (Tit 1:12).
"It hurts you to kick against the goads" (Acts 26:14).

[11] From "The Language of the Night" as cited in Lynette Porter, David Lavery, and Hillary Robson, *Finding Battlestar Galactica: An Unauthorized Guide* (Naperville, IL: Sourcebooks, 2008), 248.

"In him we live and move and have our being ... for we are indeed his offspring" (Acts 17:28).

Many are surprised to discover that in every verse above, Saint Paul is quoting pagan writers.[12] In fact, in its original form, the last quote refers to Zeus![13] Throughout the history of the Church, Christians have built upon the truths apprehended by pagan poets and philosophers. I did something similar when I quoted Plato and Aristotle. Saint Paul exhorts us to "test everything; hold fast to what is good" (1 Thess 5:21).

Conclusion

In order to watch movies in a beneficial way, we first need to learn how to understand them, so that we neither miss the good nor uncritically accept the bad. With some basic guidelines, anyone can make accurate assessments of a movie's message. When this process becomes natural, you will begin to see things you might never have noticed or appreciated in films before. You might find that this training helps you enjoy movies more, in the same way that musicians often have a greater appreciation for music than do those of us who don't play instruments.

This book can help you avoid careless affinity, unnecessary abstinence, and overzealous advocacy of films by discovering, appreciating, and fairly appropriating the messages behind the movies. To accomplish this, it shows you how to discern a movie's message or *significance* as revealed

[12] The first two are attributed to the Epicureus, followed by Menander, Epimenides, Euripides, and Epimenides/Aratus.

[13] The statement "we are his offspring" is either true or false, depending on to whom "his" refers, and in Paul's case it was the true God.

by its *story*, including how that story is told (its *style*) and its assumptions about the world (its *suppositions*). Whether a movie presents strong Christian, non-Christian, or anti-Christian themes, it can be discussed thoughtfully in our conversations and help us to see truth. Therefore, the second part of this book will feature lessons in message evaluation and response from a Christian position.

Chapter 2

How a Story Is Told versus
What a Story Tells

How to Watch a Movie

The philosopher Mortimer Adler wrote a book titled
How to Read a Book. Adler knew, of course, that at some
level every literate person can read a book (otherwise his
would be useless!). But he also knew that some people
read better than others. Some readers skim paragraphs, skip
sections, or pay little attention to how a paragraph relates
to the ones before and after it. Other readers engage books
more actively. They read not just to pass the time, but to
learn something. To do this they pay careful attention to a
book's structure, form, and content. In the end, the better
a person reads, the more he receives from the effort, and
the more he enjoys reading.

What is true of reading books is also true of watch-
ing movies. In a sense, anyone can watch a movie—if
"watch" simply means sitting in front of a flashing
screen. But there is more to the experience of watch-
ing a movie than passively receiving images and sounds.
Fortunately, with a little instruction, anyone can learn to
watch movies well. Now, the idea of "learning to watch
movies" might sound intimidating or even boring. But
just as learning to read more carefully makes books more

enjoyable, knowing more about movies actually makes them more entertaining.

One of the first steps in the process of becoming a thoughtful moviegoer is learning to discern the difference between *how* someone tells a story and *what* that person is telling us with the story. To cite a biblical example, think for a moment about Jesus' account of the prodigal son in Luke 15:11–32. Essentially, the message of the parable—what Jesus is telling us with the story—is that God loves his children deeply and unconditionally. But Jesus' method of communicating that message—how he tells the story—is to create fictional characters and place them in a first-century setting where they behave in certain ways. If we assume that Jesus' story is simply an entertaining tale of a man and his two sons, we miss his point completely.

We'll explore the specific methods moviemakers use to tell their stories in later chapters. First, though, it is important that we make a few distinctions that will help us discern the difference between a movie's form and its message.

Direct versus Indirect Communication

Good storytelling communicates a message subtly and indirectly. Speaking of screenwriting, Robert McKee puts it this way: "Audiences are rarely interested, and certainly never convinced, when forced to listen to the discussion of ideas."[1] What audiences want instead is to be hooked by a powerful story and engaging characters. When that

[1] Robert McKee, *Story: Substance, Structure, Style, and the Principles of Screenwriting* (New York: ReganBooks/HarperCollins, 1997), 114.

happens, they are much more likely to "hear" a movie-maker's message and take it to heart.

Because audiences watch a movie primarily for its story, they can be extremely resistant to movies that forcefully promote a message with the intent to persuade, rather than entertain, them. People call this "propaganda", and for good reason—the purpose of propaganda is to propagate, to spread, ideas in order to further an ideology or cause. The more blatant the message, the more likely it is, in fact, propaganda. For example, see if you can guess the message that is communicated in this quotation:

```
                    JACK
Global warming is melting the polar
ice caps and disrupting this flow.
Eventually it will shut down. And
when that occurs there goes our
warm climate.... If we do not act
soon, it is our children and grand-
children who will have to pay the
price.
```

 (*The Day after Tomorrow*)

Not very subtle, is it? Based on this short excerpt, the clear purpose of this film is to propagate a message about environmentalism and, in particular, the theoretical catastrophe that could occur if we do not take measures to stop climate change. In contrast to this approach, storytelling techniques that communicate indirectly, yet personally, are more likely to capture the imagination of an audience and influence its ways of seeing and thinking about themselves. An excellent example of an indirect approach to the same topic addressed in *The Day after Tomorrow* is *WALL-E* (2008). This movie warns against pollution and

human excess, realities we all know, by following the daily experiences of a lovable character as he works to clean a wasted, garbage-strewn Earth, while showing the unpleasant destiny of self-indulgent human beings.

This difference between direct and indirect approaches relates to the purpose of movies. If the purpose is primarily to entertain, then messages will be indirect and will arise out of showing us a glimpse of ourselves. If the purpose is propaganda, then the message will be blatant and enjoyed only by those who already agree with it (consider, for example, the eager reception in 2004 of *Fahrenheit 9/11* by those on the political left or *Expelled* by proponents of intelligent design in 2008). Almost by definition, then, popular movies will rarely state their messages explicitly. This means that determining what a movie has to say will probably require some investigation.

This distinction also helps explain why Christian movies (and reviews) are often very different from their non-Christian counterparts. When clean style and spiritual messages are taken to be the primary issues to address when making a movie, it is often little more than propaganda, and as a result, art and storytelling usually fall by the wayside (hence the generally low entertainment value of many "Christian movies").[2] In turn, many Christians judge movies on the basis of style and message rather than artistic merit or entertainment value and don't understand when a "Christian movie" is disliked or ignored because it lacks those qualities.

The problem is that a good story can be told so poorly that no one will want to hear it. Poor quality work should

[2] See Spencer Lewerenz and Barbara Nicolosi, *Behind the Screen: Hollywood Insiders on Faith, Film, and Culture* (Grand Rapids, MI: Baker Books, 2005) for several insightful articles on this issue.

not characterize Christian artists.[3] Étienne Gilson wrote, "Art should be at its best when the cause to be served is religion."[4] This insight has implications for Christian ministry. Christians often think of faith-based movies as a potentially effective means of evangelism. Filmmakers and writers may believe that if they can present the gospel clearly and dramatically, non-Christians will be convinced and embrace the faith. But in too many cases, by the time the protagonist delivers a successful gospel presentation to the antagonist at the climax of the movie, usually only Christians who like these kinds of films are applauding. As film producer Ralph Winter (of *X-Men* and *Fantastic Four* fame) once said, "We have to master the art of filmmaking and create a powerful story before we think about how we're going to put some kind of Christian message in the film."[5] By stating their message so explicitly, filmmakers actually undermine the purpose of their movie.

NEIL
Don't let yourself get attached to
anything you are not willing to
walk out on in thirty seconds flat
if you feel the heat around the
corner.

(Heat)

[3] Some blame this on inadequate funding, but there have been plenty of low-budget successful movies such as *Monty Python and the Holy Grail* (1975), *The Usual Suspects* (1995), *Cube* (1997), *Pi* (1998), *The Blair Witch Project* (1999), *The Boondock Saints* (1999), *Memento* (2000), *Frailty* (2001), *Primer* (2003), *Napoleon Dynamite* (2004), *Juno* (2007), *Ex Machina* (2015), and *Get Out* (2017).

[4] Étienne Gilson, *The Arts of the Beautiful* (Champaign, IL: Dalkey Archive Press, 2000), 182.

[5] William D. Romanowski, *Eyes Wide Open: Looking for God in Popular Culture* (Grand Rapids, MI: Brazos Press, 2007), 223.

The sad irony is that many nonreligious movies have communicated moral themes more effectively than many overtly Christian films. For example, the 1995 film *Heat* was a fairly unique heist movie for its time. The head of the criminal crew lives alone in a beautiful but barren house (an apt metaphor for his life, the guiding principle of which is reflected in his line above). His lieutenant has a gambling addiction and abuses his wife, who in turn cheats on him. The other crewmembers have all spent time in and out of prison and are merciless murderers. In *Heat*, being a criminal is not glamorous; it is a dark, hard life that is full of disappointments.

The creators of *Heat* could have had one of the criminals get arrested, lose everything, meet a wise pastor while in prison, accept Christ, and end the film with a fiery sermon about the evils of crime. Instead, this indirect, but clear, presentation of the emptiness of sin is much more powerful. We will return to this theme when we discuss questionable style features (such as violence, profanity, and sexuality) in chapter 4.

Fiction versus Falsehood

Audiences do not expect or want to be told the truth explicitly in every feature of a film (even those allegedly based on true events). And there's nothing wrong with that, for it is the nature of fiction to show, not tell. Jesus told fictional stories (parables) about people and natural phenomena that reveal simple truths about life. The specific characters and events in the parables are imagined—this is understood— yet they correspond to human experience.

Fiction becomes a lie when the features that are presented as true are false or misleading. Consider *The Da Vinci*

Code (2006), which caused a stir in Christian circles due to its blatant attack on traditional Christian beliefs as well as proven history while claiming to be historically accurate. Many fans could not understand why people would get so upset by a story everyone knew was fiction. The problem was that while the story was fictional, the author claimed that its background was based on the "real" history of the Catholic Church, which confused many viewers.

In contrast, Pixar's 2017 hit *Coco* revolves around the Mexican holiday Día de Muertos (Day of the Dead, or All Souls' Day). The film presents an afterlife that has little resemblance to that of historic Christianity, but it does not argue with the tradition or attempt to supplant it with something else. The film's message (family comes first in life) resonates widely with many people without any reference to particular beliefs about the afterlife.

Fictional storytelling and communication of falsehood need to be distinguished when messages behind movies are being discerned. Confusing the two can easily lead to mistaken judgments about what truths the message contains.

Literal versus Figurative

In some Christian circles it is common to hear that interpretation of Scripture must be "literal" if it is to be taken seriously, and that "allegorizing" the text is anathema. This hermeneutical theory often spills over into film creation and analysis and causes artistic problems. It is clear from Scripture itself, however, that neither of these options represents the intention of Scripture's author (God). The truth is found, as it often is, between the two extremes.

Some scriptural passages are clearly meant to be taken literally (e.g., "bring the cloak that I left with Carpus at

Troas" in 2 Tim 4:13). There are also passages that are clearly meant to be taken figuratively (e.g., empires are pictured as beasts in Dan 7:4–7 and Rev 17). While most faithful interpreters agree on these, there is a third way that Scripture is often taken that sits in between these two options. For example, Saint Paul speaks of Israel's twin mountains as being figures of the old and new covenants (Gal 4:24). Now, nothing in the Old Testament would lead anyone to think that this is the case, but Saint Paul had no problem assigning this additional "layer" of meaning to the literal geography of the nation. The support for his doing so does not come from the text, but from what he nevertheless believes to be true.

Jesus does the same thing when he explains all of the Old Testament with reference to himself (Lk 24:27). Clearly the Old Testament does not speak literally of Jesus in every passage! It does speak of him in a figurative sense, however. The Church has taken this multi-layered hermeneutic to heart and employed it when such understandings can be supported theologically even if not scripturally (in the literal sense). Although what lies on the literal surface of the text must always take precedent, this does not mean additional figurative layers are not legitimate.

Like Scripture, movies have their own way of "speaking", and it rarely lies on the surface. Indeed, the movies that put their message on literal display are not often good ones (artistically speaking). As we have seen, this is one reason so many "Christian movies" flop—the messages are delivered with such ham-fisted lines that one cannot help but feel a sermon is being delivered. Verbal literalism does not always work well with biblical interpretation, and it almost never works well with screenplays!

One cannot simply approach a movie as if it were a text meant to communicate explicitly a position or an opinion.

To the degree that one cannot discern underlying themes and messages in the depths of a film's structure and characterizations, it is unlikely that the true message(s) will be discovered.[6]

Description versus Prescription

Filmmaker Lawrence Kasdan once said, "The thing about writing and directing a film is that you are presenting a view of the universe.... Every time you put the camera down you're saying here's a vision of the universe as I perceive it. And that is being tested by everyone who sees that movie."[7] This observation brings up another important distinction to bear in mind when evaluating the message of a movie. Just because a filmmaker communicates that something *is* the case does not necessarily mean it *should be* the case. This is the difference between *description* and *prescription*. A filmmaker may describe urban life as violent and dangerous. That doesn't mean that he wishes urban life was dangerous or that he is glorifying violence. One can portray something without promoting it.

Readers of the Bible will recognize the truth of this principle immediately. The Bible records many instances of violence and sexual immorality, but these are not prescriptions. The Bible is not saying that these things should have occurred, only that they did. Christians should remember this distinction when criticizing movies that simply portray immoral behavior. If immorality is portrayed as immorality, that is actually a good thing (Is 5:20). This does not

[6] The "literal-only" hermeneutic is generally limited to Protestant circles, while the multi-sense understanding of Scripture reflects official Catholic teaching. This may explain why many great Hollywood movies are the creation of Catholics, and nearly all typical "Christian movies" are made by Protestants.

[7] Romanowski, *Eyes Wide Open*, 52.

excuse gratuitous depictions or exploitation of such things, but it does mean we should allow for the communication of the truth about human behavior.

Message versus Purpose

A final distinction we should be careful to make when assessing a movie is between its message and its purpose. We should avoid the temptation to assign motives to movie-makers based on the messages of their movies. There are several important reasons for this.

First, if we incorrectly judge a filmmaker's motives on the basis of certain attributes of the film, we risk slandering the filmmaker. Consider accusations against Mel Gibson when he released *The Passion of the Christ* (2004). Because he (correctly) depicted the murder of Jesus Christ as being caused in great part by the Jewish leadership of the first century, Gibson was accused of being anti-Semitic. Regardless of Gibson's personal thoughts on the Jewish people, simply telling this part of the story as it is recorded in Scripture[8] is hardly grounds for the charge of anti-Semitism.[9]

A second reason to avoid assigning motive is that films are rarely the creation of a single person. It is not unusual for a script to be written by one person or team, who then sells it to a studio, which has someone else rewrite it, only to hand it over to a director who can also change it. The director's power to influence the story may also be extended to the actors, who shape the work as well. After

[8] Mt 27:24–25; Acts 2:22–41; 10:34–43
[9] Statements Gibson has made at other times have suggested an anti-Semitic posture. For examples see Emma Nolan, "All the Times Mel Gibson Has Been Accused of Anti-Semitism and Racism", *Newsweek*, June 23, 2020, (https://www.newsweek.com/mel-gibson-anti-semitism-racism-accusations-1512808).

the filming is complete, changes to the story will often continue to be made in editing (thus the reason for "director's cut" versions of many movies). In fact, it is so rare for one person to receive singular credit for a film that the industry reserves a term for people who do: "auteur". An auteur is a director whose influence is so strong in the films he directs that he is essentially considered to be its creator. An example is Terrence Malick, the acclaimed writer-director of *The Thin Red Line* (1998), *The Tree of Life* (2011), and *A Hidden Life* (2019). Conversely, there is an option in place for directors who feel that they have lost control of a project so that they may choose to receive no credit for it.[10]

A final reason we should be slow to judge a moviemaker's motive on the basis of the message of a film is that sometimes a movie may communicate a message the creator did not intend.[11] In fact, there are times when a movie's indirect (and unintended) message overshadows the creator's direct (intended) message. An example of this is the 2006 film *Facing the Giants*. The movie's direct message is that we must trust and glorify God regardless of what happens in our lives. This is stated by various characters enough times that it is unmistakable. In the course of the movie, however, no one faces disappointment with any of God's decisions, because every character who trusts God ultimately gets what he wanted in the first place! The indirect message of the film comes through loud and clear: a life lived for God gets you what you want. This

[10] In these cases, the director may choose to use the Director's Guild–approved pseudonym Alan Smithee, an anagram of "the alias men". Actors may do the same with the alias George or Georgina Spelvin.

[11] In some cases, filmmakers state that their work means "nothing" at all. One of the creators of *Frailty* (2001) stated in the DVD's extra features that the film's story did not really mean anything—yet its message (one of extreme faith in God) was clearly communicated.

un-Christian message might not be what the filmmakers had in mind, but it is what their story communicates.

So, when evaluating a movie's message, we should not necessarily be concerned over who is responsible for its creation or what his goal might have been when he made it. *The Lord of the Rings* trilogy (2001–2003) was not a product of overtly Christian screenwriting, directing, or acting; yet, it is one of the most truth-filled and faith-affirming stories ever to be shown on screen. Although the books on which the films were based were written by a Christian, J. R. R. Tolkien, they do not contain explicit Christian messages but rather truths about the journeys and the battles common to human experience.

On the other hand, when someone goes to the trouble of making his motive patently obvious, that should not be ignored—especially if the movie's message is unclear. *The Golden Compass* (2007), for example, is an adaptation of the first novel in Philip Pullman's trilogy His Dark Materials—books written in opposition to Christianity in general and Christian author C. S. Lewis in particular.[12] Pullman's anti-Christianity may not come through strongly in the film, but practically speaking, it should not be ignored when assessing it. Subtle features of the story can take on added significance when more context is known.

Conclusion

When we set out to evaluate a movie's message, we must let the story tell itself. Stories come with their own

[12] Peter Hitchens referred to Pullman as anti-Lewis, the one the atheists would have been praying for, if atheists prayed (https://hitchensblog.mail onsunday.co.uk/2014/05/is-this-the-most-dangerous-author-in-britain-philip -pullman-revisited.html).

guidelines for understanding the messages they carry. We ignore these guidelines when we fail to make the distinctions we discussed above. In the upcoming chapters, we'll consider how stories are put together, how the different styles in which stories may be told impact audiences differently, and what role background suppositions play. Finally, we will see how these elements combine into a coherent message. All of these things will help make you a better movie watcher and will make movies a lot more fun to watch.

Chapter 3

Story: Characters and Confrontation

Story Rules

KID

You read that wrong. She doesn't
marry Humperdinck, she marries
Westley. I'm just sure of it. After
all that Westley did for her, if
she didn't marry him, it wouldn't
be fair.

GRANDPA

Well, who says life is fair? Where
is that written? Life isn't always
fair.

KID

I'm telling you, you're messing up
the story! Now get it right!

(*The Princess Bride*)

It has long been recognized that there are certain properties
that are common to nearly all good stories. Like the Kid
in *The Princess Bride*, almost intuitively, we can sense what
should happen next in a story, how it should develop, or,
at the very least, when something happens that seems out
of place. When storytellers ignore or violate the rules of

good storytelling, audiences take notice. As a form of story-telling, movies also tend to follow conventions of form and structure. In addition, moviemakers use a variety of artis-tic techniques to articulate their message and enhance the viewing experience. Lighting, depth of focus, scene cuts, soundtracks, and many other cinematic devices change the way viewers experience the world of the film.

Understanding the constituent parts of stories and being sensitive to the techniques moviemakers use to tell their stories are foundational to assessing the message commu-nicated by a movie. Below, we will have a look at how a story's underlying act structure and character types convey the message behind the movie.

Story Scripts

Acts

Over two millennia ago, Aristotle pointed out that stories have a beginning, a middle, and an end.[1] In his landmark book *Screenplay*, Syd Field detailed how these "three acts" functioned in screenwriting, and his technique has been followed ever since.[2] In this structure, each act has its own purpose, and each is marked by some major event.

The purpose of act 1 is to set up the story by introducing viewers to the main characters and telling them something about their situation (the *context*). Two primary characters

[1] See Aristotle, *Poetics* 6. 1450b25–35.

[2] Syd Field, *Screenplay: The Foundations of Screenwriting* (New York: Delta, 2005). Although the classic three-act structure is not the only model available, the plot of most stories can be structurally reduced to fit into it. See Gustave Freytag's *Technique of the Drama: An Exposition of Dramatic Composition and Art* or *The Writer's Journey: Mythic Structures for Writers* by Christopher Vogler.

are the protagonist and the antagonist. The protagonist—often the main character—is typically the person whom the action follows and with whom the audience identifies. The antagonist challenges the protagonist and helps drive the conflict of the story. These kinds of characters are sometimes referred to as the "hero" and the "villain", respectively, but this not always accurate. Many times, the protagonist is not terribly heroic, and antagonists are not always villainous. In fact, they aren't always even human. In the movie *Cast Away* (2000), for example, an island serves as the antagonist to a stranded human protagonist (whose sidekick character was played by a volleyball!).

Once the characters are in place and the story's context is known, the time comes to discover what is going to happen. The first thing to happen is some sort of serious *challenge* that pivots the story in a new direction. This begins act 2. In a standard two-hour movie, the challenge usually occurs near the half-hour mark.

The challenge is confronted throughout act 2, which normally constitutes about half of the movie. Regardless of how many twists and turns there are in this act, the conflict should continue to escalate until it reaches its penultimate moment of *crisis*. This is where the story pivots once again and enters act 3.

Act 3 is where we see how the protagonist will face the final crisis of the conflict and the results of that choice. We discover this with finality at the *climax*—where the protagonist either overcomes the challenge (a "comedy" in classical terms) or is overcome by it (the classic "tragedy"). The climax, then, resolves the challenge.

The story is, in a sense, over at this point even if the movie isn't. Sometimes movies simply cut to the credits once the challenge is resolved. Other movies continue to what is sometimes referred to as the *denouement*

(pronounced *day-nyoo-mahn*). Here the audience is told of the lasting effects of the climactic event. This might be accomplished in a number of ways: a brief narration akin to an epilogue in a book or perhaps scenes from the protagonist's life during the credits. Either way, the climax is really the key to the story, because it is only then that the audience knows for sure whether the protagonist succeeded or failed.

Here is an example of the three-act structure in a fairy-tale-style narration:

> Once upon a time in act 1, there lived a protagonist. Things were going great until act 2, when an antagonist came along and presented the protagonist with a challenge. The protagonist later realized that certain actions would have to be taken to meet the challenge. Things kept getting more difficult until the protagonist entered act 3, finally overcame the antagonist's challenge at the climax, and lived happily ever after.

The interesting thing about this basic plot is that it is essentially universal.

It is difficult if not impossible to tell a genuine story without a structured beginning, middle, and end—and

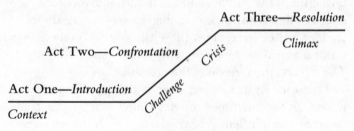

Three-Act Structure

that goes double for stories on film. Even an unusual "two-part" movie such as *Room* (2015) exhibits this structure in each half as well in the film overall. *Memento* (2000) tells its story backwards, and *Pulp Fiction* (1994) tells three overlapping stories, each out of chronological order, and yet those stories still follow the pattern. *Dunkirk* (2017) tells three overlapping stories in chronological order to show how the same events are being experienced by different protagonists at the same time, and here too, all three stories have a beginning, a middle, and an end. Films in series, such as (preplanned) trilogies, typically exhibit this structure in each movie as well as in the overarching structure.

Moreover, these plot elements are not simply a story-writing formula. As Robert McKee wrote in his comprehensive treatment of narrative, *Story*, "Classical design is a mirror of the human mind."[3] Thus, there is something dissatisfying about movies that veer too far from this universal pattern. The movie *Adaptation.* (2002) demonstrates this brilliantly. The movie is about a screenwriter who is reading McKee's book while struggling to adapt a novel into a film. The movie self-consciously strays from the scripting model that McKee (who appears as himself in the film) describes in the book until the screenwriter learns more and more about story structure. As he learns, the movie itself begins to reflect the rules of *Story*, and it gets better and better.

Other elements of stories are so pervasive that mythology expert Joseph Campbell came to believe that nearly all great narratives share the same basic character types and story structures. He describes this universal pattern as the

[3] Robert McKee, *Story: Substance, Structure, Style, and the Principles of Screenwriting* (New York: ReganBooks/HarperCollins, 1997), 62.

"Hero's Journey".[4] Christopher Vogler, an accomplished screenwriter and Hollywood story consultant, summarizes the Hero's Journey in twelve stages that map on to the classic three-act structure:

Act 1

1. *Ordinary World*—The Hero's world before the Journey begins.
2. *Call to Adventure*—The Hero is called to the Journey.
3. *Refusal of the Call*—Something temporarily keeps the Hero from embarking on the Journey.
4. *Meeting the Mentor*—The Hero receives guidance and something needed for the Journey from someone wiser.
5. *Crossing the Threshold*—The Hero begins the Journey.

Act 2

6. *Tests, Allies, Enemies*—The Journey progresses as the Hero is confronted with various characters and an escalating series of challenges.
7. *Approaching the Inmost Cave*—The Hero faces a serious personal challenge that must be overcome if the Journey is to continue.
8. *Facing the Ordeal*—The Hero is now dealing with the Journey's primary conflict. It is now all or nothing.
9. *Seizing the Sword*—The Hero overcomes the Ordeal and is transformed by it, often gaining a prize.

[4] See Joseph Campbell, *The Hero with a Thousand Faces*, 2nd. ed. (Princeton: Princeton University Press, 1973) or (with Bill Moyers) *The Power of Myth*, ed. Betty Sue Flowers (New York: Anchor Books-Doubleday, 1988). Campbell has been criticized for presenting oversimplified versions of myths and ignoring glaring inconsistencies to support his theory by, for example, Tom Snyder in *Myth Conceptions: Joseph Campbell and the New Age* (Grand Rapids, MI: Baker Books, 1995).

Act 3

10. *The Road Back*—Despite victory, the Journey continues as the Hero seeks to return to the Ordinary World.
11. *Resurrection*—The Hero must face the most challenging conflict yet—the Hero's very life may be required of him.
12. *Returning with the Elixir*—The Hero, having been reborn through ordeal and resurrection, completes the Journey by returning to the Ordinary World with a special gift.[5]

Actors

Along this journey, most stories introduce certain kinds of characters that Campbell, borrowing from Swiss psychiatrist Carl Jung, referred to as "archetypes". Not every archetype is always present, and one character (or object) may take the role of multiple archetypes—but in general, these characters show up in most large-scale stories.

The Hero: the protagonist, the main character whose actions form the story.
The Herald: a character who initiates the Hero's call to adventure.
The Mentor: the "wise old man" who supports the Hero, often with a gift of some sort.
The Ally: a companion who aids the Hero on the Journey.
The Threshold Guardian: a character who tests or challenges the Hero on the journey.

[5] From Christopher Vogler, *The Writer's Journey: Mythic Structure for Writers*, 2nd ed. (Studio City, CA: Michael Wiese Productions, 1998), 12–14, 26.

The Shapeshifter: a character whose function changes throughout the story.

The Shadow: a rival or the main villain or the dark side of another character.

The Trickster: often a sidekick or minor character used for comic relief.

Campbell's work provided the key to the success of George Lucas' original *Star Wars* script.[6] In fact, these archetypes fit Lucas' script so well, one might think they were based on the movie rather than vice versa! However, even seemingly dissimilar films like the classic children's story *The Wizard of Oz* (1939), the modern Western *Tombstone* (1993), the mind-bending adventure of *The Matrix* (1999), the epic fantasy *The Lord of the Rings: Fellowship of the Ring* (2001), the animated comedy *Cars* (2006), or the dark drama *Hunger Games* (2012) include Campbell's character categories.

Later we will discuss how to use these observations to interpret and assess the movies we watch. For now it is enough to recognize these common story features when we see them.

Conclusion

Being alert to these details does not make objective assessment of movies a foolproof procedure. After all, despite a century of investigation, the art of movie making is still that—an *art*, with features open to interpretation and elements that are sometimes difficult to explain. (See

[6] See Dale Pollock, *Skywalking: The Life and Films of George Lucas* (New York: Da Capo Press, 1999).

chapter 12 for a sample analysis of *The Truman Show*.) Nevertheless, being equipped with a basic knowledge of the standard features of a story and aware of the artistic techniques moviemakers use to tell their stories will help us to discern the messages of movies.

Chapter 4

Style: Sights and Sounds

Spoilers!

My father used to drive me crazy, because he could almost always guess the end of a movie midway through. When I asked him how he did it, he explained that everything that stands out in a movie has a purpose, so if you pay attention to what the movie shows you in the beginning, you'll often be able to guess what's going to happen at the end. I later learned that this is a principle of theater known as Chekhov's Gun. Anton Chekhov was a nineteenth-century Russian playwright who said that if you show a gun in act 1, it had better be fired by act 3.[1] Almost nothing in a movie is there by accident. What you see on the screen is very carefully controlled. What this means to us is that every dominant detail in a film, from what we see to what we hear, should matter.

Sensations

Sights

This brings up our next film term: *mise-en-scène* (to impress your friends, pronounce it *mee-zahn-sen* with an *outrageous*

[1] See Donald Rayfield, *Anton Chekhov: A Life* (New York: Henry Holt and Company, 1997).

French accent, emphasis on the last syllable). This phrase is used regularly in film analysis and literally translates as "put on stage". It refers to whatever is on the screen during a given shot, including physical scenery and the techniques used to present them.[2] Thus, mise-en-scène can include actors, sets, props, costumes, lighting, camera angles, lens focus lengths, aspect ratios, editing, and even the chemical treatments used to develop the film.

Because these elements help tell the film's story, it is a good idea to ask yourself why the filmmakers make the decisions they do. Note which actors are most or least attractive and which are the good guys and the bad guys. Be alert to whether the scenes are shot in deep focus, presenting an overview and some distance from the characters and action, or shallow focus, calling attention to certain objects or characters and creating intimacy. Consider a scene from *Spotlight* (2015)—a film about the scandalous sexual abuse cover-up in the Catholic Church. During a scene in which a survivor is describing his abuse to a reporter, they are standing near a playground with an imposing church building just behind it. The message is clear: *The Church is a threat to children.*[3]

It is also helpful to identify which character the camera follows—is the scene shot from one character's point of

[2] Some make a stronger distinction between "what is in the scene" and "how the scene is shot" (mis-en-scène vs. mis-en-shot). See Warren Buckland, *Film Studies* (London: Hodder and Stoughton, 1998), 10.

[3] *Spotlight* was a good movie exposing a major problem in some segments of the Catholic Church. It is important to note that the scandal had more to do with lack of disciplinary action on the Church's part than the actual numbers of cases or any particular problem with Catholicism. See Boz Tchividjian, "'Spotlight': It's Not Just a Catholic Problem", Religion News Service, December 7, 2015, religionnews.com/2015/12/07/spotlight-its-not-just-a-catholic-problem, and Pat Wingert, "Priests Commit No More Abuse Than Other Males", *Newsweek*, April 7, 2010, newsweek.com/priests-commit-no-more-abuse-other-males-70625.

view, and do cuts follow that character's gaze? Are two scenes overlapped in a montage sequence, indicating parallelism in time or action? Do scene changes cut slowly (showing time's passage) or rapidly (creating suspense), or is the scene one long take (creating *gravitas*)? Being sensitive to these techniques and others like them will not only increase your appreciation of the film but also aid you in understanding what the filmmakers wanted to communicate.

Note the contrast between the dream world and the real world in *The Matrix* (1995). The former is shot in bleached-out blue-green tones while the latter is filmed in deeper, darker colors. These contrasting traits help the viewer to distinguish between what is supposed to be real and what is the false world of the Matrix. A scene from *Pretty Woman* (1990) shows a prostitute, Vivian, getting dressed. The scene is a montage of close-ups of various body parts and sexy clothing. This scene was not necessarily designed simply to arouse the audience. Rather, it establishes that Vivian is seen as just a collection of sexy body parts. The famous introductory flyover of *Star Wars* (1977) begins with a tiny white transport vessel being pursued by an enormous dark battleship, brilliantly illustrating the impending struggle between a small band of good guys (the Rebellion) and the overwhelming enemy (the Empire). Filmmakers take great care with what they present us on screen, and we do well to notice.

Sounds

It is not simply what we see but what we hear that helps us understand a movie's story, and the sound is just as carefully controlled in a film as is the mise-en-scène. It is so important, in fact, that virtually everything we hear in a movie besides the dialogue—from the film's score to the actors' footsteps—is usually created in post-production.

Again, almost nothing in a movie is accidental. When it comes to what we hear, there are two major types of sound in a movie: diegesis and the score.

Diegesis refers to the sounds that come from within the world of the movie. These include dialogue, external noises like car horns or thunder, and even sounds internal to the actors, such as a narration in a character's mind. Dialogue is obviously paramount, but even subtle sounds can make a big impact on setting and mood and can become an important part of the story itself. During the conversation in *The Patriot* (2000) in which Gabriel Martin confesses to his father that he will not return to the war, the cannon fire in the background subtly reinforces his concerns. Background sounds are often at the periphery of our notice, but their absence is impossible to ignore when they are removed.

A film's *score* also communicates story by arousing our emotions and creating mood. A film's score helps to produce the emotional experience the director wishes the audience to have. Imagine the funeral scene from *Braveheart* (1995) without the beautiful bagpipes playing in the background or the denouement of *Titanic* (1997) without Céline Dion's "My Heart Will Go On". Monty Python films often contain scores that are intentionally mismatched with the gravity of the scene to add to the ludicrousness of the dialogue.

Using a technique known as *leitmotif*, the score can also aid in narration and character identification by matching a recurring melodic phrase or figure with a certain idea, person, or situation. In both the Broadway play and the film version of *The Phantom of the Opera* (2004), music is used to accentuate characters and actions. When we hear the initial chord blast from the pipe organ, we know trouble is near! Because the song "Angel of Music" plays in scenes between Christine and the Phantom, and the songs

"Think of Me" and "All I Ask of You" refer to Raoul and Christine's relationship, the mixing of these songs in "Point of No Return" in the final scene greatly intensifies the climactic clash of the three parties.

A powerful use of *leitmotif* is found in *The Lord of the Rings: The Fellowship of the Ring* (2001). For this film, themes were specifically written to provide proper atmosphere for characters and places. Hobbits, orcs, dwarves, and elves have their own music. Locations such as Moria, Mordor, and Hobbiton have distinctive sounds. In the realm of the elves, the music is light and beautiful (if a bit melancholic). Scenes involving the orcs showcase discordant instrumentation created with anvils and piano strings struck by chains. Even the film's plotline is subtly revealed in its music. The first time we hear the Fellowship theme is when Sam steps dramatically into the cornfield—a step that takes him farther from home than he has ever been. This is the true beginning of the Fellowship, albeit with only two members (thus the simple instrumentation). When we hear the theme again at the conclusion of the council at Rivendell, it is fully orchestrated, because the Fellowship is now complete. The last time we hear it is when Frodo stands alone at the edge of the river above the falls, the sparse instrumentation confirming that the Fellowship has crumbled.

The Ratings Game

Having explored various artistic techniques that moviemakers employ to tell their stories, we should address potentially offensive style. The elements that most often concern Christians include profanity, violence, nudity, and sexual immorality. The purpose of this book is not to provide a guide for moral movie making. However,

because these style decisions stand out, they need to be dealt with as part of the film's interpretation.

When evaluating the content of movies, we need to avoid confusing *message* and *method*. How one tells a story and what that story communicates are not always tied closely together. To the degree that style does not support the message of a movie, it can be ignored insofar as that message goes. In these cases, though, one may well ask why those elements were included. If everything we see and hear in a movie should matter, then the inclusion of this content should be justifiable. If not, it may indicate a lack of integrity on the part of the filmmaker, artistic or otherwise.

Related to integrity, it may also be a sign of market capitulation. Part of the reason Hollywood continues to produce movies with questionable style may be because of the ratings system itself. Because the Motion Picture Association of America (MPAA) bases its designations on appropriateness for children, audiences often think of G- and PG-rated films as "kid movies". Thus, if a studio plans to make a serious movie for mature viewers, it may push for an R rating in order to attract more adults.[4] (There are times, too, when producers eliminate some style elements to earn a lower rating, in order to attract younger viewers.) Because style alone affects ratings, the only way to attain an R rating is to include "adult" content.

The mere presence of profanity, violence, or nudity, however, does not automatically indicate that a film is immoral or artistically lacking. Style inclusions must be evaluated according to both their *presence* and their *propriety*.

[4] The popular director M. Night Shyamalan, known for being "Mr. PG-13", states in the bonus feature commentary of his 2008 film *The Happening* that the studio asked him to make the film R-rated.

The acceptability of a film's style depends largely on its importance in supporting the story. If such elements are merely gratuitous additions included to excite the audience or garner a more "respectable" rating, they are worthy of criticism. Conversely, if they serve as worthy amplifiers of a movie's message, then they should be acknowledged as such. While one's personal acceptance of various style components will necessarily be at least partially subjective, when judging their use in a movie, we should exercise as much objectivity and charity as possible.

Concerning the MPAA

Many people—Christians included—give great weight to the MPAA ratings system. They might decide as a matter of principle to watch anything G-rated while avoiding all R-rated movies. Unfortunately, the MPAA's ratings do not necessarily provide an accurate evaluation of a movie's overall message or moral value. This is because such a judgment depends upon both a movie's story and its style, and the ratings system focuses only on style.

Here's a thought experiment. On the basis of the following descriptions, which of these movies would more likely be considered acceptable to a Christian audience:

- Movie A contains profanity, nudity, and disturbing images of violence.
- Movie B is a family-friendly cartoon with no nudity, cursing, or violence.

Given these details, the answer might seem clear. But notice that all I gave you were style features. If I add the following information, the equation changes:

- Movie A depicts history accurately, is anti-racist in message, and promotes traditional religious values.
- Movie B is dishonest in its presentation of history and anti-Christian in its message.

The two films above are the R-rated *Schindler's List* (Movie A) and Disney's G-rated *Pocahontas* (Movie B).

It is important to understand that the MPAA rating system is designed to make parents aware of thematic content that might be inappropriate for children.[5] It is not intended to determine what makes for appropriate viewing for adults, and it does not take a movie's message into consideration. Movies that are decidedly off limits for children, then, are not necessarily inappropriate for adults,[6] and movies with appropriate style for all ages might contain terribly misleading messages. The MPAA rating system is simply not a sufficient guide for making decisions about which movies to watch and which ones to avoid. (For more on that subject, see Act Three below.)

In one of its earlier ratings explanation posters, the MPAA recommended that parents "think before taking the kids" when a film is rated R. I agree. I would add that regardless of a film's rating, we should *always think* before we see a movie!

Christian versus Cultural Criticism

The following sections will discuss the style elements mentioned above that are of particular importance to Christian

[5] See MPAA Ratings Explanations at its website, www.mpaa.org/FlmRat_Ratings.asp.

[6] I was once asked if I would let a two-year-old watch *The Passion of the Christ* (2004). I answered in the negative, but I added that I also would not feed steak to a two-month-old. Developmental readiness is at issue in both cases.

moviegoers. Before getting into these particulars, some general principles are worth considering.

When we critique a film's style, we should do so from a Christian—rather than a merely *cultural*—perspective. While that principle may seem rather obvious, there are two sides to the coin. First, we should not make the mistake of assuming that contemporary cultural judgments about what is acceptable are always correct. When settled moral principles are declared part of the Christian faith, they should be respected as the standards by which we make our judgments.

Second, we must also avoid raising our personal opinions to the status of Christian standards—and this can happen in Christian cultures just as easily as in secular ones. For example, when the theologian-poet Dante Alighieri wrote *The Inferno*, he placed the lustful at the top ring of hell and the violent below them; even closer to the bottom of hell are those who commit various kinds of fraud. In Dante's architecture, this means that sins of lust are not "as bad"—that is, premeditated—as those of violence or betrayal. To be clear, for Dante all sin is *very* bad, which is why unrepentant sinners are in hell. Dante's ranking of sin comes as a surprise to many Americans who are typically more concerned about sexuality and nudity in movies than violence.[7] In Europe, the opposite is true, and violence is taken much more seriously when rating a film. To judge these aspects fairly, then, we cannot simply apply cultural norms.

Style Features

Let us now turn to the particular style features that often catch the attention of Christian viewers.

[7] Kirby Dick reports in his documentary *This Film is Not Yet Rated* (2006) that the MPAA rates four times as many movies NC-17 for nudity/sexuality than for violence.

Profanity and Harsh Language

 JUDGE
Tell the witness to rephrase the
answer.

 DEFENSE
Well, that's just it, Your Honor.
He can't. The word has a very dis-
tinct connotation. There's nothing
else that quite captures it.

 PLAINTIFF
I object! You're saying the presi-
dent of a bank can't articulate his
thoughts without using profanity.

 DEFENSE
What I am saying, sir, is that there
aren't many words to describe the
particular slime that your client
oozes.

 (*From the Hip*)

As the dialogue above humorously portrays, sometimes a
profane word is the only one that can do the job a word
needs to do—communicate well.

The late comedian George Carlin got a lot of mileage
from his famous "Seven Words You Can't Say on TV"
routine. He noted, "There are four hundred thousand
words in the English language, and seven of them you
can't say on television." While Carlin's figures may be
outdated, profanity in media continues to be a contested
issue. The question of when a profane word is necessary in
a scene remains a thorny one.

What is it exactly that makes a word profane? It can't
simply be its definition. Some of the most common pro-
fanity concerns body parts and functions, sexual activities,

or religious references that can be replaced with acceptable synonyms. So, it is not what a word means that makes it profane, but the manner in which it is used. Looking closer, it seems that profanity is often a perversion of goodness (speaking of a good thing as if it were evil). This alone should give people pause when deciding how to express themselves.

For Christians, though, there seems to be an additional issue, since the Bible also says to avoid the use of "harsh language".[8] This would seem to include use of profanity. This warning does not, however, extend to merely impolite word choice.[9] Biblical writers used impolite language themselves at times, although it is often softened by less-than-literal translations. One famous example concerns Saint Paul's description of his former "good works" apart from Christ (Phil 3:8) as *skubalon*, which means "rubbish or dung". It is easy to imagine how this might be translated in a less sensitive cultural environment!

The Old Testament contains many similar examples of impolite language. In Isaiah 64:6, the prophet compares Israel's righteousness to bloody menstrual cloths in contrast to God's righteousness. In the King James Bible, boys are described as those who "pisseth against the wall". (Modern versions translate the expression as simply "males".) Elijah sarcastically mocks the prophets of Baal by suggesting that their god was off relieving himself (1 Kings 18:27, although again, many translations are not

[8] Specific texts include Colossians 3:8, Ephesians 4:29, and perhaps principles such as those found in Matthew 15:10–20.

[9] The underlying Greek term (αἰσχρολογια) in Colossians 3:8 is used only here in the New Testament and means "speech of a kind that is generally considered in poor taste, obscene speech, dirty talk". William Arndt, *A Greek-English Lexicon of the New Testament and Other Early Christian Literature* (Chicago: University of Chicago Press, 2000).

so literal), and doomed men are described as those who will eat their own dung and drink their own urine (2 Kings 18:27). Israel and Judah are described as prostitute sisters who had their breasts "pressed and bruised" from handling (Ezek 23:3). Saint Paul says he wishes that legalistic circumcisers would castrate themselves (Gal 5:4–12).

In none of these cases was this sort of impolite language required simply to get the facts across. Such language was necessary to communicate accurately the writer's message and, perhaps, to shock listeners to attention. However it is explained, the same God who inspired Saint Paul to tell the Colossians to put away "foul talk from your mouth" (3:8) inspired all the above examples as well. So, we should not judge something as immoral simply because it uses impolite or harsh language.

Regardless of specific commands or prooftexts, it seems wise, just as matter of prudence and courtesy, to avoid using strong profanity. However, in order to maintain realism and relevance, it may be necessary to include this type of speech in some movies. Powerful films could be laughable if the characters shouted, "Gee whiz!" when confronted with violent, life-altering events. Imagine G-rated versions of *Schindler's List* (1993) or *American History X* (1998)! It is the gritty portrayal of the darker side of life that often causes Hollywood's unpopularity among Christian viewers, but it is the idyllic and unrealistic portrayal of life in some Christian movies that can make them ineffective in reaching unbelievers, and even sophisticated believers, with a positive message.[10]

So, the presence of profanity in some movies should not automatically exclude them from consideration as

[10] Hollywood generally avoids "honest realism" when it comes to depicting things like boredom, going to the bathroom, or performing an abortion.

otherwise moral films. We must always take context into consideration. It is good to show bad things *as bad*—not just good things as good. If profanity is celebrated in a movie, then criticism is appropriate, but we should take into account the fact that a character might use profanity in order to be realistic or to convey the kind of person he is. As with all potentially objectionable style elements, whether or not such usage justifies an individual's watching it for mere entertainment is a different question.

Violence

It would be difficult to define *the* Christian view on violence, as believers fall across a wide spectrum of opinions on the issue (in real life as well as that which is depicted on the screen). Perhaps this is because the Christian view of violence is that sometimes the use of force is right and sometimes it is wrong. God has ordained appropriate use of force in order to uphold justice, including actions ranging from capital punishment to just warfare.[11] Jesus himself was aggressive on occasion, as when he overturned tables and chased the moneychangers from the temple with a whip (Jn 2:14–15). Saint Paul expected and accepted the protection of the Roman army.[12] The common theme appears to be that God has at times allowed or even commanded the use of force to protect the innocent or to judge the wicked.

If the use of force, what some call in all cases violence, is not always wrong, then it follows that its portrayal in movies is not always wrong. Just as in life, there may be instances when violence is more appropriate to a movie than nonviolence. Consider *The Passion of the Christ* (2004).

[11] Josh 6, 10; Ps 44; Rom 13; Gen 14; 1 Sam 23:1–2.
[12] Acts 22:25–29 and 23:23.

Some Christians took issue with the film's stylized violence, while others found its visceral shock quite appropriate in an accurate portrayal of Christ's sufferings.[13] Even if we judge that it was appropriate, we need to understand that it might still be excessive for younger or more sensitive viewers. Isaiah 52–53 indicates that the Messiah would be so brutalized that he would be barely recognizable as a man, illustrating how ugly, distorted, and horrific sin truly is. Add to that what we know about the Roman practices of scourging and crucifixion, and it can be argued that *The Passion of the Christ* is effective in portraying both the profundity of sin and the harsh reality of Christ's Passion.

Although the *quantity* of violence in film is relatively high compared to everyday life, the realistic *quality* of it is rather low. The realistic consequences of violent activity are often toned down for movie audiences. Examples could be multiplied of shotguns blowing intact bodies across rooms rather than blasting holes through them. Or consider the purportedly realistic sniper drama *Shooter* (2007): a man is shot in the head by a .50-caliber rifle from an extreme distance—yet the scene merely shows the victim falling to the ground with some blood spray behind him.[14]

While this may seem like a positive practice, toning down violence to make it palatable may actually be more

[13] The argument that it was acceptable to include all the gore because "that's the way it really was" may be overstating the case. See William D. Romanowski, *Eyes Wide Open: Looking for God in Popular Culture* (Grand Rapids, MI: Brazos Press, 2007).

[14] Patrick Garrity, who served as the military technical advisor on *Shooter* (2007) had this to say regarding the scene: "Because of the caliber of that round and the hydrostatic shock that follows it, it peels you apart. You have limbs flying two hundred feet away and you're in twenty different pieces. They can't show that in a movie." From the "Special Features" interview on the *Shooter* DVD.

harmful than representing it accurately. Unrealistic violence can make it look like harmless fun. Compare the gun battles of *The Matrix* (1999) to the opening scene of *Saving Private Ryan* (1998), which gave viewers one of Hollywood's first realistic portrayals of the horror of warfare. It is easy to leave *The Matrix* wishing you could experience life like Neo, the film's protagonist. No one leaves *Saving Private Ryan* eager to experience war.

Nudity/Sexuality

According to the Bible, nudity and sexuality are natural and good in their proper contexts. God's greatest work of art is mankind, male and female, and he made them naked. It was only after they sinned and their relational intimacy was broken that they began to use clothing.[15] While generally accepted in fine art, nudity and sexuality in movies are a bit more complicated. Scripture and Christian tradition are clear that sexual desire, when ordered to and expressed in marriage, is healthy and beautiful.[16] The human longing for sexual intimacy is entirely appropriate. It stands to reason, then, that the portrayal of this longing on screen can likewise be entirely appropriate.

The Bible itself contains appropriate sexual activity in its pages—some of it spelled out in very descriptive, intimate language. In the context of the marriage relationship, the full breadth and beauty of sexual love can be expressed—and artistic expressions of that love can be appropriate.

[15] This does not mean that clothing itself is "part of the fall" in the sense that it is evil—for God made Adam and Eve even better clothing soon afterward. Rather, clothing protects us from improperly close relationships. Nudity is not, therefore, a "return to innocence" in a sinful world.

[16] For starters, see the Song of Solomon and John Paul II, Apostolic Exhortation on the Role of the Christian Family in the Modern World *Familiaris Consortio* (November 22, 1981).

This does not excuse graphic and explicit portrayals of sex—even in marriage—of course (see below). There are tasteful means of portraying sexuality when warranted by the subject of the film, and sexual actions need not be put on display in order to communicate that they occurred.[17]

We need to consider not only whether a movie depicts sexuality appropriately, but what claims it makes about sexuality. We should not find positive entertainment in immoral sexual activity. By nature and God's revelation we see that sinful sexual acts fall into two main categories: fornication, which is sexual activity between unmarried people; and adultery, which is sexual activity between married people and other partners.[18] Marriage is a sacred bond between a man and a woman; thus homosexual acts, incest, bestiality, and other deviant sexual behavior are not acceptable.[19] Christians should never consider the positive depiction of sexual sin as acceptable no matter how tastefully it is portrayed.

On the other hand, there can also be inappropriate depictions of virtuous sexual activity. In the movie *300* (2006), for example, there is a fairly explicit sexual scene that is both morally positive and supportive of the theme. The Spartans are depicted as full of life, passion, and loyalty. They will not be restrained or controlled by those outside their "family". The scene is a celebration of marital passion over and against that which would destroy it. The same message could have been conveyed without the explicit camera work, although it would not have fit the film's hyperbolic style as well. Such does not excuse sensual voyeurism in the name of art, but the scene's positive

[17] A good discussion of this subject can be found in Romanowski, *Eyes Wide Open*, 198–205.

[18] Acts 15:20; 1 Cor 6:18, 10:8; Eph 5:3; Col 3:5; 1 Thess 4:3.

[19] Lev 18:22, 20:13; Mt 19:3–8; Rom 1:26–27; 1 Cor 6:12–20.

message should be taken into consideration when the film is evaluated.

Sometimes sex and nudity are used to reveal character or give action more *gravitas*. The opening scenes of *American History X* (1998) introduce us to two characters in a sexually violent manner that quickly and clearly communicates a lot about them, as well as foreshadowing the consequences of the protagonist's actions. *Schindler's List* (1993) uses nudity to convey the humiliation suffered by the Jews in Nazi Germany. Although such shots might have been avoided without too much damage to the films' integrity, they do not seem to be merely gratuitous inclusions.

Now, the careful reader may note that many of these examples of acceptable nudity and sexual activity are rather negative. This might lead to the suspicion that some "puritanical" notion of sex being dirty or shameful is at work here, and so only these uses of sex and nudity are warranted. Far from it![20] Rather, it is simply the proper nature of nudity and sexual activity that it be kept private. Therefore, when exposed to the public, both become improper—and that works as long as that is the purpose of their inclusion.

The problem is this: sex that is true, good, and beautiful is by its very nature personal, intimate, and exclusive. To show such acts on film, then, is at best voyeuristic and at worst pornographic. When viewers watch sex scenes, it is as if they are standing in the room (or lying in the bed) with the couple. Lack of nudity cannot rescue such scenes from their built-in violations of intimacy. There is simply no way to depict such personal acts without making them into public objects. Far from being prudish (say, compared

[20] Faithful Catholics obviously do not have a problem with sex—look at the size of their families!

with the twin beds of *I Love Lucy* fame), the closed door of the marriage bedroom is actually the most realistic communication of the marital act to those who are not involved.[21]

So, when evaluating films with sexual scenes, in addition to discerning whether or not the scene is gratuitous in nature, we should also be sure that we are evaluating the message being communicated. Appropriate scenes and moral messages do not always go hand in hand, nor do inappropriate scenes and immoral messages.

Conclusion

Unless a movie is immoral in the extreme, we should not automatically judge it as inappropriate solely on the basis of its method of communication. Nor should we judge a movie good simply because we approve of its presentation. Rather, movies should always be evaluated on their treatment of a given subject and whether or not the film's style is appropriate to it. The message of a movie is amplified by its style both aesthetically and emotionally, so the two should work together.

Finally, we must avoid the common tendency to balk at offensive style in a movie while indiscriminately imbibing falsehood when it is presented in inoffensive ways. As we will see in the next chapter, although people often drop their guard when watching (or letting their kids view) a G- or PG-rated film, it can just as easily communicate falsehood in other ways.

[21] Even in the Song of Solomon, sexuality is a private matter not to be shared with onlookers (3:1; 5:4–6; 7:11–12).

Chapter 5

Suppositions: Worlds and Worldviews

Behind the Scenes

When the original *Star Wars* film was released, Christian reviews were mixed. Some attacked the movie for promoting Eastern religious beliefs. Others saw it as Christian allegory; one commentator went so far as to say that "the gospel according to Luke and the gospel according to [George] Lucas would seem to be virtually the same."[1] How could one movie spawn such opposite reactions? It seems that these critics disagreed over the influence of the movie's *worldview*.

The way the term is often used, "worldview" describes a collection of beliefs one has concerning important aspects of reality—one's "underlying principle and concept of life".[2] Worldview is thus deeper and more comprehensive

[1] Robert L. Short, *The Gospel from Outer Space* (New York: Harper and Row, 1983), 51.

[2] The word "worldview" is a translation of the German word *Weltanschauung*, which was introduced by Immanuel Kant in his 1790 work *Critique of Judgment*. It originally meant something like "intuition of the world" but has gone through significant changes since then. David K. Naugle Jr. devotes an entire book to tracing this usage history in *Worldview: The History of a Concept* (Grand Rapids, MI: William B. Eerdmans, 2002). The short description I quoted is from the preface (p. xv).

than one's political positions, philosophical commitments, or religious affiliation—even though any of these can strongly influence the resulting set of beliefs one holds in the other areas.[3] It functions as a backdrop against which our life is experienced and interpreted.

Similarly, what I am calling a film's *suppositions* is the collection of things it asks us to accept as true about the world in which its story takes place. The suppositions that form the backdrop for a film's characters and story can play an important role in forming a movie's message— but do not necessarily do so. Many particulars of a film's supposition collection may not reflect the real-world views of the filmmakers. The creators of *Reign of Fire* (2002), for example, likely do not believe that dragons exist or might overrun the Earth in the near future even though the world they created in the film presupposes that very thing. On the other hand, given the story they tell using these dragons, they likely affirm the virtue of courage and the value of self-sacrifice. Distinguishing between these features is one of the important and sometimes difficult tasks of evaluating movie messages.

Setting the Stage

In order to understand and enjoy a movie, the audience must be willing to accept temporarily the film's suppositions concerning the world of the film. Doing so is called "suspension of disbelief". This lets the writer use a fictional story to communicate what is, hopefully, a truthful message.

[3] Confusion has been caused by those who attempt to create simple lists of worldviews. None account for *all* of one's understanding of the world.

Some background suppositions help communicate a movie's message, but some have little bearing on the movie's overall message. For example, *Finding Nemo* (2003) tells a story of a frightened father facing his fears to rescue his son and finding courage along the way. The fact that father and son are talking clown fishes instead of human beings has nothing to do with the film's worldview—what the fish *do* communicates the message. Conversely, in the Star Wars movies the existence of the Force is not simply a fictional feature of the films' world; it also figures heavily into the communication of the message because it supports the worldview of the story.[4]

We might be tempted to assume that movies that are set in the "real world" are intended to address real issues, while movies set in a fantasy world—or any place where the suppositions are different from daily reality—are meant only for entertainment. But this would be a mistake. Any basic story can be placed in different settings and still communicate the same message.

Genre Conventions and Popular Tropes

These considerations are especially important when we consider genres and tropes. A *genre* is a category of storytelling made up of certain attributes, including background suppositions, that have been repeated until they become part of an overall formula (which, if overused, become clichés). These genre formulas help to orient the viewer quickly to the world of the film so as to avoid confusion, unnecessary

[4] The Force—which is activated by emptying the mind, controlling emotional states, and trusting intuition over rational thought—reflects classic Eastern or New Age mysticism. Whether the Force exists in the real world is unimportant; what it represents is what counts.

argument, or time-consuming exposition. We do not need to spend much time worrying over the possibility of alien life in many science fiction films, because it is simply taken for granted to get the story going.

> KAUFMAN
> The only idea more overused than serial killers is multiple personality. On top of that you explore the notion that cop and criminal are really two aspects of the same person. See every cop movie ever made for other examples of this.
>
> (*Adaptation.*)

Once we are familiar with genres, we also begin to recognize instinctively popular *tropes*—common particulars that exist in many movies and especially within film genres. Some examples are the monster in horror movies that is rarely dead the first time it is defeated, the baguettes that must be purchased in romance movie grocery runs, the jaded cop on the edge of retirement, and the fallen but wise priest (nearly always Catholic, since he is easily identified). These elements are a sort of shorthand for film and are thus less likely to communicate anything important about its suppositions.

In other cases, though, genre conventions and tropes can help us discern a story's overall message. Because genres follow certain patterns, they create expectations (whether conscious or unconscious) in the minds of the audience. How a movie treats conventional genre patterns may provide clues to its message or amplify what it is saying. Below we will consider several common genre types and how the suppositions of each may affect the movie's message.

Romance

 HARRY
 I came here tonight because when
 you realize you want to spend the
 rest of your life with somebody,
 you want the rest of your life to
 start as soon as possible.

 (*When Harry Met Sally*)

In a romance or love story, the challenge is of utmost importance. Once the "boy meets girl" in act 1, something (and often a series of things) will stand in the way of their true love. This challenge will drive the action of the movie to its end (usually the beginning of a romantic relationship). Through this process, we can often detect the writer's suppositions concerning how he understands the nature of love, whether it be passion, fidelity, self-sacrifice, or something else. In most cases, the message of a romance film will be that love is more important than, and worth the effort of overcoming, whatever challenge threatens to prevent it (tradition, family, social status, etc.).

Sex scenes are common in the romance genre because the two are nearly synonymous in today's secular culture. Because marriage is rarely proposed as the solution to the challenge in a romance, sex is simply an easy display of overcoming the challenge. Sexuality will often be introduced before it is morally appropriate according to Christian ethics, and marriage (if it occurs at all) is often relegated to a mere denouement. Some romantic comedies, such as *When Harry Met Sally* (1989) and *My Big Fat Greek Wedding* (2002), do link sex and marriage even if, from a Christian point of view, the cart comes before the horse.

This feature of many romance movies rightly offends many Christians, but it can also prevent them from

perceiving the intended message of the movie. Because sex has become a sort of archetypical action to portray romantic love on the big screen, it functions as a sign of that love and is thus important to the story regardless of how it is portrayed.[5] This understanding of love may be questionable; this does not mean that a movie is *about* sex or that its overall message is sexual. Distinguishing between the propriety of a romantic scene and its contribution to the message of the movie is an important part of the interpretation process.

Western

```
              WYATT EARP
You called down the thunder, well
now you've got it. . . . So run, you
cur, run! Tell all the other curs
the law's coming! You tell 'em I'M
coming, and hell's coming with me!
```

(*Tombstone*)

In the good old days, Westerns were often basic morality tales of good versus evil. The stories were simple and easy to understand: the bad guys come to harm the innocent, and a hero arises to fight them. In these movies, the suppositions were fairly consistent and straightforward. They assumed there are competing forces of good and evil in the world and that evil must be fought. The messages in this genre were typically positive: the good guys win.

This kind of simplicity did not ring true for later viewers, though, and the Western genre has evolved into more

[5] This is similar to the way a Catholic priest is an archetype for "pious religious character". Hollywood writers may know nothing about Roman Catholic dogma; it is simply that they need a recognizable figure to represent easily a certain kind of character.

sophisticated dramas. While retaining the settings and basic character types, a considerable depth has been added. Generally speaking, though, the Western still includes themes such as honor, justice, and protection of the innocent—even if they are illustrated through morally imperfect people. Sometimes the combination pleases audiences more than critics, as in the case of *Tombstone* (1993), which on Rotten Tomatoes has a critics score of 74 percent and an audience score of 94 percent. According to *New York Times* film reviewer Stephen Holden, the movie "wants to be at once traditional and morally ambiguous. The two visions don't quite harmonize."[6]

Action/Adventure

> PROXIMO
> Ultimately, we're all dead men. Sadly, we cannot choose how; but, what we can decide is how we meet that end—in order that we are remembered as men.
>
> (*Gladiator*)

Action movies might seem like nothing more than mindless excuses for violence and car chases—and many are just that. However, like all other genres, action movies can communicate profound messages.

In even the most action-packed specimens, there is often more to the movies than blowing up bad guys. For instance, *First Blood* (1982) was a serious drama focused on the sad plight of a Vietnam veteran. The film's *Rambo* sequels (1982, 1985, 1988, 2019), however, presented him

[6] Quoted by Rotten Tomatoes, https://www.rottentomatoes.com/m /tombstone.

as more of a bitter, unstoppable killing machine.[7] In some movies, *how* the protagonist fights might reveal something about the movie's suppositions. In the highly stylized fighting of martial arts films such as *Crouching Tiger, Hidden Dragon* (2000) and *Hero* (2002), fighting styles are deeply interconnected with the characters' philosophies.

Similarly, *what* the protagonist is fighting for will often reflect the film's message. Here, too, we must be careful to abstract from genre tropes. A foreign villain is not unusual, but this is not necessarily an indictment of a particular race (even if it does contribute to xenophobia)—especially in war or espionage movies. Instead, we must look at what such villains stand for (totalitarianism, oppression, etc.), as well as what the hero represents (hopefully moral virtue).

Comedy

```
CAPTAIN GEOFFREY T. SPAULDING
One morning I shot an elephant in
my pajamas. How he got in my paja-
mas, I don't know.

                    (Animal Crackers)
```

The comedy genre got its name from classical theater, where it described a play with a positive outcome for the protagonist. Today, of course, "comedy" is equated with "funny", which is most often associated with slapstick antics and jokes like the one from the Marx Brothers quoted above. This may seem obvious, but we must remember this fundamental fact when we evaluate

[7] The 1980s saw a spate of Vietnam War–related movies in addition to the Rambo series: *Missing in Action* trilogy (1984, 1985, 1988); *Uncommon Valor* (1983); *Platoon* (1986); *Bat 21* (1988); *Full Metal Jacket* (1987); and *Hamburger Hill* (1987). These films ranged from serious commentary to near spoofs.

movies in this genre. After all, humor can be used to clothe a serious message—in fact sometimes it's the best way. Although comedies often address weighty and serious issues, they must do so lightly. This means comedies shouldn't be criticized simply because they appear to make light of serious issues.[8] In fact, it is for just this reason that comedies provide an important service. Audiences seem to have greater sympathy for certain topics when they are addressed in a light-hearted manner rather than in a dark and serious tone.

Juno (2007), for example, champions life as it addresses the topics of teen pregnancy and abortion. Using disarming comedy to deal with this emotionally charged subject helps keep the audience in sympathy with the protagonist. Had this serious subject been treated more intensely, it might have lost many before it could get its message across. On the other hand, comedies that use humor to mock their subjects need to be judged accordingly (even in Hollywood, abortions are not often used for laughs). So in a comedy we need to evaluate both what is being made light of and how. Serious messages can be couched in comedic deliveries, and these can come in both negative and positive tones, depending on what they are communicating.

Science Fiction/Fantasy

CORNELIUS
Beware the beast man, for he is
the Devil's pawn. Alone among God's
primates, he kills for sport or
lust or greed. Yea, he will murder

[8] Robert McKee notes that one of the important features of comedy is the fact that ultimately no one gets hurt. *Story: Substance, Structure, Style, and the Principles of Screenwriting* (New York: ReganBooks/HarperCollins, 1997), 87.

his brother to possess his broth-
er's land. Let him not breed in
great numbers, for he will make a
desert of his home and yours. Shun
him, drive him back into his jun-
gle lair, for he is the harbinger
of death.

(*The Planet of the Apes*)

When evaluating movies in the science fiction and fantasy genres, it is important to ask whether the suppositions reinforce the message or are merely "window dressing". For example, the Disney version of *Cinderella* (1950) includes some magical elements such as a fairy godmother and talking mice. It is highly unlikely, though, that the story intends to communicate that these should be considered real. Rather, the fairy tale genre allows for fantastical creatures and events; these are to be expected as part of the genre's suppositions and not taken too seriously as far as messages go. Witches and talking animals are just the beginning of the amazing world of Narnia created by C. S. Lewis, but he certainly wasn't promoting witchcraft (quite the opposite, actually) or denigrating mankind's unique place in God's creation, nor do the film versions of his books: *The Lion, the Witch, and the Wardrobe* (2005) and its sequels.

Through the use of imaginary, fantastical beings on other planets, science fiction films often speculate on the effects of cultural, technological, and political factors on Earth. Futuristic tales do the same. *Planet of the Apes* (1968), for example, is set at a future time on Earth when the great apes have evolved to the point that they now rule over human beings. Whatever one's thoughts on this theoretical possibility, once we (temporarily) accept the filmmaker's

suppositions, we discover a powerful statement about human nature. Sometimes a true message can be communicated quite effectively through fiction.

Horror

> EMILY
> People say that God is dead. But how can they think that if I show them the devil?
>
> (*The Exorcism of Emily Rose*)

Horror is probably the genre least favored by the majority of Christians. This is due in part to the genre's style, which often includes graphic violence and dark moral themes. Even so, the genre can communicate important messages in a more effective way than other genres. As in the quote above, they can even argue for the existence of God by showing evil as the attempt to twist or destroy what God creates.

Ironically, horror movies are often quite moral in their suppositions. The heroes and the villains are usually made obvious, and this alone sends a significant message to a world that often thinks of evil in shades of gray. In most horror movies the hero is the most morally pure character. The wise-man figure in the slasher film parody *Scream* (1996) recognizes this and includes "the sin factor" in his rules for surviving a horror movie.

Further, in contrast to humanistic assumptions concerning the innate goodness of mankind, horror movies have a unique ability to show the dark side of mankind. Famous monsters like werewolves and vampires, as well as specific characters like Dr. Jekyll and Mr. Hyde, capitalize on the idea of man's struggle with inner evil. Modern serial killer

films often depict the villain not as a crazed lunatic (as we would prefer to think of him), but as a seemingly rational, intelligent person (a slap in the face to those who think only mentally sick people commit evil).

On the flip side, many horror movies make too much out of the power of evil. While serious challenges require strong antagonists, the elevation of evil to the point where goodness can just barely overcome it sends a poor message. In some horror sub-genres (particularly those that spawn sequels), good wins some of the battles but never the war—which, in the big picture, sends a false message that good will never finally triumph over evil.

Finally, whether or not horror films can be justified on a theoretical basis, we must always be careful not to cross the line from enjoying a bit of scary fun to developing a fascination with evil. "We are what we eat" applies to media consumption as well as food.

Revisionist

> BRIAN
> I'm not the Messiah! Will you please listen? I am not the Messiah, do you understand? Honestly!
>
> GIRL
> Only the true Messiah denies His divinity.
>
> BRIAN
> What? Well, what sort of chance does that give me? All right! I am the Messiah!
>
> FOLLOWERS
> He is! He is the Messiah!
>
> (*The Life of Brian*)

Rules, as they say, are meant to be broken. Although background assumptions in genre-specific movies don't always communicate important worldview messages, we should always pay attention when a film breaks the rules by departing from standard genre formulas. Doing so is known as *genre revisionism*, and the reason for the departure is likely to bring focus to the film's message.

Monty Python's *The Life of Brian* (1979) turns what could have been a biblical epic into a humorous farce in order to highlight the filmmaker's disdain for many features of religion and politics.[9] The infamous film *Brokeback Mountain* (2005) was a rather startling example of revisionism in Westerns (quite the feat in a genre well known for revisionism), with its use of gay cowboys as the main characters. The less-than-perfect superheroes in recent superhero film series such as *Iron Man* (2008–2013), *Dark Knight* (2005–2012), or *Deadpool* (2016–2018), can be considered revisions of the typical superhero motif.

In cases such as these, it is instructive to consider why a film was produced within a given genre, but "broke the rules". It may simply be that the filmmaker was striving for originality, but it may indicate a questioning or even rebellion against the common suppositions of that genre.

Test Case: Harry, Gandalf, and Aslan

We have seen that when discerning a movie's worldview, we must distinguish mere background elements, genre

[9] The film's creators discuss the message behind *The Life of Brian* in the DVD commentary, and two of them (John Cleese and Michael Palin) were filmed in discussion with Malcolm Muggeridge and Bishop Mervyn Stockwood on the BBC show *Friday Night, Saturday Morning* that aired November 9, 1979. The gist is that they deny attacking Jesus or Christianity per se, instead asserting that the film makes fun of modern organized religion.

conventions, and popular tropes from those suppositions truly important to a movie's message. This is not always easy, however. The difficulty has been illustrated by the debate over several fantasy films that all came out within the same basic timeframe and caused a stir in Christian circles.

In the late 1990s, the popular Harry Potter books became some of the bestsellers of all time and were quickly made into movies. Many Christians expressed concern about the use of occult magic, witchcraft, and sorcery in these stories and feared that children who watched the movies (or read the books) would be enticed into dabbling in the occult because of the way the dark arts were glorified.[10]

A common response to this position (offered by Christians and non-Christians alike) was that the same attributes are also found in two Christian fiction classics: C. S. Lewis' Chronicles of Narnia series and J. R. R. Tolkien's three-part novel, *The Lord of the Rings*, which was also made into movies. Both series involved magic and wizards—so why were these things bad for Harry but not for Gandalf or Aslan? If magic and sorcery could be used in tales written by Christians, then why was the creator of Harry Potter, J. K. Rowling (who calls herself a practicing Christian), castigated for using them?[11] While it may not resolve the

[10] Cardinal Joseph Ratzinger is said to have called the Harry Potter "subtle seductions" capable of corrupting young Christians. Elisabeth Rosenthal, "Don't Count Pope among Harry Potter Fans", *New York Times*, July 16, 2005, www.nytimes.com/2005/07/16/world/europe/dont-count-pope-among-harry-potter-fans.html. The Vatican newspaper, *L'Osservatore Romano*, reportedly took a softer stance. Reuters, "Vatican Finally Gives Harry Potter Its Blessing", ABS-CBN News, news.abs-cbn.com/lifestyle/07/21/09/vatican-finally-gives-harry-potter-its-blessing.

[11] In fact, Rowling has also claimed Christian influences. See Jonathan Petre, "JK Rowling: 'Christianity Inspired Harry Potter'", *Telegraph*, October 20, 2007, www.telegraph.co.uk/culture/books/fictionreviews/3668658/J-K-Rowling-Christianity-inspired-Harry-Potter.html.

debate, it is important to note that the stories have greatly differing suppositions. To the degree that these suppositions carry a message rather than simply function as genre features, they need to be judged separately.

The films based on *The Lord of the Rings* (2001–2003) take place in a world of Tolkien's imagination called Middle-earth. Middle-earth is a fantasy world—a "sub-creation" where nonhuman creatures such as orcs, dwarves, and elves are actually a natural part of the created order. While the elves are probably the most obviously "magical" creatures in Middle-earth, there are other creatures that are far more powerful. Though it is not made clear in the film adaptations of the stories, Gandalf the Wizard is not human; he is a Maia. The Maiar are angelic beings in the service of the Valar, who are themselves cocreators with Eru-Ilúvatar, the creator-god of the universe. Thus, Gandalf is not a "wizard" by the occult definition, nor does he perform "magic" or what we would consider sorcery in the real world. Magic for Gandalf is not unnatural or occult; it is part of his nature. Magic for men and hobbits, however, is unnatural, and leads to their demise when used.

GANDALF
There are many magic rings in this world, Bilbo Baggins, and none of them should be used lightly.

(*The Lord of the Rings: The Fellowship of the Ring*)

That the events in The Chronicles of Narnia likewise do not take place in our world is made pretty clear in *The Lion, the Witch, and the Wardrobe*. Narnia is accessed by a wardrobe that often is just as it seems, and time does not

pass in this world for Narnia's travelers.[12] Narnia is a world created by Aslan, the Great Lion. Narnia is populated by all kinds of fantastical creatures with the ability to perform acts that are natural to their world but are impossible in ours.[13]

```
                    WHITE WITCH
    Have you forgotten the laws upon
    which Narnia was built?

                      ASLAN
    Do not cite the Deep Magic to me,
    witch! I was there when it was
    written.

                    (The Chronicles of Narnia:
                         The Lion, the Witch,
                            and the Wardrobe)
```

In other words, magic in both *The Lord of the Rings* and The Chronicles of Narnia is not equivalent to the occult practices in which people in the real world can be involved. When the Bible commands against the use of sorcery and divination (e.g., Deut 18:10; Acts 16:16–18), it is not referring to the magical things that magical creatures can do in fantasy worlds.

Harry Potter, however, is the opposite case. Instead of taking place in a fantasy world, his story unfolds in our world.[14] In line with modern versions of Wicca and other

[12] In the story's prequel, *The Magician's Nephew*, this is made even clearer as the main characters witness the creation of Narnia itself.

[13] This is highlighted in the story's prequel, *The Magician's Nephew*, when the White Witch is unable to work magic after entering our world.

[14] Richard Abanes, *Fantasy and Your Family: Exploring The Lord of the Rings, Harry Potter and Modern Magick* (Camp Hill, PA: Christian Publications, 2002), 194.

occult belief groups, magic in the Harry Potter books is considered morally neutral and is performed by human beings in the real world (and humans who do not practice magic are looked down upon as simpleminded "Muggles"). However, many specific practices condemned by Scripture are used in the books by both good and bad characters.[15]

```
            HAGRID
If that dolt of a cousin of yours,
Dudley, give you any grief you
could always, um, threaten him with
a nice pair of ears, to go with
that tail.

         HARRY POTTER
But, Hagrid, we're not allowed to
do magic away from Hogwarts. You
know that.

            HAGRID
I do, but your cousin don't, do he?

              (Harry Potter and the
                 Sorcerer's Stone)
```

In light of these elements alone, it seems clear that these film franchises cannot be judged as equivalent simply because they share common genre features. Although all three movies share certain fantasy suppositions, the differences in worldview between *The Lord of the Rings*, The Chronicles of Narnia, and Harry Potter are significant enough to warrant consideration when the messages of

[15] See the *John Ankerberg Show*, "Questions about Harry Potter", October 16, 1999, www.jashow.org/articles/questions-about-harry-potter/.

the movies are evaluated—especially in terms of how they represent the use of magic.[16] Whether or not these differences are sufficient to condemn the Harry Potter series, I will leave to the reader to consider. Here I simply wish to point out that the inclusion of similar content is not always equivalent to similar suppositions.[17]

Conclusion

Although not often a primary indicator, a film's background suppositions (along with its style) are part of the storytelling techniques that can help us discern the message of a movie. Steps should be taken to avoid confusing method and message, however, and we must be ever vigilant to avoid focusing in on particular features and missing the big picture. In the next chapter, we'll see how story, style, and suppositions combine to create a significant movie experience.

[16] There were many reports that interest in occultism spiked at the height of these books' and films' popularity. This was certainly not the case with *The Lord of the Rings* or the Narnia series. These results should also raise questions as to the influence of the Harry Potter stories. Richard Abanes discusses this in *Fantasy and Your Family*.

[17] Issues about magic are not often raised with regard to *The Golden Compass* (2007), but its inclusion of good witches is of little concern in comparison to the antireligious themes that are so clear.

Chapter 6

Significance: Meaning and Message

Putting It All Together

As we have seen in previous chapters, stories have built-in mechanisms for communicating. By paying careful attention to these mechanisms, we are able to make more objective interpretations and evaluations of the messages behind the movies. To recap—a movie is made up of many elements: the *story* that the movie tells (chapter 3), the *style* used to tell the story (chapter 4), and the story's background *suppositions* that can indicate worldview (chapter 5).

All of these features contribute to the communication of meaning, but the ultimate significance (message) of a movie is primarily revealed through its story. The *style* of a movie is important to the message in that it elicits various emotional and aesthetic reactions (positive or negative) in the audience to amplify the story. But the story can generally survive altering the style. The suppositions of a movie may figure prominently in the message by revealing a worldview but may simply serve as a backdrop to the story.

When all these facets combine, they tell a significant story—one with a discernable message. When they do not,

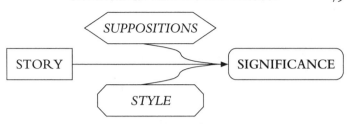

Story-Suppositions-Style-Significance

confusion results. (One can hardly use classical story structure—which conveys a purposeful, ordered reality—to communicate a random worldview![1]). This does not mean that film interpretation is always easy. Whether for artistic or philosophical reasons, ambiguity may be the filmmaker's goal, in fact. The attributes that make up a clear or unclear message, though, are objective and discernable.[2]

Story Time

Act 1: Characters and Convictions

In order to discern the message of a movie, it is important to pay attention to how act 1 establishes a story's characters.

[1] Robert McKee states, "Are you convinced of the random meaninglessness of life? If your answer is a passionate yes, then write your Miniplot or Antiplot.... For the vast majority, however, the honest answer to these questions is no." *Story: Substance, Structure, Style, and the Principles of Screenwriting* (New York: ReganBooks/HarperCollins, 1997), 66.

[2] Clear-but-conflicting elements serve to obscure a clear message. Martin Scorsese's *Silence* (2016), for example, seemed carefully crafted to avoid a one-sided message (as evidenced by the mixed conclusions from thoughtful reviewers). In a personal conversation, my insightful friend Matthew Graham noted that the film "could have been inspirational, but instead was thought-provoking".

80 WATCHING AND UNDERSTANDING

Filmmakers often tell their audiences something signifi-
cant about the characters by how they introduce them,
by what they are doing when we first see them. Most
of the film's suppositions will be revealed in act 1. So, from
the first time we meet a character, and as act 1 progresses,
we should ask ourselves such questions as: Who is the pro-
tagonist and who is the antagonist? Do the main characters
have any obvious weaknesses or strengths? Do they express
a particular ideology? The answers to these questions will
aid us in discerning the writer's message. The protagonist
is the character the audience is supposed to identify with,
so this character is important to the writer's message. Thus,
it is helpful to note the protagonist's goal, what challenges
he must face in reaching it, what decisions he must make
in order to resolve the struggle, and the consequences of
his final actions and decisions.

Once we've identified the main characters and have
begun to get to know them, our next step is to identify
other character types and the functions they serve at various
points in the story. This will help us grasp how the story
is moving along. As discussed in chapter three, these other
characters will play off of the protagonist in some fashion.
Sometimes the relationships between main and secondary
characters can communicate a lot about the film's world-
view.[3] Going back to the Campbell/Vogler archetypes, for
example, "mentors" will typically represent the same mes-
sage as the protagonist, while "shadows" and "threshold
guardians" will often oppose it. In a coherent story, the
main characters will support the main message either neg-
atively or positively.

[3] Stanley Grenz notes that in order to understand postmodernism, one need
only look at the crews of the original *Star Trek* and *Star Trek: The Next Generation*.
A Primer on Postmodernism (Grand Rapids, MI: Eerdmans, 1996), 1–10.

Act 2: Challenge and Confrontations

While we are given some preliminary insight into the characters in act 1, we really get to know them as they begin to face the challenges of act 2.

The challenge that separates act 1 and act 2 will reveal something of value to the protagonist that is unattainable for some reason. This may be an object (like money or the Holy Grail), but it could also be something abstract, such as living in peace. The threat to that thing of value will drive the plot as the protagonist strives to posses it. The manner of this pursuit reveals something of the character of the protagonist, and the goal often changes as he meets challenges along the way. How the protagonist overcomes challenges (or succumbs to them) and how his goals change form the backbone of the story and help us understand what the filmmaker is trying to communicate.

For example, act 1 might introduce a single woman desperately looking for a husband. We pivot into act 2 when her current boyfriend announces that he plans to leave the country to study abroad for a year. After deciding he is "the one", she spends the first half of act 2 trying to sabotage his plans. When each of her attempts is thwarted, she changes tactics and decides to make him jealous by pretending to date an ex-boyfriend. This new relationship, which begins as a farce, becomes more enjoyable with each of the staged dates. She comes to realize that in her desperation, she had overlooked significant flaws in her current boyfriend—flaws that her fake date doesn't have. But her scheme works, and her boyfriend proposes marriage. Now she must choose between her real boyfriend and her fake love interest (who has become her real interest). This change of values will undoubtedly form the basis of the film's climax.

Assuming the writer follows the rules of a romance movie, we all know what she will do. She will choose the "fake" boyfriend, and they will live happily ever after. The message of the movie will be that true love is more important than marrying the wrong person just to be married.

However, the writer may break the rules and have her marry the wrong man. This should remind us that while act 2 normally sets us up for the message of the movie, we cannot be certain until the climax. It has been said that "a movie is its last twenty minutes." In other words, it is at the pivot from act 2 to act 3 that the message of a movie becomes clear. This pivot is known as the climax.

Act 3: Climax and Conclusion

Of all the story parts that drive the message, perhaps none is more important to consider than the climax. Up to this point, we do not know whether the protagonist's goals will be met or how. We do not know if our hero will overcome his challenges or be defeated by them. In a (classic) comedy, remember, the hero overcomes the challenge of act 2. Thus, in a comedy the message is communicated positively; it tells you what the screenwriter thinks is the case. Conversely, in a (classic) tragedy, the hero is overcome by the challenge. This can communicate the same message that a comedy can, only in negative terms.

For example, imagine a movie in which a young girl has parents who abuse drugs. She is challenged throughout the film with the temptation to adopt their lifestyle, but she ultimately overcomes by refusing. Thus, at the climax, she may decidedly say no and go on to live a healthy, drug-free life. Now imagine another movie with the same basic premise. In this film, however, the girl fails her challenge, becomes addicted to drugs as well, and eventually dies from an overdose. Although the films tell different stories, they send the

same message: however great the temptation, resisting drug use is the wise choice. One movie celebrates the hero's good decision, while the other shows the results of a bad decision. A moviemaker's decision to follow one path or the other will likely depend upon the weight of the message. That is, while many people prefer a happy ending (a classic comedy), sometimes a message can be communicated more powerfully by a classic tragedy.

The final moments of act 3, sometimes referred to as the denouement, are when the story is simply wrapped up. The denouement traces the events following the climax, tying up loose ends and giving the audience some idea of how things will go from here (or whether there will be a sequel!). What happens as a result of the climax can be an important key to understanding the movie's message. In the movie *Thirteen* (2003), we must wait until the last scene to see the final effects of a teenage girl's year-long rebellion. We have already discovered the painful outcome of her actions at the climax, but we are not certain whether she will bounce back or lose it completely until the last second.

Story Support

The message of a movie will be most clearly communicated through its characters and their actions during the story. These story elements can be augmented, highlighted, and amplified by the way the story is told (style) and often by its worldview (suppositions).

Style

As we saw in chapter 4, proper evaluation of a movie requires an eye for the difference between story style and

significance. While style cannot create significance by itself, the use of a certain style can reinforce a movie's message.

In *Idiocracy* (2006), for example, people in the future have become so stupid and immoral that they can barely express themselves without cursing or making sexual innuendos. While Christian audiences might object to the film's frequent use of profanity and sexual references, doing so makes an ironically moral point.

The main thing to look for with regard to style when it comes to discerning the message of a movie is how the style is used to amplify the story. A good question to ask is, "How else could this scene have been shot, and what would that have changed about the characters/setting/mood/etc.?" A movie's style should reinforce the impact of its message in appropriate ways; otherwise, some style details may be considered gratuitous.

Suppositions

In chapter 5 we saw that a movie's suppositions can be central to its overall message in some cases, while remaining largely inconsequential in others. In order to evaluate a movie fairly and accurately, it is crucial that we determine how the movie's suppositions are related to its message.

The X-Men series (2000–2019), for example, is predicated upon, but does not necessarily promote, evolutionary theory. Evolution simply serves as the background for explaining the mutant characters' powers. Perhaps the characters' gene alterations could have come about in a different way, as in *The Incredible Hulk* (2008) or the Spider-Man movies (2002–2021), but this would have been more difficult to explain on a worldwide scale. It also would have lessened the story's "cautionary tale" nature regarding who should be considered human.

Although normal humans fear the mutants, it is the villain (Magneto) who wants non-mutants treated as inferior beings. Contrast this with the *X-Files* (1993) film, where we discover that aliens seeded Earth to get human evolution going and then wrote the Bible to guide us. This revelation comes at the climax of the film, where the skeptical character is shown to have been wrong. In *X-Files*, then, evolution is pitted against Christianity—hardly a subtle background element!

The suppositions in the 2005 film *The Exorcism of Emily Rose* caused some critics to misunderstand the movie's message. The story concerns a Catholic priest who is on trial for murder because his parishioner Emily Rose died while he was trying to exorcize her demons. Some Protestant viewers were so focused on whether or not the film was promoting Roman Catholic theology that they ultimately missed the point. In reality, both Roman Catholicism and the exorcism were simply part of the background (as they would almost have to be for realism). The *story* is actually a courtroom drama, with the climax focusing on whether the priest's skeptical lawyer can be objective enough to argue successfully for the possibility of the supernatural. Thus, both the exorcism and the priest function as support for the lawyer's struggle, which itself carries the message.

Another example is the philosophically intriguing Matrix film trilogy (1999–2003). *The Matrix* and its sequels (*Reloaded* and *Revolutions*) deal with human knowledge of reality as well as the question of free will. The films draw from Christianity, Hinduism, and Buddhism, as well as modern and postmodern philosophy. Although the series (especially the first film) contains many allusions to Christianity, taken as a whole, the series reflects more Eastern beliefs (e.g., reincarnation, karma, Brahman) than Christian ones.

The original Star Wars trilogy provides an interesting contrast to the Matrix series. There is no question (based on statements made by creator George Lucas and the story itself) that the film includes Eastern pantheistic suppositions, as does the Matrix. The mystical Force, the energy-nature of all living beings, the subjective nature of truth—all of these elements are found in Eastern thought. Interestingly, however, Star Wars ultimately follows a decidedly Western (and Judeo-Christian) storyline: good triumphs over evil. Undoubtedly, this is part of the reason moviegoers found this trilogy more satisfying than the Matrix movies. More importantly for our purposes, it illustrates how a movie's message is not necessarily bound to its suppositions.

The Big Picture: A Film's Ultimate Significance

The message of a movie, its overall *significance*, is more universal than the particular *story* used to communicate it. In order to get to the universal message of a movie, we need to abstract it from the story's particulars. This is usually a fairly intuitive process—in fact, kids do it all the time. When we tell the story of *Goldilocks and the Three Bears*, no kid thinks that the moral of the story is "Don't steal porridge from bears." Rather, it is "Don't enter a house uninvited (and while there steal the porridge and break the furniture)." And probably no one sees the message of Star Wars as "Battle station exhaust ports should be securely covered."[4] These are just the particulars used to tell the story. The significance of a movie is greater than any of its parts.

[4] Although the butt of many jokes, this oversight was explained ("retconned") in the *Rogue One* (2016) prequel.

Universal principles are communicated through characteristics or actions that are common to all people. If these are absent from a film, it will fail. Why? Because our connection to the characters, particularly the protagonist, is what makes stories successful. A successful film will generally tell stories with characters who are dealing with universal challenges and problems.

We won't all face death in the Roman Colosseum (as in *Gladiator*, 2000, or *Spartacus*, 2004), but we will all face death. We won't all fight in a major war (as in *Saving Private Ryan*, 1998, or *300*, 2006), but we all have our battles to fight. We may not set land speed records, meet space aliens, have super powers, sing in an opera, or start successful careers in country music—but there are themes in all of these experiences that we can share, because we have a common nature and live in a common world. Our particular lives, then, can connect at a universal level—and the best movies help us to do just that.

Conclusion

To summarize what we have discussed to this point, the distinctions between style, story, suppositions, and how they contribute to a film's overall message (significance) are crucial for accurate movie interpretation and evaluation. Keeping these different facets before us can help us avoid distractions and let a movie speak for itself. We can then responsibly react to a movie's message.

Many Christians are beginning to realize that the messages of movies, whether good or bad or a bit of both, can be helpful for discussing matters of importance. While movies can address an enormous range of important themes (e.g., racism, drug abuse, love, loyalty, family), how they

treat the subjects of faith, truth, God, and Christianity is vitally important because it impacts the ability of people to receive the most important story of all—the good news ("gospel") of Jesus Christ.

In the chapters that follow, we will look at these themes—both how they have been approached and how well Hollywood has answered the questions they raise. We will consider how to discern what Hollywood is saying through the films it produces and explore how those messages can serve as culturally relevant in-roads for presenting, clarifying, and justifying the gospel message.

ACT TWO

EVALUATING AND DISCUSSING

Chapter 7

Faith: Facts or Feelings?

Faithful Evangelism

```
        ADMIRAL MOTTI
Your sad devotion to that ancient
religion has not helped you conjure
up the stolen data tapes, or given
you clairvoyance enough to find the
Rebel's hidden fort ...
```

```
Begins choking under the power of the
force.
```

```
        DARTH VADER
I find your lack of faith disturbing.
```

 (*Star Wars: A New Hope*)

Many people today have the attitude of Admiral Motti
above. After all, without evidence, why believe in some-
thing that cannot be seen? They are rightly uncomfort-
able trusting a religion with their eternal souls and perhaps
more afraid of simply missing out on this life if a given
religion turns out to be false. Scripture recognizes this
attitude—even lending it hypothetical support. For if we
have no grounds for our faith, we might as well "Party on,
dude!" (see 1 Cor 15:32).

A line from *Keeping the Faith* (2000) sums up how people often see faith: "Faith is not about having the right answers. Faith is a feeling, faith is a hunch." This is not representative of Christianity (or at least it should not be). If we are going to be persuasive when we invite people to consider our beliefs, we should have more than just our own feelings or experiences for support. Someone might well ask, "What makes your reasons for believing in God any better than my reasons for disbelieving?" Having an answer ready is commanded in Scripture (1 Pet 3:15).

How one answers questions like "Is there truth?"; "Is there a God?"; "Has God communicated to us?"; and "How should we treat one another?" informs his religious worldview. When movies with religious themes prompt their audiences to confront these kinds of big questions, we must not only seek answers but also consider our method for reaching them. Is faith built on facts, feelings, or both?

Now, we do not need to have faith that $1 + 1 = 2$ or that a whole is greater than any one of its parts. These things are true by nature and can be discovered using reason alone. But when it comes to questions such as "Does God exist?" or "Is it right to have an abortion?" many believe that these are simply questions of religious belief and that no one can really know the answer to them. Most of the greatest philosophers and scientists throughout history were people of faith—so it seems that reason and faith do not contradict each other.

Whether someone believes something based on faith, according to reason, or both depends on how it can be known. For example, we can learn by studying history that a man named Jesus died on a cross in first century Judea. But we can only know that Jesus' death atoned for the sins

of the world by faith (the science of history simply cannot look into such a thing, any more than it can mathematics). We can listen to a witness in a court of law and hear about other pieces of evidence that support his testimony, but in the end we must decide whether *to believe* that the witness is trustworthy or not. Thus, some truths are verifiable by facts and reason, others are matters of faith, and others can be discovered by both means. Problems can arise when we mix up these categories.

So, what about religion? Can religious truth be proved by reason or science? The answer is, it depends. Some issues of religion can be known by reason and some only by faith. But if we can get far enough along on reason and evidence, then the faith part can come a lot easier. Unfortunately, the difficulties Christians face when trying to communicate the faith are not often helped by Hollywood.

Hollywood's Christian ~~Characters~~ Caricatures

While in its Golden Age, Hollywood stuck to positive religious figures (it helped that they were being monitored by the Catholic League of Decency!). After the sexual revolution of the 1960s and 1970s, religion and conservative viewpoints were allowed to become a target (something the self-governing MPAA did nothing about). For all its alleged tolerance and liberal idealism, Hollywood fairly consistently portrays religion in a negative light. Ignorant believers and religious nut jobs have regular appearances in film, and fallen-away priests are a popular trope. Now this is not to say that these folks aren't out there, but like the archetypical "cop on the edge", the "distant father", or the "hot nerdy girl", these "crackpot Christian" characters are standards of the movie industry.

Consider the ridiculous "Christians" of *Saved!* (2004). The plot revolves around a Christian girl who gets pregnant while trying to save her boyfriend from turning gay by giving up her virginity to him (because Jesus told her to, of course). In the meantime, her mother is having an affair with their pastor, who is also the principal of the local Christian high school. The girl's schoolmates are each, in their own personal way, discovering just how lame Christianity is: we have a gay-but-sincere boyfriend, a rebellious-but-tender-hearted female, a pious-but-mean prima donna. Not exactly a typical church crowd! In the end the pregnant girl decides that her boyfriend being gay is OK because God wouldn't make everyone so different if he wanted everyone to be the same. Her adulteress mother and pastor realize that their love affair is OK because they are really in love. The rebellious girl succeeds in winning the heart of a fence-riding Christian because not being a Christian is OK as long as one is sincere. The clear message of the movie is that whatever anyone does is fine so long as he is following his heart. Thus, we should just stop judging. Rather than the characters realizing that their version of Christianity is false, they turn even further from the truth. There is not one good example of a true Christian anywhere in the movie.

Now, there's nothing wrong with a good lampoon, and we should be able to laugh at ourselves. Monty Python's extremely irreverent *Life of Brian* (1979), for example, is a hilarious satire on human failings from politics to religion. *Idiocracy* (2006) does the same for modern sexual morality and corporate greed. But an entire cast of one-dimensional, inaccurate caricatures is little more than propaganda (a lesson Christian filmmakers need to learn as well). Although there are goofy Christians out there who think there needs to be a "Christian" version of everything, who use "prayer groups" for gossip, and who think that evangelism is just harping on "getting saved", that does not excuse

caricaturing 2,000 years of faithful, rational, and virtuous people. Imagine if someone made a film about homosexuality where every single gay person was a flamboyant fetish freak who molested young children. Would Hollywood give it a pass? Of course not (nor should they).

The Celluloid of the Masses

Besides writing in characters that function as little more than Christian dupes, Hollywood has no shortage of decidedly antifaith films. Films such as *The Handmaid's Tale* (1990), *The Rapture* (1991), *At Play in the Fields of the Lord* (1991), *The Last Temptation of Christ* (1992), *Pleasantville* (1998), *Dogma* (1999), *The Magdalene Sisters* (2002), *The Da Vinci Code* (2006), *The Golden Compass* (2007), *The Man from Earth* (2007), *Agora* (2009), and *The Ledge* (2011) present faith in a very bad light. This theme is not always so blatant, of course. Movies like *The Truman Show* (1998), *The Invention of Lying* (2009), and *The Lego Movie* (2014) have been criticized for more subtly subverting Christianity as well. (A fuller treatment of *The Truman Show* is included at the end of this book.)

Yet Hollywood is not bereft of faith-friendly films. There are, of course, clearly religious movies such as *The Ten Commandments* (1956), *Ben Hur* (1959), *Chariots of Fire* (1981), *Babette's Feast* (1987), *The Prince of Egypt* (1998), *The Passion of the Christ* (2004), *One Night with the King* (2006), or *The Nativity Story* (2006). Added to these are other positive portrayals of faith that occur in films such as *The Apostle* (1997), *Narnia: The Lion, the Witch and the Wardrobe* (2005), *Amazing Grace* (2006), *Life of Pi* (2012), *Hacksaw Ridge* (2016), and the *A Quiet Place* films (2018, 2021).

Further, there are also movies that respect the faith even when not promoting it. *Contact* (1997), although originally

written by an atheist, succeeds in showing that Christians can be intelligent people. *Keeping the Faith* (2000) is both realistic and positive in its presentation while remaining a fun picture. Some interesting issues about faith and morality are brought up in the frightening film *Frailty* (2001), which deals with a man who believes that God had him kill certain people because they were really demons. Both *Bruce Almighty* (2003) and *Evan Almighty* (2007) succeed as comedies without being abusive in their portrayal of God and religion.

Despite these examples, Hollywood's more regular assaults on religion pose serious threats to the popular perception of Christians—and that is no small thing. Many people today are getting their worldviews from screen light rather than sunlight. That is to say that more and more, modern life experience is filtered through media providers—sometimes to the point where a sort of "hyper-reality" replaces real life.[1] When someone's opinion on Christianity is formed by false simulations of the faith, we need to be ready to help him see the truth when he looks up from his screen.

The Gospel according to Hollywood

> ROSE
> He saved me, in every way that a
> person can be saved.
>
> (*Titanic*)

[1] The French philosopher Jean Baudrillard has devoted numerous works to this problem, the most famous being *Simulacra and Simulation* (1981). See chap. 11 in this book for some thoughts on the issue.

Christians are not alone in recognizing mankind's need for salvation. Several story analysts have noted that salvation of some sort is a common theme in movies.[2] Because of the narrative nature of movies, some offer of redemption (whether accepted or rejected) is a virtual necessity.[3] Stories are activated by conflict, and conflict has to be resolved in order to complete the story in a satisfying manner. Such stories present salvation gained or lost.

Salvation in nonreligious movies will rarely be of the ultimate, eternal sort—but this does not diminish its importance. Scripture itself speaks of salvation for Israel from Egypt (Ex 14:30), of armies from enemies (Josh 10:6), and even of wheat from invaders (Judg 6:11)! The New Testament speaks of salvation from drowning (Mt 14:30), crucifixion (Lk 23:35; Jn 12:27), judgment (Acts 2:40), weather (Acts 27:20–31), labor (1 Cor 3:15), childbirth (1 Tim 2:15), and a bad conscience (1 Pet 3:21). So, whenever we speak of salvation, we should always be sure we know who is being saved from what.

In accord with what we saw earlier, we can determine a movie's salvation message by considering how it answers the following questions:

[2] For example, Brian Godawa, *Hollywood Worldviews: Watching Films with Wisdom and Discernment* (Downers Grove, IL: Intervarsity Press, 2009), chap. 2; Robert Johnston, *Reel Spirituality: Theology and Film in Dialogue* (Grand Rapids, MI: Baker Academic, 2006), chaps. 6 and 8; Christopher Vogler, *The Writer's Journey: Mythic Structure for Writers*, 2nd ed. (Studio City, CA: Michael Wiese Productions, 1998), 203–36; William D. Romanowski, *Eyes Wide Open: Looking for God in Popular Culture* (Grand Rapids, MI: Brazos Press, 2007), 156–58; Paul Kuritz, *The Fiery Serpent: A Christian Theory of Film and Theater* (Enumclaw, WA: Pleasant Word, 2006), chap. 5.

[3] Brian Godawa believes that the nature of story is itself a reflection of the biblical redemption story (a "metanarrative" or "story of stories"). See "Movies, Storytelling, and Apologetics" at https://chalcedon.edu/magazine/movies-storytelling-and-apologetics-part-i.

ACT 1: Who are we and where did we come from?

CHALLENGE: What happened to get us off track?

ACT 2: What must we do to rectify the situation?

CRISIS: What ultimate choice will we make?

ACT 3: What are the consequences of our action?

CLIMAX: Are we saved?

Oftentimes in Hollywood films, salvation is understood as "self-realization". According to Maslow's Hierarchy of Needs, self-realization is the pinnacle of human experience, and films from *The Wizard of Oz* (1939) to *Into the Wild* (2011) reflect that idea.

Consider the record-setting blockbuster and Oscar winner *Titanic* (1997). Virtually everything in the film sends the same message: Do not live according to society's boring rules but by the most romantic and ideological means possible. This is not merely a happy-go-lucky attitude. The protagonist, Rose, is "saved" not once but three times by her lover, Jack. The first time is when they meet and he talks her out of committing suicide; the second is when he brings her safely through the sinking of the ship. But neither of these saving acts reveals the message of the movie. The real challenge Rose deals with throughout the film is the upper-class expectations that her lower-class lover, Jack, teaches Rose how to escape. By rejecting societal rules and expectations, Rose can truly be who she wants to be. In *Titanic*, this realization is salvation itself. The fact that *Titanic* won eleven Oscars and remained the highest grossing film of all time for over a decade after its

release suggests that the movie's "salvation message" reso-nated deeply with many people.

The 1998 film *Rounders* is another good example of this kind of message. The protagonist, Mike McDermott, is a professional poker player who has given up his love of the game to pursue a legitimate career in law. Everything in the story argues against this choice: his best friend chides him for not doing what he does best; his mentor-professor calls it a mistake to ignore one's true calling in life. Only his girlfriend demands that he give up gambling. In the end, he gives in to his "true" nature and wins big. In this film, salvation must be found in following one's true des-tiny, from which there is no satisfactory escape.

Maslow was correct in a sense—true self-actualization is more significant than physical needs, safety, or self-esteem. After seeking satisfaction in every place imaginable, the wisest man on Earth discovered that to "fear God and keep his commandments" is the whole duty of man. In other words, we are created for God and will only find our true "self-realization" in him.[4] But this is a rare message indeed for a popular film!

Most people would agree that Hollywood is a dan-gerous place to go looking for gospel truths, but there is another type of film message that can be more harmful still. Rather than attack the Christian faith directly, many films undermine foundational Christian principles, includ-ing man's need for salvation. These films present a false "gospel" that leads people away from the truth. Recogniz-ing these messages in movies can help us and others avoid being adversely influenced by them.

[4] Eccles 12:13. Augustine echoed these words centuries later when he wrote, "You have made us for yourself, O Lord, and our heart is restless until it rests in you" (*Confessions* 1.1.1).

The True Gospel

Imagine if a stranger walked up to you on the street with a large syringe full of some weird-looking liquid and said you needed this shot because it really helped him. Would you roll your sleeve up? Of course not! Offering people a solution fails if they don't believe there's a problem. As Saint Thomas Aquinas said, "No one is afraid to lose what he does not desire to gain."[5] Those without a proper understanding of sin will not correctly understand salvation. The gospel must begin with all that we are being saved *from*.

Jesus Christ died a horrific and unbelievably painful death to accomplish our salvation. Did he die so that God can be our buddy? Is the gospel about finding our "best purpose-driven life now"? To hear some Christian evangelists, you might think so! Although squaring well with the Hollywood gospel, this message is simply not found in the teachings of Christ.

In order to form true disciples, we must first *testify* to the true gospel message. Then we should *clarify* any misconceptions or explain anything that our hearer finds confusing. Finally, we must be prepared to *justify* our belief in the truth of the gospel.

Testify

A sufficient explanation of the true gospel includes the creation, the fall, and the redemption of mankind. We were created by an all-good God so that we could worship, love, and serve him and thereby be in union with him. This happy state was destroyed when mankind

[5] Thomas Aquinas, *Summa Contra Gentiles* 3.145

disobeyed God. Since then we have labored under the mastery of sin and the misery of its consequences: suffering and death. In his mercy, God made a way for reconciliation with himself by becoming the man Jesus, dying and descending into hell on our behalf, and rising from the dead. When we turn from sin and accept God's offer of forgiveness, we become his children in Christ and partake in his divine life on our journey to heaven. If we reject this gift and continue in rebellion, we risk suffering forever our chosen separation from God, which is hell.

This good news is often distorted—and not just by Hollywood. For many years now, a popular method of evangelizing has been to tell people that God has a wonderful plan for their lives and that they can achieve it if they only trust in Jesus. This is true so long as the abundant life offered by Jesus is understood not as status and wealth and everything going just the way we want, but as divine life in Christ as we pick up our crosses and follow him.[6] What happens to a suffering Christian who has been told that Christianity is about avoiding suffering? He may question the goodness and faithfulness of God or even join the ranks of those who "tried Christianity" and then decided it didn't "work".

Clarify

Saint Paul skillfully communicated the basics of Jesus' redemptive work when he laid out "the gospel, which you received, in which you stand, by which you are saved, if you hold it fast ... that Christ died for our sins in accordance with the Scriptures, that he was buried, that he was

[6] For example, Mt 10:22; Mk 10:37–39; Lk 6:22; Jn 16:33; Acts 5:41, 14:22; Rom 5:3–5, 8:13–17; 2 Cor 12:7–10; Phil 1:29, 3:8; 1 Thess 3:3; 2 Tim 1:8, 2:3, 3:12; Heb 5:8; Jas 1:2–4, 12; 1 Pet 1:6–7, 2:20–21, 4:12–19; Rev 1:9.

raised on the third day in accordance with the Scriptures, and that he appeared to Cephas, then to the Twelve" (1 Cor 15:1–5). Depending on whom you are talking to, it will likely be necessary to clarify many of these points.

For example, Jesus Christ is not just a great teacher but both fully God and fully man, who died a physical death and was buried as proof.[7] Then, after three days, he was physically raised from the dead. That is, his Resurrection wasn't simply spiritual; it was an actual, historical fact. This is evidenced by Saint Paul's point that Jesus appeared to eyewitnesses after his Resurrection. If we place our faith in this good news by following Jesus, he will save us from hell and lead us into eternal life with God.

```
                    VITRUVIUS
        All you have to do is to believe.
        Then you will see everything.

                            (The Lego Movie)
```

The word "faith" is often misunderstood by both unbelievers and Christians. Skeptics often think of faith as believing in something without good reason,[8] and many Christians see it as believing in something with merely incomplete reason.[9] Others define it as some

[7] Jn 1:1; Rom 10:9–13; Col 1:13–23; etc.

[8] Atheist Richard Dawkins defined faith as "the great cop-out, the great excuse to evade the need to think and evaluate evidence. Faith is belief in spite of, perhaps because of, the lack of evidence." Quoted in *Nullifidian*, December 1994, https://web.archive.org/web/20150403080517/http://old.richarddawkins.net/articles/89.

[9] For example, popular evangelical apologist Norman Geisler wrote, "A fundamental principle of reason is that we should have sufficient grounds for what we believe. An unjustified belief is just that—unjustified." "An Apologetic for Apologetics", Norman Geisler website, normangeisler.com/an-apologetic-for-apologetics.

combination of knowledge, assent, and trust.[10] These descriptions could also describe mere belief, however, which does not require God's grace or even necessarily an act of the will. People may accept Christianity simply because they were raised to believe it, or they might have been convinced of some of its truths by strong arguments. None of these definitions, however, describes the Church's understanding of faith.

Faith involves a free submission of one's intellect and will to God's revelation.[11] Thus, faith involves trusting a religious authority regardless of whether the things taught by that authority are also verifiable in other ways.[12] Otherwise, one is merely trusting in one's own opinion (no matter how well it is justified)—and one does not submit to one's own opinion! True faith is a free act of the will—not an intellectual act demanded by evidence (which is *knowledge*). This does not mean that faith equates to a lack of evidence or reason, however. One must exercise reason and investigate evidence in order to determine which authority is of God in the first place. Once that is accomplished, however, the proper response is submission.

Now, motivators of faith exist in many forms—historical, philosophical, and scientific arguments support many aspects of the faith. These simply cannot *coerce* the will (otherwise God's judgment concerning one's faith would make no sense). There are many truths of Christianity that can be demonstrated with various degrees

[10] For example, "Faith Defined", February 11, 2005, Ligonier Ministries, www.ligonier.org/learn/devotionals/faith-defined.

[11] *Catechism of the Catholic Church*, no. 143.

[12] Thomas Aquinas wrote, "A heretic with regard to one article [of faith] has no faith in the other articles, but only a kind of opinion in accordance with his own will." *Summa Theologica*, II-III q.5, a.3.

of assurance from reason and evidence. This is why the Church distinguishes between *natural* and *supernatural* faith: the former requires only naturally discovered reasons for assent and simply gives in to them ("mere belief"). Supernatural faith requires an act of God, because nothing in the natural order can prove a supernatural fact.[13] Religious faith, then, is a gift from God, and one that requires our free acceptance.

All orthodox Christians believe that salvation is a gift and not something that can be earned as if it were a wage or something due to "being good people" (Eph 2:8–10). Indeed, God "saved us, not because of deeds done by us in righteousness, but in virtue of his own mercy, by the washing of regeneration and renewal in the Holy Spirit, which he poured out upon us richly through Jesus Christ our Savior, so that we might be justified by his grace and become heirs in hope of eternal life" (Tit 3:5–7). Our works certainly *matter* for salvation, however. Jesus said that our deeds will be judged by God (Mt 25:31–46; Rev 20:11–15). Saint Paul teaches that God "will render to every man according to his works: to those who by patience in well-doing seek for glory and honor and immortality, he will give eternal life" (Rom 2:6–7; see also 1 Tim 6:18–19). Therefore, faithful Christians must "not grow weary in well-doing, for in due season we shall reap, if we do not lose heart" (Gal 6:9; see also Phil 2:12–13). We cannot, then, be saved by works alone (that is, apart from faith) or by faith alone (if faith is understood as mere

[13] It is a settled dogma of the Church that God's existence can be known via natural reason and evidence. (See the *Catechism of the Catholic Church*, no. 36, and Ludwig Ott, *Fundamentals of Catholic Dogma* 1.1.1.1.1). When these things are ascertained in this manner, however, they are no longer considered objects of faith, but rather of knowledge.

belief). Both are part of the same equation (Rom 3:28; Jas 2:21).[14]

Other aspects of the gospel message and how people can avail themselves of its power to save themselves must be carefully explained to avoid error. Once understood accurately, the gospel may be rejected because it simply does not seem to be true. This is where our third duty comes in.

Justify

Once we have correctly stated and accurately explained the gospel, we should also be prepared to defend it. To do this effectively, we must know the reasons why we believe what we believe. We can also study various subjects that support Christianity in order to "destroy arguments and every proud obstacle to the knowledge of God, and take every thought captive to obey Christ" (2 Cor 10:5). This is called *apologetics*, which literally means "to make a defense" (1 Pet 3:15).

Apologetics was central to Saint Paul's mission (Phil 1:7, 16), and he even made the practice a requirement for church leadership (Tit 1:9). Jude, an apostle of Jesus, echoes the same apologetic emphasis when he writes that "being very eager to write to you of our common salvation, I found it necessary to write appealing to you to contend for the faith which was once for all delivered to the saints" (Jude 1:3). Jesus himself stated that people should believe him because of the evidence he provided

[14] Martin Luther, unable to reconcile these two verses with his own theology, declared James "an epistle of straw" and added the word "alone" to his translation of Romans 3:28. Unfortunately, the distinction between "works of the law" and "good works" is often overlooked leading to charges of legalism against those who affirm Saint Paul's words.

for what he taught (e.g., Jn 10:38). Although our faith is in an invisible God, our God has revealed himself in visible history.[15]

The above task may seem daunting. And well it should! However, as will be shown below, three primary issues can resolve the debate. If reality exists and is knowable, then truth is not just a matter of opinion or preference; if what we know of reality points to the existence of a God who has revealed himself through supernatural events that are historically verifiable, then most other religions are "off the table".

Now, movies cover an enormous range of themes—as many as life itself. And while there are hundreds of themes that are truly important (racism, drug abuse, love, loyalty, etc.), how a film treats the subjects of truth, God, and religion is especially important. In the chapters that follow we will look at how these subjects have been approached and how well Hollywood has answered the questions they raise.

Coffee Shop Talk: Beginning with
Batman Begins

"So how did it go with Nita?" Renee asked Mike, after their first sips of coffee had begun to warm them.

Mike looked shocked. "Um ...," he began, "how did you ...?"

"Mike, I work here—I see all!" Renee laughed. I was watching you guys from behind the counter last week, and now I'm dying to know what you were talking about."

[15] Ex 4:1–8; 1 Kings 18:36–39; Acts 2:22, 43; Heb 2:3–4; 2 Cor 12:12.

Renee was a part-time barista at Café Veritas. She and Mike had met in a comparative religion class their freshman year.

"Well, if you must know, 'it' went fine. We were just hanging out, anyway—it wasn't anything serious," Mike said, trying to sound casual. "We're just friends."

"For now." Renee smirked.

"Yeah, well, I got into hot water when I brought up movies," Mike replied.

"How could movies get you in trouble?" Renee asked. "Everyone likes movies."

"I know!" Mike said a bit too loudly. "I think we just had some differences of opinion over what constitutes a good movie. It kind of turned into a debate."

"Maybe you just need to work on your small talk."

Mike laughed. "All I said was, 'Seen any good movies lately?'"

Renee laughed. "Not enough *o*'s in smooooth," she teased.

Before Mike could offer a counterresponse, Renee said, "Speaking of movies, I watched one of my favorites last weekend—*Batman Begins*. I saw it was playing on Netflix, and I remembered loving it when it first came out. I still think Christian Bale is the best Batman ever."

"Agreed," Mike replied. "What did you think about the story?"

"I liked that they made him and the villain believable, and the story was more sophisticated than most of the other Batman movies," Renee answered.

Mike was impressed. Warming to the discussion, he said, "Yes, exactly. The hero started off as a vengeful vigilante and ended up fighting for true justice. The villain seemed like a good guy at first, so it was even more interesting when he turned out to be evil."

"Well, I wouldn't call him evil," Renee answered. "He wanted justice, too. He just tried to achieve it the wrong way."

"So, you don't think that poisoning an entire city is evil?" Mike asked, surprised at this unexpected turn.

"Well, I think that we have to look at why people do things, not just what they do, before we call them evil," Renee said. "Otherwise we're just being judgmental."

"So, it would be OK to kill a million people if someone had good motives?" Mike countered.

"Sure," she said, shocking him. "What about war? If we have to kill people to stop evil, then that isn't an evil thing. Haven't you taken Ethics 101 yet?" She smiled, assuming that Mike was probably going to agree with her on this one.

"OK." Mike paused as he struggled with his response. "I agree that war is sometimes necessary to fight evil, so we can't just say that killing is evil. If we limit killing to murder (intentionally killing an innocent person), then we can agree it is always wrong—right?"

"So you have taken Ethics," Renee said with a laugh.

"Yeah." Mike laughed too. "In fact, the professor used an even more extreme example of evil just to head off any troublemakers ..."

"Like me?" Renee asked pointedly.

"Yes, exactly," Mike answered with a wink. "I think it was torturing babies for fun."

"Wow," Renee replied. "Extreme is right!"

"So, we do agree that some actions are evil—and that if someone does one of those things, it isn't judgmental to say so?"

Renee shook her head.

"Well, let's back up a bit. How do we decide that something is evil?" Mike asked. Renee answered, "That's

a good question, because everyone decides morality for themselves. Although sometimes it's just cultural."

"I don't think so," Mike answered. "If there were such a person or culture that allowed torturing babies for fun, that wouldn't make it right, would it?"

"Well, no," Renee answered, "but I don't think anyone would ever do that."

"Are you sure?" Mike asked. "The Nazis thought it was OK to torture and kill people—even children—and other countries judged their actions as evil."

"What does this have to do with *Batman*?" Renee asked, steering the conversation back to the movie.

"A lot," Mike answered. "Why did you think the villain was more believable?"

"Because he wasn't just some lunatic—he was rational," she answered. "He had reasons for what he did."

"Were they good reasons?" Mike asked.

"Well, sort of," Renee said thoughtfully. "He wanted to rid the world of evil. The problem was that he would have killed a lot of good people, too."

"Hitler didn't think he was killing any good people," Mike pointed out.

"But there were good people—everyday people like you and me," Renee replied. "We certainly don't deserve to be killed for anything we've done—unless you have some deep, dark past I don't know about."

Mike looked around the coffee shop suspiciously, then said, "I could tell you, but then I'd have to kill you."

Renee rolled her eyes. "Too easy," she laughed.

"OK, fine," Mike continued. "But if morality is relative, how can anyone say it's wrong to kill a bunch of mostly good people?"

Renee thought about this for a moment. "I guess in extreme cases like this we can."

"What makes it extreme? The numbers? So it might be OK to murder ten people but not a million? That's arbitrary."

"Yes, but most people would agree that killing millions of people is wrong," Renee answered.

"But what if they didn't? If Hitler had won the war, then the entire Western world might have eventually agreed that killing off the Jews was a good thing."

"Well, something inside us seems to tell us what is right and wrong; otherwise we wouldn't agree on anything," Renee answered. "Maybe it is because of evolution."

"Could we evolve into thinking that torture and genocide are good things?" Mike asked. "Is morality just the effect of some gene passed on by our ancestors? If so, why don't we follow it, like an animal following its instinct? The fact that we often don't do what is right indicates that morality is something outside of us, even though it's something we are able to recognize with what we call our conscience. But that still doesn't answer the question of where morality comes from."

"Gee, I guess that leaves God, of course," Renee replied sarcastically. "Is that where you are going with this? We need God to give us morals?"

"I wasn't going anywhere," Mike answered, smiling, "but since you brought it up—God, as in the Creator of objective reality, would solve the problem, right?"

"What if I don't believe in God?" Renee asked.

"I have several good arguments that he exists if you're interested," Mike offered with a smile.

"I'm sure you do, church boy," Renee said with a gleam in her eye. "But it is not the existence of some kind of deity that I have a problem with ..." Renee grew more serious. "No offense, but it is your God specifically."

This was unexpected. Mike knew Renee was not a Christian, but he thought maybe she just needed some

more time to see that Christians are just people like everybody else, but people who know they need God. Apparently not. His adrenaline was starting to flow, and this often indicated that he was about to say something stupid, so he tried to calm down and just let Renee explain. "What problem is that, Renee?" he asked.

She sighed. "I was hoping to avoid this because you seem like a nice guy, Mike, but the Christian God seems like a real jerk. Your God loves me so much 'that he sent his only son to die for me' but I will burn forever in hell if I don't love him back. How is that not crazy?"

Mike understood her thinking. "Renee," he began, "threatening someone into loving God never sounded right to me either. But that's not what the Bible actually says."

"Well," she retorted, "someone needs to tell your buddies at church then. Every time someone has tried to preach to me, it seems like equal parts 'God loves you' and 'You're going to hell.' So, which is it?"

"Let me explain how I understand the situation," Mike said, "and see if it makes more sense to you." He gulped down a large swallow of coffee in preparation.

"It is true that God does love you, and it is also true that he gives you the freedom to accept or reject his love. When we rebel against God, we choose hell for ourselves, and God respects our choice. But God also knows our weakness and blindness. In his compassion, he became a man like us to die on our behalf so that we could be saved from the eternal consequences of our rebellion and be restored to friendship with God."

"If he loves us so much, why doesn't he just forgive us?" Renee asked.

"He does forgive us, when we repent and accept his forgiveness. But if we choose to remain God's enemies ... well ... then he honors that choice as well."

"This is a lot different from what I have heard before," Renee said. "And it is a nice story, don't get me wrong, but lots of religions have nice stories." Renee started to fidget and look around. "Well, my break is over. You've given me a lot to think about." She got up and smoothed her apron. "Now I've got some sleepy people to wake up."

"OK," Mike said. "Can we talk about movies again sometime?"

"Sure."

"Great," Mike said, beaming. "Maybe next time we can talk about the Narnia movies or *The Lord of the Rings* or *The Passion of the ...*"

"Nice try, pal," Renee said wryly, looking over her shoulder as she moved toward the counter. "How about one with a theme that doesn't scream 'Christianity is True!'"

"Name a good movie that doesn't talk about redemption," Mike said, "and you're on!"

Conclusion

Any movie worth watching will include some features of truth. The main theme of *Batman Begins* is that vigilante justice is not true justice. Some form of objective morality is being assumed here. This is an excellent starting point from which to explore the truth of things and to see whether that truth can be found, or illuminated more fully, in Christianity. Notice in the dialogue that Mike allowed the conversation to flow naturally. Rather than launch into a preplanned speech or practiced arguments for God, he asked questions to find out what Renee thought and why. He discovered that Renee did not have an intellectual problem with the existence of a supreme being. Rather,

she had a problem with the gospel due to the way it had been poorly presented to her before and to her not having been challenged to think about the logical consequences of moral relativism. Mike *testified* to the truth of objective morality and of the gospel. He did not water down the truth or use manipulative emotional appeals. He gave it to her straight. He also *clarified* Renee's misunderstanding of the gospel message. Further, he *justified* the gospel by showing Renee that her reasons for rejecting Christianity were unsound in light of the true message of the gospel.

Finally, Mike kept the discussion respectful and friendly. This should keep the door open for future conversations. The rest is in God's hands.

Reality: Veritable or Virtual?

What the #$*! Do We Know?

> COBB
> However lost I might seem ... it's
> always there. Telling me something.
> Reminding me of the truth.
>
> MAL
> What truth?
>
> COBB
> That you were wrong to doubt our
> world. That the idea that drove you
> to question your reality was a lie.
>
> MAL
> How could you know it was a lie?
>
> COBB
> Because it was my lie.
>
> (*Inception*)

As we have seen in the last chapter, movies can present us with opportunities for observing and thinking about the truth of things and discussing it with others. In this chapter, we'll discuss a major obstacle to this—skepticism about the knowability of reality and truth.

I remember the first time I met someone who questioned the human ability to apprehend reality and thought truth could be different for different people. He said, "It is great that you believe in Christianity, but it just isn't true for me." This response threw me for a loop. I was prepared to respond to people who thought Christianity was false, but I was not ready for someone to tell me that it was true—*but only for me*. As it turned out, this was my introduction to *postmodernism*.

Since the early 1990s, film after film has reflected the idea that one's reality might not be what it seems. These include *Jacob's Ladder* (1990), *Total Recall* (1990), *eXistenZ* (1999), *The Matrix* (1999), *The Thirteenth Floor* (1999), *Fight Club* (1999), *Vanilla Sky* (2001), *Mulholland Drive* (2001), *What the #$*! Do We Know!?* (2004), *The Machinist* (2004), *The Jacket* (2005), *Moon* (2009), *Inception* (2010), *Shutter Island* (2010), *Source Code* (2011), and *Archive* (2020). The prime example is perhaps *The Matrix* (which continues to garner discussion and theorizing over twenty years after its release in 1999 and shows no sign of slowing down with its third sequel released in 2021). The notion that we might not really know reality has become a hot-ticket item.

While it is always fun to explore thought experiments in the movies, the underlying postmodern philosophy of these films is actually quite dangerous.[1] Films such as these must of necessity affirm the knowability of the real world (even indirectly) in order to make sense of their stories. However, their simultaneous affirmation that

[1] "Western civilization is for the first time in its history in danger of dying.... Increasingly, the very idea of objective truth is being ignored, abandoned, or attacked—not only in practice but even in theory, directly and explicitly, especially by the educational and media establishments, who mold our minds." Peter Kreeft and Ronald Tacelli, *Handbook of Christian Apologetics* (Downers Grove, IL: IVP Academic, 1994), 23–24.

one's entire experience of reality might very well be an illusion makes it impossible to maintain consistency on this point. Given the Matrix trilogy's storyline, there is no way to disprove the possibility that the "real world" is simply another simulation.

To understand postmodernism, one must first understand modernism, but it is a difficult term to define. Although modern philosophies have toyed with different kinds of relativism, most have retained the belief that truth is known through observation and logic. Postmodernism, by contrast, doubts the objectivity of our observational skills and, as a result, calls our knowledge of reality into question. Postmodernists are uncomfortable with "metanarratives"—stories that encompass and explain all of reality—preferring instead more personal, localized views of the world.

Postmodernism involves a change not only in *what* people think but also in *how* they think. If all we can know for certain are the ideas in our own minds, then my ideas are just as good as anyone else's—even if they disagree with mine. This leads to the conclusion that we all have equal say in what is real—things may be "true for you" but not necessarily "true for me".

Previous ways of thought began with the assumption that we perceive reality as it really is—and that is the very thing postmodernism denies. After all, we can all think of times when people have been fooled by their senses. Hallucinations, mirages, dreams, and optical illusions are all examples of the unreliability of our perceptions. Memory loss or confusion, the Mandela effect, and other issues call our memories into question as well. But postmodern skeptics take this fact a step further and ask, "How do we know our senses aren't fooling us right now?" or "How do we know that the pictures in our mind represent what outside reality is actually like?"

In this chapter, we will demonstrate that truth is objective (based on reality, not our thoughts *about* reality), absolute (universal), and knowable (even though our knowledge has limits and is subject to error or misunderstanding). This will not be as difficult as you might imagine, because we are basically arguing for what children already know. Although it may seem philosophically deep to ponder our ignorance of reality, some knowledge of reality cannot be coherently denied. Once it is time to cross the street or balance a bank statement, even skeptics are every bit as objective as their realist opponents. Outside of religion and morality, the view that we can know reality is taken for granted. Even popular movies that make the attempt to legitimize skepticism provide us with the opportunity to prove this important truth.

Knowing That We Know

> MORPHEUS
> What is "real"? How do you define
> "real"? If you're talking about
> what you can feel, what you can
> smell, what you can taste and see,
> then "real" is simply electrical
> signals interpreted by your brain.
>
> (*The Matrix*)

Truth is a statement that matches reality.[2] So if reality exists, truth exists—and if we can know the difference

[2] This definition should be fairly noncontroversial although philosophers wrangle over it. This classical "correspondence theory" of truth accords with what most people mean when they say something is "true", and any claim that truth is something other than correspondence with reality is itself a statement thought to correspond to reality (or else it is false).

between true and false, then we must know reality. Now, if we say that truth does not exist, we are making a statement that presumably matches reality. If it does not, it is false (and so truth exists); if it does, then it contradicts itself and is necessarily false (and so truth exists). This basic flaw infects every argument against truth and reality.

There is an old fable about several blind men who happen upon an elephant in the jungle. One touches the trunk and thinks he has found a snake. The next man feels the leg and believes it to be a tree. The third man feels the elephant's side and says it is a wall. Another man touches its tusk and thinks it is a spear. Yet another touches its ear and believes it is a fan. The point of the story is that although people claim to know the truth, because we are all limited in our perspective, we can only grasp parts of it—and we may even be mistaken about those.

There is an element of truth in this story (we are limited, and we make errors of judgment), but the conclusion we are meant to draw from it is flawed. What makes the story work is that the men were wrong, and we—the audience—*know* they were wrong. The trouble is you cannot know something is wrong unless you know what is right; the story would mean nothing if we were unaware that the men had found an elephant. Ironically, then, although this story is told in order to correct people who claim to know truth, the person telling the story must know the truth in order to show how all the blind men are wrong! In other words, the intended message is self-defeating. In trying to prove that truth is relative and reality is unknowable, the story instead proves that truth is absolute and reality is knowable.

Although many movies have explored the notion that we might not really know reality, they all rely on some alternate or questionable reality for their stories to work. What they all do, however, is show that someone actually

knows reality—namely, *the audience*! Like the elephant fable above, these stories would not be interesting if the viewers were not aware of the truth—the *real* reality.

What all this means is that while we can certainly be mistaken at times about what is real, there is indeed a reality to know. In fact, the very mistakes people offer as evidence that we don't know reality actually prove that we do. We would not know there were such things as hallucinations or illusions if we did not have reality with which to compare them. Most alleged disproof of objective reality is simply an issue of judgment or interpretation of data, not our direct knowledge of the world. So, the real issue is what is true—not whether or not there is such a thing as truth.

Truth and its knowability cannot be coherently denied. To do so is to defeat oneself. There are, however, two kinds of statements that are often thought to prove that truth is either relative (to the individual) or subjective (based on the individual).

Objective versus Subjective Truths

LEONARD
I have to believe in a world outside
my own mind. I have to believe that my
actions still have meaning—even
if I can't remember them. I have
to believe that when my eyes are
closed the world's still here. Do I
believe the world's still here? Is
it still out there?

(*Memento*)

When we say something is "objectively true" we are contrasting it to something that is said to be "subjectively

true". Once again, there is often a confusion between a kind of statement and a kind of truth. Subjective statements depend on the speaker for their truth value because they are actually statements about the speaker. Objective statements depend on something besides the speaker for their truth value. Either way, we are speaking of something that either corresponds to reality (is true) or doesn't correspond to reality (is false).

For example, if I say that ice cream melts at temperatures above thirty-two degrees Fahrenheit, I am not simply telling you what I think about it. I'm offering an objective statement about ice cream because whether it is true or false depends on the ice cream (not me). However, if I say that ice cream tastes delicious, I am telling you something about me and my experience of eating it. Thus, "ice cream tastes delicious" is a subjective statement—but it is not a subjective truth. If the statement about ice cream's taste to me is true, it is true regardless of what anyone else thinks about ice cream. The statement "ice cream is delicious to me" cannot be made false by someone who disagrees. So, we can speak of subjective *statements*, but not subjective *truths*. Again, statements either correspond to reality or they don't.

Relative versus Absolute Truths

BITSEY
There is no truth, only perspectives.

ZAK
Can't say that. If you say there's no truth, you're claiming it is true there's no truth. It is a logical contradiction.

 BITSEY
Working on our philosophy merit
badge are we, Zack?

 ZACK
It is just my perspective.

 (*The Life of David Gale*)

Similar confusion occurs around the issue of relativism. Relativism says that truth is dependent on individuals. For example, "It is cold in here" seems to depend on the speaker for its truth value. In reality, all such examples are simply relative *statements*—not relative *truths*. Some statements are only true in certain contexts. The statement "Giraffes are tall", for instance, depends upon what I am comparing to the height of giraffes. If the statement is comparing giraffes to other animals, then it is true. If it is comparing them to skyscrapers, then it is false. However, once we know the unspoken context of the statement, its truth or falsity is easy to determine. Relative *terms* can make for relative *statements*, but not relative *truths*. All truths are absolute and universal once understood in their own context, because all statements either correspond to reality or they do not.

Truth and Consequences

 WINSTON SMITH
There is truth, and there is
untruth.

 (*1984*)

The price to pay for truth is the possibility of falsehood. If a statement is true (matches reality), then anything that

contradicts it is false (does not match reality). Because of this, truth is objective (not subjective) and absolute (not relative). While sophisticated philosophical arguments or lived examples from experience may seem to call this basic fact into question, they all end up supporting the know-ability of reality in the end.

It is sometimes easier to see this occurring in actual conversations with someone used to exposing the basic flaw in self-defeating arguments or statements. A classic example is the statement "All English sentences are false." Because this statement is itself an English sentence, it refers to itself—and because it refers to itself as being false, then if it is a true statement, it falsifies itself. And of course, if it is a false statement, then it is false. Either way, it is false! Therefore, it cannot be the case that all English sentences are false.

Even more philosophical arguments suffer the same fate. Suppose you meet a philosopher at a party and he states, "No one can know reality, because the subjective phenomena of experience can never be compared to the objective noumenal realm for verification." Wow—what does that even mean? Most of it doesn't really matter, because the first phrase ("No one can know reality") is self-defeating. All that is left is to point it out. Without getting into the grad-student lingo, one could simply ask, "Do you *know* that is the *reality* of the situation?" If the philosopher says yes, then he has contradicted his state-ment (by claiming to know reality). If he says no, then he cannot be sure the statement is true and needs to try again.

What about the experience of realistic dreams or optical illusions? Don't these prove that we don't know truth? The same tactic works here too. If someone were to claim, "We can't be sure what is real because we sometimes dream things that seem real but are not", he would be

assuming that he knows the difference between dreams and reality. But he could not know that difference if he could not know reality.

In the end, all claims that truth and reality are unknowable, relative, or subjective are necessarily false. All that is left is to demonstrate why.

Coffee Shop Talk: *The Matrix* Missionary

Renee called Mike on Thursday to invite him to an informal discussion group at the coffeehouse that she sat in on when she wasn't busy with customers. The group was led by a popular philosophy professor. She had overheard that this week they would be discussing the classic Matrix trilogy. Mike immediately agreed since it was one of his favorites.

When he arrived, he found several students whom he had seen around campus warming up with favorite quotes from the films. He greeted a few of them and met Dr. Matthews, the professor who led the discussions. Then he got a drink and sat down to see how it would go.

Dr. Matthews motioned that they were going to begin. "Tonight," he said, "I would like to discuss films that call our knowledge of reality into question. You've probably all seen movies such as *Inception* or *Shutter Island*? Well, before all of these came along, there was a ground-breaking trilogy known as The Matrix."

Heads nodded eagerly—the premise behind The Matrix was perfect philosophy-nerd fodder. The plot assumed that machines had taken over the planet and were streaming an imaginary world into the minds of humans, whose physical bodies were really trapped in cocoons. There they served as living batteries to power the machine world. The

protagonist, Neo, escapes the Matrix with the help of a few other rebels so that he is free to experience the real world and decide whether to fight the illusion or give in to it.

Dr. Matthews continued. "So here is the question: Did the film give an adequate answer to the question of what the Matrix is?"

One student spoke up and said, "Yeah, the Matrix was the machine world's way of controlling humans. It was a program like virtual reality."

"OK, good," said Dr. Matthews, "and what is the 'machine world'?"

"The real world," ventured another student. "Morpheus explained that to Neo after he first came out of the Matrix: 'Welcome to the real world.'"

Nods followed as the students remembered the dramatic moment when Neo opened his eyes for the first time to see the real Morpheus standing over him.

"And how does this relate to our own world?" asked Dr. Matthews.

"It doesn't," answered the first student. "We're not in the Matrix—this is the real world." He picked up a spoon and tapped it against his mug. "There is a spoon!" he proclaimed, eliciting laughter from the group.

"Is there?" Dr. Matthews asked. "How can you prove that the world you see around you is the real world? How can you be sure that your thoughts of the spoon correspond to a real spoon that exists outside your mind?"

The student tapped the spoon again as if to say, "Can you not hear that?"

Dr. Matthews was ready. "How can you be sure that your thoughts of the spoon hitting the mug correspond to a real spoon hitting a mug that exists outside your mind?"

This caused a pause. No one could come up with a test that did not depend on his thoughts being accurate in the first place. Mike felt a bit out of his league, but he needed to say something. After all, he thought, if we can't trust our senses and thoughts, then nothing is definite. Worse, he noticed Renee watching him. If he could not defend the knowability of reality, then everything else they had talked about was useless. He decided to give it a shot. He tried to turn the question around. "Dr. Matthews," he asked, "is there any reason to think we don't know reality?"

Eyebrows raised around the circle, but Dr. Matthews didn't hesitate. "Certainly," he responded, glad to have someone thinking seriously about the subject. "For example, we've all thought we saw something that turned out not to be real—mirages, hallucinations, optical illusions, and so on. These are evidence that our senses cannot be trusted to deliver accurate information about the external sensible world."

"I see," answered Mike. "But don't these occurrences actually prove the opposite?"

Everyone turned to Mike with confused expressions, and Dr. Matthews smiled. "Continue," he said.

"Well," Mike began, "those are all examples of things that we know do not match reality. Mirages and optical illusions are mistakes in judging what our senses report—like thinking that a stick bends in water when really the light makes it appear bent. Hallucinations are sensory mistakes, yes, but we only recognize them as mistakes because we can compare them to reality."

"But those examples do show that what we think we know is not always the case," Dr. Matthews began. "For example, you probably think the chair you are sitting on is solid—and it certainly appears to be so. But we know

that in reality—if you will—it is made up of atoms. The appearance is not the reality in this case."

Mike hoped he was not digging his own philosophical grave, but he continued. "Do you think this is an error in perception or an error in our judgment of those perceptions? Maybe the problem is simply imprecise language. Saying the chair is solid when it is actually made up of atoms does not change the fact that my hand does not go through a chair as it goes through water. If that's all I mean by 'solid' then the belief is not false. And once again, aren't we relying on sense data to reveal that the chair is made of atoms? It seems to me that if we say, 'Here is an example of our senses fooling us', then we are trusting in what our senses are telling us to conclude that we can't trust what our senses are telling us!"

The other students were beginning to enjoy this. Mike's arguments did seem to make sense.

Dr. Matthews offered his response. "You are right that to some extent it is my senses that tell me not to trust my senses. But it is really the combination of my senses plus my reason that suggests to me that my usual observations only indicate what the world seems like to me and do not reveal what the world is really like."

This was going well beyond Mike's knowledge base. He did not really follow all the details of Dr. Matthews' argument, but his main question still seemed relevant.

"I hope I'm not just being dim," Mike began, "but it still seems to me that you are making what you think are accurate descriptions of the world as it really is. If it is true that we don't know the real world, then isn't that a statement about the real world that you know?"

"Yes," answered Dr. Matthews. "But let's return to the example of your chair. You admit it is not as it appears to be. Your senses tell you that there is a solid object before

you, yet reason tells you that it is made up of atoms. If you were the size of an atom, you would think a chair was millions of large objects floating around in space. So, which of those perceptions is accurate?"

"I think they're both accurate," Mike said. "I might see a grape as being very large if I were an ant, or I might perceive raindrops as giant deadly blobs ..."

"Like in *A Bug's Life!*" someone interrupted.

"Another excellent movie!" Mike replied. "But isn't that what they actually are? Neither perception is inaccurate. Perspective might affect my language or relationship to a thing, but I'm describing the same thing in any case. Different perspectives of an object surely do not make that object unreal, do they? I don't see how the fact that things appear different from different angles or perspectives threatens our knowledge of reality. Our reason allows us to go beyond sensory appearance, as you pointed out; that just tells me that our reason helps us to know reality. I don't know that it helps to say our senses plus reason tell us that our senses plus reason are false."

This was getting heavy. Another round of coffee was ordered before the discussion continued. Dr. Matthews responded to Mike's last question with a rather uncomfortable conclusion: "It is true that bringing in reason does not solve the issue, but I've never felt that there was really a problem. I would return to the internal/external distinction. My internal reality—which I can know—is that I don't know external reality and may never know it."

They both stared at one another for a minute. Mike finally asked, "You don't think it is a problem to say we don't know reality?" The students all turned to Dr. Matthews.

"No," he replied, "not in any practical sense. We can still lead coherent, moral lives without knowing the world beyond our senses and thoughts."

"I'm not sure how ethics can work without reality," Mike said. "I wonder how you justify things like the value of humanity or other basic moral principles without a knowable reality. For example, if I don't really know that the object in front of me is a person, how can I decide whether or not it would be OK to kill it?"

"If all of us perceive reality the same way, then it is not a problem," answered Dr. Matthews.

"And how could we know that?" asked Mike. "This was one of the things that really bothered me about the Matrix films. You asked in the beginning of the discussion if the film gave an adequate answer to the question of what the Matrix was. I'm not convinced it did. What Morpheus and the other escapees perceived as being the Machine World could have simply been another level of the Matrix. If skepticism about knowing reality is taken as one's starting point, there is no way out. Maybe we need to begin instead with what seems to be the case and go from there."

"All right, guys," Renee interrupted, jangling her store keys. "This has been fascinating, but as the Oracle says, 'Everything that has a beginning has an end.' It is closing time!" The students groaned with chagrin.

Mike threw in some closing statements as they began rearranging the chairs. "I think maybe there is a basic problem with the idea that we only know ideas in our mind. We never speak of things as ideas unless we know them to be simply ideas. For example, we do not go to the store and ask for the idea of bread; we want bread. The fact that we can even make this distinction seems to indicate that we can tell the difference between a mere idea and a real object. Skepticism seems to me to be one step more complicated than it needs to be, and it is a theory that can't be disproved, even if we did wake up in a pod!

"But if we begin with the view that we do know reality, we have a chance of explaining what most people take for granted. Maybe this is simplistic, but I can't see any good reason to reject it!"[3]

Conclusion

As you can see, even obviously fictional movies can do a lot of damage to one's faith if they are not considered critically. If you had trouble following the conversation, don't despair. I simply wanted you to see that even a sophisticated philosopher can be answered with good, sound reasoning on your side. All Mike did in the above conversation was to keep bringing the discussion back to the self-defeating problems of skepticism: that if the knowability of reality is required to prove its non-knowability, then its non-knowability is absurd.

Although we may be wrong about what the truth is, we must agree that it does exist. Even if we sometimes have a difficult time discerning how we know truth, we do know that it can be known. To deny this is incoherent. What this means is that while we can and should argue about what is true, we should never call either truth itself or our ability to apprehend it into question.[4]

[3] I am indebted to a conversation with Dr. Matthew Lawrence for several portions of this dialogue. For his thoughts see his *Like a Splinter in Your Mind: The Philosophy Behind the Matrix* (Malden, MA: Blackwell Publishing, 2004).

[4] For more on this issue, see Francis J. Beckwith and Gregory Koukl's *Relativism: Feet Firmly Planted in Mid-Air* (Grand Rapids, MI: Baker Books, 1998) or Paul Copan's *"That's Just Your Interpretation": Responding to Skeptics Who Challenge Your Faith* (Grand Rapids, MI: Baker Books, 2001).

Chapter 9

Deity: Creator or Creature?

Can God's Existence Be Proved?

 ELLIE
All right. So, what's more likely
... that an all-powerful mysteri-
ous God created the universe and
then decided not to give any proof
of his existence or that he simply
doesn't exist at all and that we've
created him so we didn't have to
feel so small and alone.

 JOSS
I don't know. I couldn't imagine
living in a world where God didn't
exist. I wouldn't want to.

 ELLIE
How do you know you're not deluding
yourself? I mean, for me, I'd need
proof.

 JOSS
Proof. Did you love your father?

 ELLIE
What?

 JOSS
 Your dad, did you love him?

 ELLIE
 Yes, very much.

 JOSS
 Prove it.

 (Contact)

Although the question of what can really be known shows
up in movies, people don't stand at the crosswalk in a state
of indecision because they doubt that the cars whizzing
by are real. But they do often doubt the most primary and
important thing of all—the reality of God. Now that we
have demonstrated that reality can be known, we can look
at what it can teach us about the existence of God.

 Both Sacred Scripture and the Nicene Creed begin
with the affirmation that God exists. The Creed makes
this explicit, while it is implied in Sacred Scripture: "In
the beginning God ..." (Gen 1:1). We sometimes refer to
the Bible as God's Word or his *revelation*—but if we are
talking with someone who denies the very existence of
God, it does little good to quote creeds or Bible verses!
Christians usually take the existence of God for granted
when sharing the gospel with nonbelievers, but some peo-
ple need to deal with God's existence before they will be
open to discussing his revelation.

 The Church, in both Sacred Scripture and tradition,
teaches as dogma that that there is evidence of God's
existence and attributes available for all people—and that
his existence and attributes can be known with assurance
though creation.[1] Saint Paul tells us in Romans 1 that

[1] See Ps 19; Rom 1–2; *Catechism of the Catholic Church*, no. 36; and Ludwig
Ott's *Fundamentals of Catholic Dogma* 1.1.1.1.

creation itself testifies to God's existence, that it is clear to all people. So why are there atheists? The same chapter says it is due to man's fallen will—people simply do not want to believe, so they worship (in some form) the creation rather than its Creator (Rom 1:18–23). This willful exchange of creature for Creator has consequences for the intellect and moral action as well (Rom 1:24–32). While we cannot force people to believe with experience, logic, or science, we can motivate their faith by giving good answers as to why we think God exists.

In the movie *Contact* (1997), a Christian named Joss makes a great point when he challenges the agnostic scientist Ellie to "prove" she loved her dad. Asking for scientific proof of something like love is rather ridiculous—as is Ellie's asking for scientific proof for God. During the film, I hoped Joss would offer a good argument or two for God's existence, but they might have fallen on deaf ears if Ellie had not first understood that asking for scientific proof for God is like asking for scientific proof for love.

The scientist's knowledge, like everyone else's, is limited to the areas in which he has been trained—and proof for the existence of a nonphysical God cannot come directly from the physical sciences. This does not mean we cannot use scientific facts as evidence to support theological conclusions; it simply means that empirical science cannot prove or disprove subjects outside its scope.

```
                    CHANTILAS
I realized science couldn't answer
any of the really interesting ques-
tions. So I turned to philosophy.
Been searching for God ever since.
Who knows, I may pick up a rock and
it'll say underneath "Made by God."
The universe is full of surprises.
```

GALLAGHER
That would be a big one.

(*Red Planet*)

Although God does not write messages on the bottom of rocks, philosophers, theologians, scientists, and saints have used the created order in several ways to argue for the existence of God. In this chapter, we will look at a few of the most important. Bear in mind as you read that there is no "silver bullet" argument appropriate to all situations or objections. Different arguments will appeal to different people for different reasons. Because human beings have minds, hearts, and wills, we should seek to satisfy the whole person in our presentation. The mind may be most satisfied by the Creator or design arguments. The argument from desire touches the emotional level, because it seeks to explain a universal human feeling. A person's will may be moved more by the moral argument, which shows not only that an ultimate Lawgiver exists, but that we must bow to him as his creatures. These arguments are not intended to force someone to believe in God—nor can they. None are absolute proofs, such that no reasonable person could possibly deny them. But they do motivate faith and help people understand that for Christians, faith is not blind.

From Creation to the Creator

Consider the old question about the chicken and the egg—you know, which came first? The problem, of course, is that if every chicken came from an egg and every egg came from a chicken, then we could never reach an answer. But this problem hints at a solution. Just how far back can the

chicken-egg-chicken chain go? It cannot go on forever. It has to stop somewhere. Moreover, the procession must begin with something that is not from a previous chicken or egg. Otherwise the series would never end.

The same goes for all other chains in the universe—trees and seeds, parents and children, even the formation of galaxies. If we apply this idea to the whole universe, it appears we need an explanation for the universe itself. If chickens come from eggs, what do universes come from? A skeptic might respond that the universe had no beginning.[2] But this position has become more difficult to defend in recent years in light of ever-increasing scientific evidence for the Big Bang theory (which was first theorized by a Catholic priest!).[3]

This evidence includes the second law of thermodynamics, which states that the usable energy in the universe is running down. It is clear that what is running down had to *begin* to run down; therefore, the universe had a beginning. Galactic expansion, a prediction verified by Edwin Hubble's discovery of the red shift in 1927, showed that the galaxies are moving away from each other and must have originated from a central point (at the beginning of the universe). Cosmic microwave background radiation, the predicted radiation left over from the Big Bang, was discovered by scientists Penzias and Wilson in 1965. The temperature ripples in this background radiation, also

[2] Albert Einstein himself initially rejected the idea that the universe had a beginning (and even fudged his relativity equations to avoid such a conclusion). See Cormac O'Raifeartaigh, "Einstein's Greatest Blunder?", *Scientific American* guest blog, February 21, 2017, blogs.scientificamerican.com/guest-blog/einsteins-greatest-blunder.

[3] Fr. George Lemaître "linked the new astronomical observations with general relativity by suggesting that the data were evidence of a universe that was not static but expanding. Apparently, Einstein did not receive this work favourably either: in his memoirs, Lemaître recalled that Einstein described his model of an expanding universe as 'abominable'." Ibid.

predicted by Big Bang theorists, was discovered in 1992 by astronomer George Smoot.[4]

From Here to Eternity

Interestingly, simple mathematics leads to the same conclusion that modern science does. No matter what is being counted, it is impossible to have an infinite number of anything. Sure, it was fun on the playground to claim that we were so strong that we could lift "infinity pounds". But in reality, this makes no sense. An "infinitieth number" is impossible, because all numbers are finite (limited). You cannot add up a bunch of limited things to reach an unlimited amount. We can use infinity as an abstract mathematical idea, but an actual infinite number of things cannot exist in reality. With apologies to Buzz Lightyear, not only can one not go beyond infinity, one cannot even get to it!

Another way to look at it is that everything that has an end has a beginning. Try to imagine a one-ended stick. You can't, for the limit of the stick cannot only be on one end. If either end were unlimited, the stick would be unlimited in length. The same thing is true of the number of moments in time before now. Since we are at one end (limit) of the chain of moments, this chain had to start somewhere. And if everything in the universe is part of a limited chain, then the whole universe had a beginning. And if the universe began, it required a beginner.[5]

[4] See William Lane Craig and Quentin Smith's *Theism, Atheism, and Big Bang Cosmology* (Oxford: Oxford University Press, 1995); Robert Jastrow, *God and the Astronomers* (New York: Norton, 2000); Stephen Hawking, *A Brief History of Time: From the Big Bang to Black Holes* (New York: Bantam, 1988).

[5] For more on this argument see William Lane Craig, *The Kalām Cosmological Argument* (Eugene, OR: Wipf & Stock Publishers, 2000).

Science and philosophy agree that the universe has not always existed and that things cannot create themselves. Things that have not always existed must have been created by something else. Thus, if we trace the chain all the way back to the beginning, we must find something that has always existed and that explains all the things that have *not* always existed. The best explanation for this is the eternal God. Agnostic astronomer Robert Jastrow put it this way: "For the scientist who has lived by his faith in the power of reason, the story ends like a bad dream. He has scaled the mountains of ignorance; he is about to conquer the highest peak; as he pulls himself over the final rock, he is greeted by a band of theologians who have been sitting there for centuries."[6]

From the Unnecessary Cosmos to the Necessary Theos

A more philosophical way of looking at creation begins by realizing that the cosmos is *metaphysically unnecessary*. This is a fancy way of saying that it doesn't have to exist just because of what it is. We can define everything in the cosmos whether any of those things exist or not. Rabbits and the Easter Bunny, teeth and the Tooth Fairy—we know what these things are, even though some of them exist and some do not. Anything that can be defined without existence is not something that exists simply because of what it is—otherwise, existence would be part of its nature—its definition.

Because they don't have existence by nature, metaphysically unnecessary things have to have existence "added on

6 Jastrow, *God and the Astronomers*, 105–6.

to" their natures. They must be caused to exist. Since this is true of everything in the cosmos, something outside the cosmos is required to make it exist *right now* (not just "in the beginning"). Further, this thing cannot be getting its existence from something else, or we would be right back where we started.

Therefore, the existence of metaphysically unnecessary things shows that there must be something that *does* exist of metaphysical necessity. Something that has existence as its nature—that does not get existence from something else. But something that has existence as part of its nature—what it is—cannot have ever not-existed, or it wouldn't be what it is! Moreover, something that has existence as part of its nature can never stop existing. Finally, this thing's existence would be unlimited—because a thing's nature limits its existence (all that an existing thing is, is what it is). But a thing that is existence itself has no additional nature limiting its existence—because *it is existence*!

What this all means is that the cause of our metaphysically unnecessary, limited cosmos must be the metaphysically necessary, unlimited Creator. This, of course, is God.

From Design to the Designer

KANE
In order for life to have appeared
spontaneously on Earth, there first
had to be hundreds of millions of
protein molecules of the ninth con-
figuration. But given the size of
the planet Earth, do you know how
long it would have taken for just

one of these protein molecules to
appear entirely by chance? Roughly
ten to the two hundred and forty-
third power billions of years. And
I find that far, far more fantastic
than simply believing in God.

(*The Ninth Configuration*)

In the movie *Only the Brave* (2017), a firefighter is teased by his crew for dating a girl who believes that Mount Rushmore is a natural phenomenon and has to decide if her body is worth putting up with her evident lack of brains. The issue, of course, is that no one in their right mind would think that such design and detail could have been produced without an intelligence behind it. Whenever we see design, we assume from experience that it came from a designer. We can tell the difference between sand dunes and sand castles, for instance, because we see purposeful design in the castles. None of us would happen upon a sandcastle and believe that it arrived there by chance. Furthermore, when we speak of design, we mean a specific, complex design—not simply a pattern of some sort. It is the difference between "BDHIGEHGDVNB", which is complex but has no design, "BBBBBBBB", which has design but is not complex, and "Be back at 8 P.M.", which is both designed and complex. When we see complex, specific design, we recognize it as the result of an intelligent being.

The same can be said for creation. There is much design evident in it—from the smallest life form to the largest galaxies. In the movie *Contact*, alien intelligence is discovered when the aliens communicate a short, simple, but nonrandom series of numbers into space. World renowned scientist Carl Sagan, who wrote the story,

believed that all it takes to assume an intelligent creator is four nonrandom numbers. Interestingly, Sagan himself stated:

> The DNA double helix is a language written only in four letters. The variation of these letters is seemingly infinite. As for human beings, their hereditary material requires some five billion bits of information. These bits of information in the encyclopedia of life—in the nucleus of each of our cells—if written out in, say English, would fill a thousand volumes. Every one of your hundred trillion cells contains a complete library of instructions on how to make every part of you.[7]

Now, if four prime numbers in sequence require an intelligent creator, then so would twenty million volumes of information found in human DNA.[8]

The universe itself shows purpose and design as well. Astrophysicist Hugh Ross lists over one hundred finely tuned features of our universe (from the average distance between galaxies to the decay rate of the proton); of our solar system (from our galaxy size to the number of moons); and of our planet (from the number of forest fires to soil mineralization) that are all necessary for the existence of life as we know it.[9] Ross has calculated the

[7] Carl Sagan, *Cosmos* (New York: Ballantine Books, 1980), 227.

[8] Today, scientists believe that the human brain has a capacity of one petabyte—the equivalent of 4.7 billion books. See "Human Brain Can Store 4.7 Billion Books—Ten Times More Than Originally Thought", *Telegraph*, January 21, 2016, www.telegraph.co.uk/news/science/science-news/12114150/Human-brain-can-store-4.7-billion-books-ten-times-more-than-originally-thought.html.

[9] Hugh Ross, *The Creator and the Cosmos* (Colorado Springs, CO: NavPress, 2001). See also Paul Dooley, "Fine-Tuning of the Universe", Evidence to Believe, https://evidencetobelieve.net/fine-tuning-of-the-universe-2/.

odds of all these necessary requirements for life arising from random chance, and they are stunning. If there were 10,000,000,000,000,000,000,000 (a sextillion) planets in the universe, there would be only a 1 in 10^{138} chance that any one of them could support life. To gain some perspective on how large the number 10^{138} is, consider that the number of atoms in the entire universe is around 10^{80}. This makes the odds of this finely tuned universe occurring by random chance essentially zero.

Contrary to Ted and Ellie's opinion in the movie *Contact*, there is a reason for all the seemingly wasted space around the Earth. Psalm 19 tells us that "the heavens declare the glory of God; the skies proclaim the work of his hands." In other words, the awe we experience when we consider the vastness of creation points to God.[10] Just as a limited creation implies an unlimited Creator, the design within creation implies a designer. Because design is evident at every level of the universe, we must logically infer that it was created by an intelligent designer.[11]

Endless Forms Most Beautiful

Another type of design argument is one from aesthetics (aka the argument from beauty). Some assert that beauty, as well as the ability to appreciate beauty, points to the existence of God. The reason for this is that atheism, it is said, cannot account for this state of affairs. Naturalistic Evolution, the theory that made the world safe for

[10] Scientists also point out that the vastness of the universe is a prerequisite for life. See Ross, *Creator and the Cosmos*.

[11] Even evolution produces this design inference when its odds are calculated and so requires an explanation that is not forthcoming from natural explanations alone.

intellectual atheism, has little explanation for beauty or its appreciation.[12]

Christian philosopher and apologist J. P. Moreland notes that "a sunset, fall in Vermont, the human body, the Rocky Mountains [and] the singing of birds ... all exhibit real, objective beauty [that] cannot be accounted for in terms of survival value, natural selection, and the like." Although it might be theorized that some notions of beauty arise from a survival instinct, many beautiful things are actually rather dangerous (staring into a sunset) or even deadly (such as many plants).[13] Others seem completely useless—such as colorful fish that live in abject darkness. Given that no naturalistic theory of creation can satisfactorily ground the beauty of the world or our ability to perceive and enjoy it, the argument concludes that God must exist as its cause.[14]

The aesthetic argument from beauty goes back as far as Saint Augustine, who spoke of it in his famous book *City of God*, and finds deep metaphysical treatment centuries later in the writings of the brilliant theologian Saint Thomas Aquinas, who argued that true beauty reflects the real goodness of God.[15] Even the skeptical philosopher

[12] Richard Dawkins said Darwin "made it possible to be an intellectually fulfilled atheist". *The Blind Watchmaker: Why the Evidence of Evolution Reveals a Universe without Design* (New York: W. W. Norton and Co., 1996), 10. Charles Darwin once wrote, "Many structures have been created for the sake of beauty, to delight man or the Creator ... or for the sake of mere variety... Such doctrines, if true, would be absolutely fatal to my theory." *The Origin of Species* (New York: Grammercy, 1998), 146.

[13] For example, the attractiveness of full breasts/hips or large muscles in mate selection has been linked to breeding advantages.

[14] Metaphysically, truth, goodness, and beauty are considered to be features of all existing things, and thus all must be caused by a pre-existing thing that is truth, goodness, and beauty itself.

[15] Thomas Aquinas, *Summa Theologiae* I, q.5, a.4, ad 1.

Immanuel Kant famously wrote, "Two things fill the mind with ever new and increasing admiration and awe, the more often and steadily we reflect upon them: the starry heavens above me and the moral law within me." His friends placed this assertion on his gravestone.[16] The wonder of the universe, it seems, is a constant in human experience (the "moral law within" will be treated below).

In the end, the argument from beauty possesses an instinctive power difficult to place in logically rigorous terms. Perhaps Peter Kreeft said it best: "There is the music of Johann Sebastian Bach. Therefore, there must be a God. You either see this one or you don't."[17]

From Moral Laws to the Moral Lawmaker

MURPHY
Do not kill. Do not rape. Do not steal. These are principles which every man of every faith can embrace.

CONNOR
These are not polite suggestions. These are codes of behavior, and those of you that ignore them will pay the dearest cost.

(The Boondock Saints)

[16] Immanuel Kant, *Critique of Practical Reason*, 5.161.33–6. See Martin Schön-feld and Michael Thompson, "Kant's Philosophical Development", *The Stanford Encyclopedia of Philosophy*, Winter 2019, ed. Edward N. Zalta, https://plato.stanford.edu/archives/win2019/entries/kant-development.

[17] Peter Kreeft and Ronald Tacelli, *Handbook of Christian Apologetics: Hundreds of Answers to Crucial Questions* (Downers Grove, IL: IVP Academic, 1994), 81.

All people seem to know deep down that some things are right and some things are wrong. Another way to say this is that all people recognize some sort of *moral law*. By moral law we mean a law that describes what people *should* do, not what they *actually* do. If we based our moral codes on what people actually did, we would be in trouble! Yet even people who claim that morality is simply based on our own desires believe that some things are truly wrong. This universal knowledge of right and wrong suggests that there is a higher moral law than just our individual desires.

Some people think this moral code originates with and is limited to society or religion. But the fact that different societies can legitimately judge one another (in the way the Nazis were judged at the Nuremberg trials) is just one piece of evidence to the contrary. Neither society nor geographical borders nor religions preferences overthrow mankind's basic moral awareness and sense of obligation to do the right thing.

So where do we get these ideas? On the basis of our experience, we know that laws require lawgivers. If, as the Bible says, our moral awareness comes from an ultimate Lawgiver,[18] we would expect to find exactly what we observe—a moral code that is universal for all mankind.

Atheism, on the other hand, can provide no higher basis for morality. Because there is no higher authority than mankind, each person becomes his own standard of morality. All that is left is to see which person or persons become the most powerful. Hitler took this idea seriously and almost spread his evil through the entire world. Karl Marx, the father of Communism, discarded religion for Darwinian evolution, and his disciple Joseph Stalin caused eighteen million deaths. Another thirty million people

[18] Rom 2:12–16.

were killed under Chairman Mao, yet another follower of atheistic Communism. The twentieth century saw 188 million people killed (up from forty million in the nineteenth century—a 470 percent increase). Clearly, these ideas have consequences.

When we try to base morality on mankind, we end up with no objective standard by which to judge between good and evil. Only in a world with objective morals can anyone really claim to be morally right or to judge another person's actions as morally wrong.[19] Where there is no lawgiver, there is only survival of the fittest.

If the consequences of ideas can be this far reaching, then it makes sense to expect good reasons for holding them. When we try to base man's morality on mankind, we end up with nothing to judge between good and evil men. If there is a movie that exactly demonstrates the moral bankruptcy of a culture that has given up on higher law, Se7en (1995) is it. The movie sets us up for a serial-killing monster who performs unspeakable crimes against his victims. But, as the older and wiser detective in the film predicts, in the end we get only a man. The killer's actions seem to be inhumane and insane, but the relativist has no answer as to whether or not this is truly the case. As the detectives question the killer ("John Doe") about his motives, they find the killer's rationale more difficult to argue against than they first thought. They are unable to get anywhere with him. Consider Doe's responses to the idea that he killed innocent people:

JOHN DOE
Innocent? Is that supposed to be
funny? An obese man, a disgusting

[19] For more on the moral argument see J. Budziszewski, *Written on the Heart: The Case for Natural Law* (Downers Grove, IL: InterVarsity Press, 1997).

man who could barely stand up ...
A man who if you saw him on the
street, you'd point him out to your
friends so that they could join you
in mocking him. A man who if you
saw him while you were eating, you
wouldn't be able to finish your meal.
And after him I picked the law-
yer. And, you both must have been
secretly thanking me for that one.
This is a man who dedicated his
life to making money by lying with
every breath that he could muster
to keeping murderers and rapists on
the streets ... a woman so ugly
on the inside that she couldn't bear
to go on living if she couldn't be
beautiful on the outside. A drug
dealer—a drug dealing pederast,
actually. And let's not forget the
disease spreading whore. Only in a
world this shitty could you even
try to say these were innocent peo-
ple and keep a straight face. But
that's the point. We see a deadly
sin on every street corner, and in
every home. And we tolerate it.
We tolerate it because it's com-
mon, trivial, we tolerate it morn-
ing, noon and night.... Well, not
anymore.

(*Se7en*)

Detective Mills assumes that his own moral feelings are
sufficient to condemn Doe's evil actions, yet the killer turns
the table on his every argument. At the film's climax, one

of the most powerful in recent film history, Doe is right about one thing: with no moral code beyond their own feelings, people may do anything they feel is right. Only in a world with objective morals can anyone really claim to be morally right or to judge another person's actions to be morally wrong.

Atheism has led to some of history's most horrible atrocities. This is unsurprising—for without God there is no ultimate basis for morality above that of each individual person. (Of course, most atheists are moral anyway—but they have difficulty explaining, beyond practical reasons, why they *should* be.) While this problem does not by itself disprove atheism, it argues strongly against it.

> KANE
> I just think about sickness, can-
> cer in children, earthquakes, war,
> painful death. Death, just death.
> If these things are just part of
> our natural environment, why do we
> think of them as evil? Why do they
> horrify us so? Unless we were meant
> for someplace else.
>
> (*The Ninth Configuration*)

If God does not exist, we are merely cosmic aberrations, of no eternal value, who lack any significant purpose. If we are the ultimate beings, then all that makes sense is selfishness. Children are taught in school that they are just animals, and then we are surprised when they act like animals. The cover of the *Time* magazine issue that covered the 1999 killings at Columbine High School featured the one-word question on everyone's minds: "Why?" The more difficult question to answer given today's atheistic assumptions is "Why not?"

The Problem of Evil

It is important to note that there is a flip side to the argument from morality: the problem of evil. The Greek philosopher Epicurus is credited with posing the following riddle: "Is God willing to prevent evil, but not able? Then he is not omnipotent. Is he able, but not willing? Then he is malevolent. Is he both able and willing? Then whence cometh evil? Is he neither able nor willing? Then why call him God?"[20]

> KANE
>
> Maybe God cannot interfere in our affairs.
>
> CUTSHAW
>
> So I noticed.
>
> KANE
>
> Maybe He can't because to do so will spoil his plans for the future. Some evolution of man and the world that's so unthinkably beautiful that it's worth all the pain of every suffering thing that ever lived.
>
> CUTSHAW
>
> I say it's spinach and to hell with it.
>
> KANE
>
> You're convinced that God is dead because there's evil in the world.
>
> CUTSHAW
>
> Correct.

[20] Cited in David Hume, *Dialogues Concerning Natural Religion* (Indianapolis: Bobbs-Merrill, 1980), 198.

KANE
Then why don't you think He's alive
because of the goodness in the
world?

(*The Ninth Configuration*)

Hollywood is no stranger to the problem of evil. *The Ninth Configuration* (1980)—William Peter Blatty's follow-up to *The Exorcist*—dealt heavily with the existence of God and the problem of evil. *Amadeus* (1984), which won the Oscar for best picture, tells the story of the composer Salieri—a man so devoted to God that he makes a vow of celibacy to become a great composer, yet loses his faith (and his sanity) when an immoral scoundrel (Mozart) outshines him with seemingly supernatural musical gifts. In the film *Signs* (2002), a fallen-away Episcopalian priest loses his faith in God after his wife is killed in a traffic accident. The seeming randomness of the event convinces him that life has no ultimate meaning and that "there is no one watching out for us. We are all on our own." *The Tree of Life* (2011) presents a modern take on the biblical story of Job when a family loses their young son. An independent film made in 2013 was even titled *The Problem of Evil*.

Shadowlands (1993) is one of the few film-length treatments of the problem of evil. It follows author and professor C.S. Lewis (known as "Jack" to his friends) through the loss of his wife, Joy, and is based on Lewis' own writings—most notably, *A Grief Observed*. In one scene, Lewis' colleagues attempt to comfort him with "standard" words of consolation, which he rejects:

PRIEST
Only God knows why these things
have to happen, Jack.

JACK
God knows but does God care?

PRIEST
Of course. We see so little here.
We're not the creator.

JACK
We're the creatures, aren't we? We're
the rats in the cosmic laboratory.
I've no doubt the experiment is
for our own good, but it still
makes God the vivisectionist,
doesn't it? No. It won't do. It's
this bloody awful mess and that's
all there is to it.

(*Shadowlands*)

This despair, coming from a noted Christian, is oddly refreshing. Unlike the protagonists in many faith-based movies, Lewis is not painted as a pious suffering saint but as a real man reacting the way most men would. However, unlike most Hollywood fare, *Shadowlands* offers Lewis' thoughtful response to evil in the world, although he struggles with it later, after the death of his wife:

JACK
Isn't God supposed to be good? Isn't
He supposed to love us? Does God
want us to suffer? What if the answer
to that question is yes? See, I'm
not sure that God particularly
wants us to be happy. I think He
wants us to be able to love and be
loved. He wants us to grow up. I
suggest to you that it is because

```
God loves us that He makes us the
gift of suffering. To put it another
way, pain is God's megaphone to
rouse a deaf world. You see, we are
like blocks of stone out of which
the sculptor carves the forms of
men. The blows of His chisel, which
hurt us so much are what make us
perfect.
```

(*Shadowlands*)

Philosopher Alvin Plantinga is often credited with suffi-ciently answering the problem of evil (in its purely logical form, anyway) by arguing that human free will is of such value that it outweighs all the evil that results. In popular form, the argument is that God could only end evil by making robots that were not free to love—and the risk of evil was deemed worth it. Critics point out that the actual magnitude of evil is not justified, though, because freedom does not necessarily entail evil and God could certainly allow human freedom even while reducing the worst evils. Further, much suffering is not even caused by human choices in the first place (disease, natural disasters). Finally, even if this "free will defense" were rescued from these criticisms, it does not seem to speak sufficiently to the deeper, emotional side of suffering. Telling distraught parents that it is better that their child was allowed to be murdered than to violate the murderer's free will hardly seems sufficient.

After surveying a number of other responses, another philosopher, Eleonore Stump, argues that the problem of evil simply cannot be resolved by philosophy alone. In fact, it cannot be answered by most religions, either. Rather, she argues that only a specifically Christian solution is

possible.[21] What Christianity adds to "mere theism" is the entire story of mankind's fall into sin and God's loving offer of salvation. This gospel message explains both the origin of evil as a result of sin and evil's continued existence as a pointer to a world worth suffering for (heaven) and away from a world that can never truly satisfy (Earth). Without the continued presence of evil, many could easily accept this world as "good enough" and miss out on eternal life (not to mention potentially suffering for eternity in hell).

This big-picture perspective can make sense out of even allegedly useless suffering—for enduring a hundred years of pain is worth the infinite joy some would not attain without it. The Church teaches that no suffering need be useless if the sufferer is able and willing to offer it up to God by joining that suffering to Christ's for his own salvation and the salvation of the world. Saint Paul states in his epistle to the Colossians, "I rejoice in my sufferings for your sake, and in my flesh I complete what is lacking in Christ's afflictions for the sake of his body, that is, the Church" (Col 1:24). Paul is not saying that Jesus' suffering is not enough to accomplish its work, but rather that because Christians are his body, they share in Christ's redemptive work by uniting their suffering to his.

The atheist who rejects God because of the problem of evil only adds to it by making suffering ultimately meaningless. While there are other explanations for God's allowance of evil (e.g., character-building or its usefulness as a moral deterrent), and no "resolution" will provide emotional satisfaction to the sufferers, it seems that only a uniquely Christian view can adequately address the problem of evil.

[21] Eleonore Stump, "The Problem of Evil", *Faith and Philosophy* 2, no. 4 (October 1985): 392–423.

From Desire for the Transcendent
to the Transcendent God

```
          KNIGHT
I want knowledge, not faith, not
suppositions, but knowledge. I want
God to stretch out His hand towards
me, reveal Himself and speak to me.

          DEATH
But He remains silent.

          KNIGHT
I call out to Him in the dark, but
no one seems to be there.

          DEATH
Perhaps no one is there.

          KNIGHT
Then life is an outrageous horror.
No one can live in the face of death,
knowing that all is nothingness.

              (The Seventh Seal)
```

Human beings have a natural desire that never seems to be satisfied by the things of this world. Of course, when we feel hunger, we can be satisfied with food. When we desire to breathe, we can be satisfied with oxygen. But we also want more than what this life offers. They desire transcendence. This is true in every culture. Somewhere deep down, all people desire to know that "there is more to life than this." To put this another way, mankind is inherently religious.

We find a sense of significance in ourselves and our lives that requires this transcendence. Not only can atheism not provide an objective standard for morality, it leaves us

with no hope and no ultimate meaning for life. Nothing we do would have eternal significance if our existence simply ceased at death. It may take billions of years for all people to die, but eventually nothing anyone has ever done would matter. The best explanation for this desire is that transcendence and everlasting meaning exists. As C. S. Lewis said, "If I find in myself a desire which no experience in this world can satisfy, the most probable explanation is that I was made for another world."[22] This other world must be without end and must reflect the values of actions taken in our previous life if our actions are to have true significance. If our existence truly ends at death, then ultimately nothing will matter.

> ROY BATTY
> All those moments will be lost in
> time, like tears in rain.
>
> (*Bladerunner*)

Now, someone may look for transcendence in the wrong place, but at least he knows to look. The testimony of atheists who have convinced themselves that there is nothing else beyond the physical world is revealing. Atheist philosopher Bertrand Russell lamented, "It is odd, isn't it? I care passionately for this world, and many things and people in it, and yet ... what is it all? There must be something more important, one feels, though I don't believe there is."[23]

If, on the other hand, someone claims that simply getting more of this world will satisfy them, we can easily show that this is untrue. From Solomon, one of the

[22] C. S. Lewis, *Surprised by Joy* (New York: Harvest/Harcourt, 1966), 120.

[23] As quoted in Martin Gardner, *The Whys of a Philosophical Scrivener*, 2nd ed. (New York: St. Martin's Griffin, 1999), 451.

wealthiest men of antiquity, who said, "All is vanity", to John D. Rockefeller who, when asked how much money was enough, answered, "Just a little bit more", we have the entirety of human experience to show that ultimate satisfaction in this life is impossible. It is up to Christians, then, to show that our ultimate desire can only be fulfilled by an ultimate God.[24]

Coffee Shop Talk: Connecting with *Contact*

After the philosophical discussion group, Renee asked Mike if he would be interested in taking Nita out again, this time on a double date with Renee and her friend Bert.

As it turned out, one of the campus groups Bert belonged to was hosting a movie night. Renee suggested that they begin there and follow up with free coffee at the café afterward. Never one to say no to free coffee, Mike made the call. Nita agreed, and they all met in Bert's dorm.

Bert was a physics major, and he and his colleagues liked to unwind at the end of the school week with a movie. They enjoyed science fiction and other science-related films, because they enjoyed picking them apart after viewing. As Mike, Nita, and Renee entered the room, they overheard someone loudly complaining, "You can't hear explosions in space, and ships can't fly like that!" The rebuke to this critic was immediate and decisive: "The original *Star Wars* still rules, so shut it!"

"Guys, this is Bert," Renee announced to Mike and Nita. It was Bert who had rebuked the *Star Wars* critic.

[24] For more on the argument from desire see Kreeft and Tacelli, *Handbook of Christian Apologetics*, 78–81.

"Good to meet you," said Bert.

"Likewise," said Mike. "Renee told me your group likes to analyze films on the basis of scientific knowledge. Sounds interesting."

"Then you're more than welcome to join us," said Bert.

The movie was *Contact*, a film written by the late atheist astronomer Carl Sagan. Mike had seen it long ago, but he looked forward to watching it again. He knew it took some jabs at religion—and Christianity was not very well represented by the religious character—but in the end, the hard scientist heroine became somewhat softened by her experiences beyond the lab.

When the movie ended, the two couples and a few students headed over to the café, where Renee got them all complimentary drinks. "What did you think of the movie, Mike?" Bert asked when they were all seated.

"Great story," he began, "but I don't think it gave Christianity a fair shot."

Groans followed, but Bert seemed genuinely interested when he asked, "How so?"

"The Christian character was immoral," Bert began, "and too much of a fideist." He threw in this last term to sound a bit more sophisticated, something he assumed the scientists would appreciate. "A fideist," he explained, "is someone who thinks faith is irrational or unable to be proved—so people should just have faith despite any evidence."

"I thought that's just what faith was!" groused one of the science students. "I put my faith in facts!"

"Me too," replied Mike and took a long sip of his coffee. Surprised stares greeted him, so he continued. "Belief in God can be inherited from parents or taken on faith, but I think there are good arguments for God's existence that do not rely on mere hopes."

"Like what?" the first student asked.

"Well, you all agree that the universe has not always existed, right?" Mike asked. Everyone nodded. "OK," he continued, "then what caused it to come into existence?"

"Nothing!" blurted one of the freshmen.

"So it is more scientific to think the universe came into being by nothing than by something? Where else in science are there effects without causes?" Mike asked.

"Nothing cannot cause something," Bert said. "But here's your problem: You're going to say God caused the universe. So, what caused God?"

"Nothing caused God," Mike answered, and before the freshman could object, he added, "God is uncaused. He simply exists."

"You can't just say 'the universe needs a cause, so my God exists,'" said Bert. "Why couldn't it be two gods, or the Muslim God?"

"At this point, I'm only arguing that God exists not that my religion's version of him is the truest. That has to be decided on other grounds. But your issue seems to be whether or not God exists at all."

Bert nodded and said, "Fair enough. But I don't have enough faith to trust in some old man up in heaven that made everything. You'll have to do some major convincing to get me to believe. And leave religion out of it!"

"You have every right to ask for evidence," Mike answered. "Christianity does not ask for blind faith. So, besides religion, what would you suggest as a means of inquiry?"

"Well, scientific proof would be nice." This was followed by nods all around the group. Renee had perked up, and suddenly Nita joined in.

"Science can't say anything about God. Science studies only the physical world. God is not physical."

"That's right, Nita. It is not fair to ask for proof from a method that can't possibly supply it," Mike said. "Bert, remember in *Contact* when Joss asked Ellie if she loved

her dad and then asked her to prove it? She couldn't—at least not in the way she demanded that Joss prove God—because love is not an object of science either. Asking science to provide proof for God is like asking biology to explain why a car won't run." There was laughter at this.

"Then what besides religion can say anything about God?" asked Bert.

"The word *science* used to just mean 'knowledge,'" Mike replied. "Before science became so narrow as to apply only to physical things, it was called philosophy. Philosophy is an acceptable method for investigating God, because it studies all of reality."

"OK, so what does philosophy have to say about God?" Bert asked.

"Let's start with a premise that everyone can agree on: things exist."

"That's a pretty safe starting point!" Bert laughed. "OK, things exist."

"Where did the things that exist today come from?" Mike asked.

"From other things," Bert responded.

Mike nodded and said, "You mean like trees come from nuts?" Bert nodded, waiting for something interesting to be said. Mike took a sip and continued. "And the nuts come from other trees, and so on and so on. Where does it stop—or I should say, where did it start?"

"At the Big Bang singularity," Bert said authoritatively. "At the Big Bang, all matter and energy exploded into being. It separated and cooled, forming galaxies and stars and planets. Science has proven this, so don't try to argue that God made it all in a week!"

"We agreed not to talk about religion, so why are you bringing God into it?" Mike asked seriously, then cracked a smile, and everyone laughed. "Whether the creation story of Genesis is literal or figurative and what the 'creation

week' is describing are debated among Christians. What we do know is 'In the beginning God created the heavens and the earth.' What happened after that, and how long it took, is for another discussion. Right now let's assume this is speaking of the Big Bang—if it wasn't God, then what caused the Big Bang?"

"We know what happened a small fraction of a second afterward, but there are a lot of theories as to how it was caused. Is this where you're going to insert God?"

"Would that be wrong?" Mike asked.

"Yes, it would," Bert explained. "When mankind did not understand lightning or rain, they blamed God for it. Science has not explained everything yet, but I don't want to make the same mistake the cavemen did and stick God into the equation anytime science has not had enough time to figure something out. Like Ellie said in the movie, Occam's razor says that the simplest explanation is the right one. Now that's science."

"Actually, that's philosophy," Mike corrected with a wag of his finger.

"How so?" Bert challenged.

"What scientific experiment can you perform to prove Occam's razor?" Mike asked.

"OK, you got me. But that hardly excuses you sneaking God in where he isn't needed."

"What if something cannot be explained without God?" Mike asked. "Wouldn't Occam's razor demand that God be part of the equation if there were no simpler theory that could explain all the evidence?"

Bert nodded and then added, "But that isn't the case. There are plenty of theories being discussed for how the Big Bang could have happened without God. Advances in quantum physics, string theory, multiverse scenarios ... It is just a matter of time before they figure it out."

"I disagree," Mike said. "Do any of these theories avoid the need for a first cause beyond the natural realm?"

"Well, yeah," Bert answered, "if any of them are true, we don't need God—the universe just exists in some form or another, and that's all there is to it."

"Would that mean that the universe—in some form—has always existed?" Mike asked.

"Yes," Bert answered decisively.

"That's impossible," Mike answered, drawing incredulous looks.

"How so?" Bert asked. "And remember—no appeals to religion!"

"If the universe has always existed," Mike began, "then it has existed for an infinite amount of time. But an infinite cannot also be finite. Since we are here at the end of time, its limit, in other words, the universe cannot have existed for an infinite amount of time."

There was a brief pause as Bert collected his thoughts. "I don't see the problem," he began. "We do equations with infinite numbers all the time, and they work. That's why you have microwaves and computer chips."

"Doing math with symbols for infinity is fine," Mike answered, "but infinite numbers cannot exist in reality. Once they are applied to actual quantities, absurdity results. For example, if you had an actual infinite number of books and you subtracted half of them (say, the odd-numbered ones), you would still have an infinite number (of even-numbered books). So infinity minus infinity is infinity. There are many problems like this, but none of them are at issue in mathematics because that deals with abstraction."

Bert thought about this for a moment. "OK, what if there was a universe before the Big Bang or one in another dimension?"

"Would those universes have existed forever or not?" Mike asked.

"I see," Bert said. "Same problem, right?"

"As far as I can see," Mike answered.

"Wait," Bert said, "why couldn't it cause itself?"

"Nothing can cause itself. It would not have been an 'it' before it existed," Mike explained.

"OK," Bert said, "I see where you're trying to go with this. Something else has to give the whole universe its existence. I suppose you're going to say God did it."

"We agreed not to discuss religion, though," Mike reminded him with a smile, "so let's stick to philosophy for now. If there has to be something that causes all other things to exist, what sort of a being would that be?"

"An old man with a beard up in heaven?" Bert asked. Mike rolled his eyes in good humor and waited for Bert to give a better answer. "Well, it couldn't be just another created thing, so It has to have been around forever."

"We call that 'eternal'," Mike said. "Would it be limited by space?"

"No, I guess not, since space is part of the universe, and it was created, too."

"So, it is unlimited in presence—'omnipresent' in other words," Mike added.

"Yeah, and super powerful and knows everything. This is starting to sound familiar," Bert laughed.

"It should," Mike said, smiling.

"And it just happens to be the God the Bible talks about," Bert teased. "What a shock!"

"I haven't referred to the Bible once in this discussion," Mike reminded him. "But since you insist on bringing up religion in our purely philosophical discussion, I guess I will allow it. You know, the apostle Saint Paul said that God's invisible attributes were made obvious to all

people through his creation. Perhaps this is what he was referring to."

"And I suppose the apostle Paul came up with this argument, too?" asked Bert.

"Actually, Aristotle came pretty close about four hundred years earlier," Mike reflected.

"Well, just because this argument sounds good, that doesn't mean I have to believe in God," concluded Bert, a little too seriously.

"You're right," Mike said, looking him in the eye. "Saint Paul said that too."

Renee suddenly broke in. "OK, enough philosophizing for one night; my head hurts!" Everyone laughed in agreement and started cleaning up after themselves.

On the way out, Nita said, "Mike, I was really proud of you tonight. I never could have done that—stood up to a bunch of science geeks, I mean. I guess you don't just watch movies all day, huh?"

"No," Mike answered her, "sometimes I watch TV."

She hit him in the arm and laughed.

Director's Cut: Connecting with *Contact* (Extended Scene)

"Well, let's start with a premise that everyone can agree upon: Things exist."

"That's a pretty safe starting point!" Bert laughed. "OK, so things exist. So what?"

"Take a dragon. What is the definition of a dragon?"

"How about 'a large, fire-breathing, flying reptile'?"

"Sounds good," Mike responded. "Now, does the fact that there are no dragons currently in existence affect their definition?"

"No," Bert said. "Dragons have the same definition whether they exist or not. In fact, if they didn't have the same definition, we wouldn't know what one was if we saw it."

"Exactly," answered Mike. "So, what dragons are and whether they exist outside our imagination are two different things."

"OK, I think we've established that," laughed Bert.

"Excellent!" Mike said. "You're well on your way to belief in God!" Everyone laughed. Mike grinned.

"I think you skipped a step or two," Bert said wryly.

"Fair enough," Mike replied, "so let's move on. The fact that dragons do not have to exist by definition means existence is not part of their definition—not part of what they are."

Bert pursed his lips. "You're getting a bit too philosophical there, buddy."

"OK, let's try this," Mike said. "What did we say in the definition of dragons regarding their existence?"

"We didn't say anything about it in our definition."

"And why not?"

"Because existence is not part of the definition of a dragon."

"Right," Mike said. "But what would happen if existence were part of a dragon's definition?"

"Then ... dragons would have to exist, I guess," Bert replied.

"Very good," Mike affirmed. "But would adding 'existence' to the definition of dragons actually make them exist?"

"Of course not," Bert said.

"So, you see, then, that we cannot simply define something into existence. For example, I could not define a unicorn as 'a horse with a magic horn in its forehead that exists.'"

"Right," Bert agreed, "because then unicorns would just pop into existence."

"You've got it," Mike answered. "Now let's go back to dragons. Could one come into existence?"

"Technically it's possible," Bert said. "All the biological ingredients already exist. Reptiles can grow to huge proportions, some fly, and there are insects like the Bombardier Beetle that can spit fire. In fact, that was the premise of *Reign of Fire*—a sadly underappreciated film."

"Agreed!" Mike answered. "So, let's say dragons are discovered somewhere—what would that do to their definition?"

"Nothing," Bert answered. "There would just be some."

"OK," Mike continued, gearing up for the big finale. "So—unnecessary things (like dragons) can exist, but they do not have to exist. Therefore, what something is and whether or not that thing exists is not the same thing."

"Is that all we've got so far?" Bert moaned in mock exasperation. "Took us long enough!"

"I am just making sure we don't miss anything," laughed Mike. "Now, if dragons don't exist because of what they are, then if one existed, it would have to be getting its existence from something else—right?"

Bert sensed a trap closing. "Sure ..."

"OK," Mike said, growing excited. "Now, what in the universe exists necessarily—what exists as part of its definition and therefore must exist and cannot not-exist?"

Bert saw where this was going. "You're going to say nothing in the universe is necessary, and so God must be making it exist."

Mike raised his coffee mug in a toast.

"OK, OK," Bert interjected, "but if the universe is everything, and it all began with the Big Bang, then

everything came into existence, so ... so according to you, nothing is necessary!"

Mike waited a moment, then said, "Do you see a problem with that conclusion?"

Bert thought about it. "Well, according to your argument, if things exist that don't have to, then something else has to give them existence, so there must be something else besides the universe that ... is necessary?"

Mike nodded. "Yes, and if there is a necessary thing, it wouldn't have been caused to exist by something else, right?" When Bert agreed, Mike continued: "And therefore?" he asked with his best Monty Python accent, rolling his finger in a "please continue" gesture.

"OK," Bert said, "I see where you're trying to go with this. Something else has to give the whole universe its existence. I suppose you're going to say God did it."[25]

Conclusion

Saint Peter admonished Christians always to be ready with an answer for why they believe, and this conversation illustrates why it is a good idea to have a number of reasons for your faith that can be used in different situations. Intellectuals will probably appreciate a high-level discussion like this one more than an emotional testimony, though one's testimony can be added to, or supported by, such arguments. And Mike could have used other arguments, as well. But I wanted to illustrate how one of the more

[25] This is a popular-level discussion of an argument for the existence of God based on Thomas Aquinas' philosophical work *On Being and Essence*. For a high-level discussion, see Gaven Kerr, *Aquinas's Way to God: The Proof in* De Ente et Essentia (Oxford: Oxford University Press, 2015).

difficult arguments can be presented in an understandable way by asking questions rather than giving a lecture. This also keeps the conversation lively, friendly, and less confrontational. And remember, the discussion began with the shared experience of movie watching.

There is a big difference between belief that something is true and trusting in something as true. Someone might believe that Adolf Hitler was Germany's leader during World War II, but that would not make him a Nazi! Good arguments can help someone believe that something is true, but believing in something is a matter of the will. That is to say, it is up to the Holy Spirit to influence the will by bringing personal conviction of the truth, though he often uses good arguments in the process. Christianity does not require blind faith; it is founded on facts. Shouldn't we be eager to share those facts with those seeking the truth?

Chapter 10

Christianity: Miracle or Mythology?

Source Code

Because Christianity is a religion whose teachings are rooted in verifiable history, attacks against it, including those found in movies, are typically focused on its history, and these attacks must be answered. Below we will consider Christianity from the perspective of its Sacred Scripture and its historical traditions. As we will see, despite the poor representation of the Bible and the Church in many movies, each can be actually be used as some of the strongest evidence that Christianity is true.

Scripture on the Silver Screen

> CORONER
> What is it?
>
> THOMAS
> Twenty-third chapter of St. John's
> Revelations.
>
> CORONER
> And?

THOMAS
There is no twenty-third chapter.

CORONER
Well, maybe this is the Teachers'
Edition.

(*The Prophecy*)

When the Bible is used in movies, it is most often abused. Films commonly misquote references from Scripture or even make them up entirely. One character in the 1995 film *The Prophecy* states, "Years later, of all the gospels I learned in seminary school, a verse from Saint Paul stays with me. It is perhaps the strangest passage in the Bible, in which he writes, 'Even now in heaven there were angels carrying savage weapons.'" It does not take a seminarian to know that there is no such verse in the Bible.

Similarly, when discussing the end of the world in *Ghostbusters* (1984), Ray Stantz cites "Revelations 7:12" concerning the opening of the sixth seal. Unfortunately, this event is recorded in chapter 6, not chapter 7. A more sinister misrepresentation of Scripture takes place in *Pulp Fiction* (1994). Jules, a hit man, likes to recite Scripture to his victims, because "it [is] just a cold-blooded thing to say." He claims he is quoting Ezekiel 25:17, but what he says bears little resemblance to any passage in Ezekiel—or anywhere else in Scripture, for that matter.

To be fair, Hollywood does not always misuse the Bible. In *The Shawshank Redemption* (1994), for instance, Warden Norton correctly identifies a quotation of Mark 13:35, and Andy Dufresne recognizes John 8:12.[1] In *Dead Man Walking* (1995), both the warden and Sister Helen

[1] The Warden's framed needlepoint sampler comes into play more than once. It reads, "His Judgment Cometh, and That Right Soon" (cf. Sir 21:5).

cite relevant Old Testament law during their brief debate over capital punishment.

Whether the Bible is used appropriately or is unintentionally mishandled, the fact is that the use of Scripture in a movie is seldom central to the plot. We should, however, be concerned when Hollywood intentionally undermines the authority of God's Word.

A hallmark of liberal theology is the assumption that the Bible can be full of myths and scientific or historical falsehoods but still be useful for religion. While this is true for most other religions, it is not the case with Christianity. Jesus said in John 3:12, "If I have told you earthly things and you do not believe how can you believe if I tell you heavenly things?" In other words, if we cannot trust Jesus with things we can verify on our own, how can we expect to trust him for things we cannot? Thus, it is important that the Bible is trustworthy in all it says, not just the "religious" parts.

We do, of course, need to be careful to distinguish between what the Bible *says* and how it is *interpreted*. Some Christian groups take such strong stands on their own particular interpretations that they practically equate them to Scripture itself. If those interpretations turn out to be mistaken, Scripture can get the blame. Recognition of metaphor or other literary forms often depend on one's extra-biblical knowledge—and this differs widely from one person to the next. God's natural revelation through science and philosophy cannot ultimately contradict his supernatural revelation through Scripture and tradition, but how the two are to be reconciled is not always immediately clear.

The 2006 film *The Da Vinci Code* calls into question whether the Christian Bible is based on reliable sources by suggesting that the "truth" is contained in alternative

gospels that the Church has tried to cover up for millennia.[2] In order to answer critics who are persuaded by films such as *The Da Vinci Code*, it is important that we know why the Bible can be trusted.

The Bible Is Trustworthy

Below I will show that there is a *chasm* between the Bible and all other religious writings. I use the acronym CHASM as a way to remember the evidence for the Bible. It stands for Copies, History, Archeology, Science, and Miracles. The first four establish that the Bible we have today is *trustworthy*, and the last one shows that it is, somewhat like Jesus, both human and *divine*.

Copies

One common objection to the trustworthiness of the Bible goes like this: because the Bible we have today is a translation of a translation of a translation, we don't really know what the original Bible said. This is simply false. The copy evidence for the Bible is, in a word, astounding. We have more manuscripts, better manuscripts, and earlier manuscripts of the Bible than of any other ancient writing.

In the case of the Old Testament, the oldest Hebrew manuscripts we had access to for many years dated back to about the fourteenth century A.D. For centuries, these were the oldest copies translators had to work with (with the exception of the Septuagint). That all changed in 1948. In that year, shepherds discovered the Dead Sea Scrolls in the

[2] Concerning the numerous falsehoods in the book and the film, see Richard Abanes, *The Truth Behind the Da Vinci Code: A Challenging Response to the Bestselling Novel* (Eugene, OR: Harvest House Publishers, 2004).

caves of Qumran, which dated back to the third century B.C. This amazing discovery included the entire book of Isaiah and thousands of fragments from every Old Testament book except Esther. This gave scholars access to copies one thousand years older than their current manuscripts and verified the incredible accuracy of scribal copying.[3]

When it comes to the New Testament, we can be confident we are reading from accurate sources, because we have so many ancient copies to compare. For many ancient texts there are only a handful of manuscripts in existence. We have only nine or ten good copies of Julius Caesar's *The Gallic Wars*. The best-preserved, nonbiblical ancient writing we have is Homer's *Iliad*, of which there are only 643 copies. Compare these numbers to the New Testament, which is based on nearly six thousand Greek manuscripts plus over nine thousand ancient copies in other languages.[4]

Furthermore, we also have much earlier copies of the Bible than most ancient writings. While some of the earliest copies of nonbiblical writings date to thousands of years later than their originals (Homer's *Odyssey* is unusually good; only five hundred years separate the copies from the original), we have fragments of the New Testament that date to within decades of the events they record. This does not allow enough time for much distortion or myth making.

[3] For the numerous requirements for copying a biblical writing, see Norman Geisler, *The Baker Encyclopedia of Christian Apologetics* (Grand Rapids, MI: Baker Academic, 1998), 550–54.

[4] Christian apologists are fond of claiming that even if all of these copies were lost, we could reconstruct all but eleven verses of the New Testament just by reading the Church Fathers, but this is an urban legend (see Lane, "Getting Dalrymple Right—Applying Due Diligence before Making Our Claims", Existence of God, existenceofgod.org/getting-dalrymple-right-applying-due-diligence/).

Finally, we have more accurate copies of the Bible than of most other ancient texts. Because there are over thirty-six thousand verses in the New Testament, we might expect there to be hundreds of thousands of variations between the many existing manuscripts. Instead, there is a total difference of only about two percent. Very few of these variants affect the meaning of the passage—for instance, manuscripts vary in their use of "Christ", "Jesus Christ", and "Jesus"—and none of these variations affect any area of doctrine.

It seems clear that God preserved his Word as it was copied and transmitted.[5] If skeptics do not find this level of authentication satisfactory, they should be consistent and reject all ancient writings.

History

Although the Bible is itself a collection of historical documents, it would be appropriate to doubt their veracity if no other historical sources verified what it said. It would be reasonable a hundred years from now, for instance, to doubt that the tragic events of September 11, 2001 ever took place if no newspaper or television news stations ever reported on them. However, many historians of the day recorded the same events reported in the New Testament, and most of the Gospels can be reconstructed from non-Christian sources:

Tacitus (first-century Roman historian) makes references to Christians suffering under Pontius Pilate during the reign of Tiberius. He also records a "superstition" relating to the Resurrection of Jesus.

[5] For more on the copy reliability of the Bible, see Paul Barnett, *Is the New Testament Reliable?* (Downers Grove, IL: InterVarsity Press, 2005) and F.F. Bruce, *The New Testament Documents: Are They Reliable?* (Grand Rapids, MI: Eerdmans, 2003).

Suetonius (first-century Roman historian and biographer of the Caesars) records that there was a man named *Chrestus* (or Christ) who lived during the first century. Certain Jews caused disturbances relating to this man.

Flavius Josephus (first-century Jewish historian) refers to James, "the brother of Jesus, who was called Christ". He also wrote:

Now there was about this time Jesus, a wise man; if it be lawful to call him a man. For he was a doer of wonderful works; a teacher of such men as receive the truth with pleasure. He drew over to him both many of the Jews, and many of the Gentiles. He was [the] Christ. And when Pilate, at the suggestion of the principal men among us, had condemned him to the cross; those that loved him at the first did not forsake him. For he appeared to them alive again, the third day: as the divine prophets had foretold these and ten thousand other wonderful things concerning him. And the tribe of Christians, so named from him, are not extinct at this day.[6]

Thallus (first-century Roman historian) discusses darkness and earthquakes that Julius Africanus (third-century historian) says followed Jesus' crucifixion, as described in Luke 23:44–45.

Pliny the Younger (an early second-century Roman senator) describes early Christian worship practices, most notably that early Christians worshiped Jesus as God.

The Talmud (a collection of Jewish Rabbinic teachings and history) confirms Jesus' crucifixion, the timing of the event on the eve of Passover, and records accusations against Jesus of sorcery and apostasy.[7]

[6] *The Genuine Works of Flavius Josephus the Jewish Historian*, trans. William Whiston (1737), 18.3.3.

[7] Geisler, *Baker Encyclopedia*, 381–85.

From these sources alone we can conclude that Jesus lived a virtuous life, performed miracles, and was crucified during Passover in Palestine under Pontius Pilate during the reign of Tiberius, that his disciples believed him to have been miraculously resurrected, and that they worshiped him as God.

Finally, even if all the so-called "doubtful" books in the Bible were removed, historians would still have the same picture of Jesus and the formation of Christianity.[8]

Archeology

History is replete with archeological evidence for the veracity of the Old Testament. It also records many stories of how more recent discoveries have overthrown theories that attacked the Old Testament account. One example is the discovery of the Hittite civilization, first mentioned in Genesis 10:15, in 1906. Similarly, after centuries of scoffing, archeologists confirmed that Daniel had accurately recorded Belshazzar's position as coregent—something only an eyewitness would have known (Dan 5:1-2). Archeologists have even confirmed that the city of Tyre was destroyed by Nebuchadnezzar of Babylon and, later, Alexander the Great, in exactly the way the prophet Ezekiel predicted.[9]

There is similar evidence for the veracity of the New Testament. In fact, the evidence is so strong that it converted

[8] See Gary Habermas, *The Historical Jesus* (Joplin, MO: College Press, 1996) or Gary Habermas and Michael Licona, *The Case for the Resurrection of Jesus* (Grand Rapids, MI: Kregel, 2004).

[9] For good introductions to the topic of biblical archeology, see *The Archeological Study Bible: An Illustrated Walk through Biblical History and Culture*, ed. Walter C. Kaiser Jr. (Grand Rapids, MI: Zondervan, 2005); Josh McDowell, *The New Evidence That Demands a Verdict* (Nashville, TN: Thomas Nelson, 1999), 369–88; Geisler, *Baker Encyclopedia*, 46–52; and *When Skeptics Ask: A Handbook on Christian Evidences* (Grand Rapids, MI: Baker Books, 2008), 179–208.

a skeptic named Sir William Ramsay, who had originally set out to disprove Luke's account in the book of Acts. He was amazed to find that Luke's abilities as a historian were unsurpassed.[10] Similarly, Archeologist William F. Albright gave up his skeptical views on Scripture when he found archeological evidence supporting the literal accuracy of the New Testament.[11] Historian A. N. Sherwin-White concluded that "for Acts, the confirmation of historicity is overwhelming.... Any attempt to reject its basic historicity must now appear absurd."[12]

Science

It may be hard to believe today, but science has long been a friend of the Bible. In fact, many of the greatest scientists of all time have been Bible-believing Christians, including Roger Bacon, Johannes Kepler, Blaise Pascal, Robert Boyle, and Gregor Mendel.[13] Many people today have been confused about the Bible's reliability because of claims that science has disproved what it says. But in fact, science has never proven the Bible incorrect.

There are also several scientifically accurate statements in the Bible that are impressive when one considers when they were written. For instance, the Bible calls the Earth a circle that is suspended in space by nothing (Job 26:7;

[10] See Ramsay, *St. Paul the Traveler and the Roman Citizen* (New York: G.P. Putnam's Sons, 1896), 8.

[11] See "William Albright: Toward a More Conservative View", *Christianity Today*, January 18, 1963, 3–5.

[12] A. N. Sherwin-White, *Roman Society and Roman Law in the New Testament: The Sarum Lectures 1960–1961* (Eugene, OR: Wipf & Stock Publishers, 2004), 189.

[13] See also Dan Graves, *Scientists of Faith: 48 Biographies of Historic Scientists and Their Christian Faith* (Grand Rapids, MI: Kregel, 1996). See also Eric C. Barrett and David Fisher, *Scientists Who Believe: 21 Tell Their Own Stories* (Chicago: Moody Press, 1984).

Is 40:22). Long before a detailed account of chemistry was known, human beings were said to be made up of the basic elements of the Earth (Gen 2:7) and life was in the blood (Gen 9:4; Lev 17:14). The Bible also records invisible attributes of nature such as the movements of the winds (Eccles 1:6) and the cycle of water (Eccles 1:7), and the eventual end of the universe (Ps 102:25–27). While these things may seem obvious today, they were not when these passages were first penned.

One of the biggest issues between the Bible and science today is, of course, the theory of evolution. If taken literally, the story of Genesis does not seem to describe an evolutionary explanation of human origins. However, there are difficulties in any reading of the text, and a non-chronological, topical reading may be preferred.[14] Space does not permit a detailed look at the current debate, but it is important to know that contrary to what Hollywood and most media outlets assume, the issue is far from settled. There are numerous arguments by reputable scientists against the idea that random mutations can account for the complexity and the variety of life forms on Earth, and the Church has never authoritatively come down on one side or the other.[15]

[14] See Pius XII, encyclical letter *Divino Afflante Spiritu* (September 30, 1943), nos. 35–36

[15] The special creation of the first man and woman is a definitive pronouncement of the Church, but not how that creation took place. Although the soul is directly created by God, he may have guided the natural development of suitable material bodies from previous biological forms. We see this in Pius XII's encyclical letter *Humani Generis* (August 12, 1950), no. 36, and in the *Catechism of the Catholic Church*, no. 283. See also Michael Chaberek, *Catholicism and Evolution: A History from Darwin to Pope Francis* (Kettering OH: Angelico Press, 2015); Thomas B. Fowler and Daniel Kuebler, *The Evolution Controversy: A Survey of Competing Theories* (Grand Rapids, MI: Baker, 2007).

Miracles

Perhaps the most important evidence for the truth of the Bible is its inspiration by God. After all, any book can claim divine truth, and simply being historically correct and accurately copied does not indicate divine authorship. There are many books that could pass the tests of historicity and scientific validity. But whether or not the Bible is actually ultimate in its truth does not hinge on these prior proofs. The real confirmation of the Bible's claim to divine truth is in its miracles. These come in several types.

Prophecy

As early as Justin Martyr in the second century, Christian apologists have appealed to fulfilled prophecy as miraculous proof for the truth of Christianity. Blaise Pascal, the brilliant seventeenth-century mathematician, wrote, "I see many contradictory religions, and consequently all false save one. Each wants to be believed on its own authority and threatens unbelievers. I do not therefore believe them. Every one can say this; every one can call himself a prophet. But I see that Christian religion wherein prophecies are fulfilled; and that is what every one cannot do."[16]

God used prophets to proclaim his revelation. Moses himself issued the challenge: "And if you say in your heart, 'How may we know the word which the LORD has not spoken?'—when a prophet speaks in the name of the LORD, if the word does not come to pass or come true, that is a word which the LORD has not spoken; the prophet has spoken it presumptuously" (Deut 18:21–22; cf. Is 41:21–23). Does the Bible contain predictive prophecy to authenticate its message? Yes.

[16]Blaise Pascal, *Pensées* (New York: E. P. Dutton & Co., Inc., 1958), 198.

The book of Daniel predicted the coming of the four great kingdoms from Babylon to Rome. Details concerning how they would rule and fall were recorded centuries before any of those events took place. So precise are these prophecies that even critics agree that Daniel wrote accurately—they simply try to avoid the implication of supernatural involvement by claiming these words are actually evidence that Daniel wrote after the fact.[17]

Ezekiel 26 records in astonishing detail how the city of Tyre was to be destroyed, how it would be torn down, and how its debris would be thrown into the sea. When Alexander the Great marched on that area in 332 B.C, he encountered a group of people holed up in a tower on an island off the coast. Because he could not cross the sea, he could not attack the tower. Rather than wait them out, the proud conqueror had his army throw stones into the sea to build a land bridge to the tower. It worked. His army crossed the sea and overthrew the occupants of the stronghold. But where did he get so much stone? The rocks used for the land bridge were rubble from the city of Tyre. Its stones were cast into the sea exactly as Ezekiel had prophesied centuries earlier.[18]

Furthermore, there are so many prophecies concerning Christ in the Old Testament (over 270) that it would take several pages to list them all. They include the time and place of his birth (Dan 9:25; Mic 5:2) and his ancestry (Gen 49:10). These specifications alone narrow Christ's identity down to only a few possible individuals in all of human history. Prophecies concerning Jesus' death were likewise made centuries in advance, even before crucifixion was developed as a method of execution. These include the

[17] See Ivor C. Fletcher, *Daniel in the Critics' Den*, Vision, Summer 2003, www .vision.org/visionmedia/religion-and-spirituality-daniel-critics-den/1131.aspx.

[18] See John Warry, *Alexander: 334–323 B.C.* (Westport, CT: Praeger, 2005).

piercing of his hands and feet, the piercing of his side, and the casting of lots for his garments.[19] The odds of one man accidentally fulfilling even sixteen of these prophecies have been calculated to be 1 in 10,000,000,000,000,000,000,000,000, 000,000,000,000,000,000,000,000,000 (a *quattuordecillion*)!

Jesus himself made several prophecies. Among the most dramatic were those concerning the fall of Jerusalem and the destruction of the temple (Mt 24; cf. Lk 21). Jesus predicted several specific signs that would precede this event, including that believers would be saved by fleeing the city and that this would all occur within one generation. This was fulfilled in A.D. 70, when the Romans laid siege to the city and burned the temple to its foundation.[20]

The Resurrection of Jesus Christ

Besides numerous healings and nature miracles, Jesus Christ demonstrated his authority and deity primarily through the miracle of his Resurrection. Numerous historical facts surround the Resurrection that most scholars, even skeptical ones, agree are true. Alternate explanations have been put forth to explain away these historical facts, of course. Such theories include claims that Jesus only fainted and merely appeared to die, that someone stole his body, that he was buried in a common graveyard, or that his appearances were hallucinations. None of these, however, can account as well for all the data.

Jesus' death was real. We know from medical science and the nature of crucifixion that the idea that he only fainted

[19] Ps 22:16 (cf. Lk 23:33); Zech 12:10 (cf. Jn 19:34); Ps 22:18 (cf. Jn 19:23–24).

[20] Unfortunately, this exceptional prediction has been obscured by popular prophecy "experts" who see it only as an end-time event. See Douglas Beaumont, "A First Century Fulfillment of The Olivet Discourse?", douglasbeaumont .com/2010/05/05/a-first-century-fulfillment-of-the-olivet-discourse.

is false.[21] Jesus' tomb was found empty—which would not be explained by hallucinations—and his appearances were reported by many people (even his enemies). This rules out the stolen body or common grave theories.[22]

Finally, it is simply historical fact that Jesus' disciples went from hiding in fright to boldly proclaiming the truth of Christianity and dying horrible deaths because they would not recant their message of Jesus' Resurrection. Certainly, some people will die for something false that they believe is true, but no one will die for what he knows is false. Liars don't make good martyrs.

In 1 Corinthians 15:3–8, Saint Paul provides a description and defense of the gospel and Jesus' Resurrection: Jesus was buried (proving that he was dead), was raised (proving that he was who he claimed to be), and appeared to hundreds of people—both believers and skeptics—as proof that it all occurred. Christ's Resurrection is the strongest positive case for the gospel, when it could have been the strongest case against it. If Jesus did not rise, then faith in the gospel is in vain and we might as well "Party on, dude!" for death is all that awaits us.

First Corinthians 15 is one of the earliest writings of the Christian Church, written at a time when the Resurrection was being preached as the reason for Christian hope. For Saint Paul to stake Christianity's truthfulness on Christ's Resurrection at a time when it could have easily been disproved if it were false shows how strong a case there was for it. No other religion binds itself to verifiable evidence in this way.

[21] See William D. Edwards, Wesley J. Gabel, and Floyd E. Hosmer, "On the Physical Death of Jesus Christ", *Journal of the American Medical Association*, 255, no. 11 (March 21, 1986):1455–63.

[22] See Habermas and Licona, *The Case for the Resurrection of Jesus*.

As Saint Peter wrote, "For we did not follow cleverly devised myths when we made known to you the power and coming of our Lord Jesus Christ, but we were eyewitnesses of his majesty" (2 Pet 1:16). The followers of Jesus Christ were not members of some starry-eyed, gullible fan club. They were witnesses to his miracles. Jesus Christ's Resurrection transformed the disciples from timid, scared men into super-missionaries and became the backbone of the gospel message that spread throughout the world. "Therefore, my beloved brethren, be steadfast, immovable" (1 Cor 15:58).

Does Christianity Need the Bible?

Many attacks on Christianity assume that Christianity is relying on the Bible alone for its existence—which certainly seems fair, as many Christians think along the same lines. The two most popular approaches for defending the faith either begin by defending the Bible or conclude with its defense.[23] However, when a skeptic argues against the Bible, it is not usually the book that is being attacked as much as the ideas communicated by the book. (Skeptics do not, for example, typically attack the wisdom sayings in the book of Proverbs or the basic morality of Jesus' sermons in the Gospels.) What skeptics want to call into question is Christianity itself.

When the Bible is assumed to be the foundation of Christianity, calling its historicity, manuscript transmission, scientific accuracy, etc. into question is seen as tantamount to calling Christianity into question. The good news for the Christian is that if Christianity is not coextensive with the Bible, then successful attacks on the latter

[23] The methods known as "evidentialism" and the modern "classical" method respectively.

do not necessarily mean it is "Game over, man!" for the former. Even if we lost the Bible completely, Christianity would remain undefeated.

First, Christianity preceded the Christian Bible. The New Testament writings did not begin until at least a decade after Christ started the Church, yet those who believed were Christians and therefore constituted the Church (see, e.g., 1 Cor 1:2). Second, Christianity continued to exist without most of its members possessing the New Testament. Even when the New Testament began to be written, its contents were not in the possession of the average believer—even literate citizens would have to wait 1,500 years or so before the printing press made Bibles widely accessible. In our own time, people from many parts of the world become Christians when the Bible is forbidden or inaccessible in their own language. Yet Christianity has spread across the globe. It is possible, then, that Christianity's message could have been communicated by word of mouth forever.

Third, suppose some atheistic world dictator had every copy of the Bible destroyed and somehow made it impossible to create any future copies. Would Christianity disappear from the Earth? Of course not. So even if the skeptic were successful in showing the Bible to be untrustworthy, he would not really have gained much ground—at least if he was using that untrustworthiness as an attack on Christianity itself. For even if we give up the entire Bible, Christianity remains.

```
                   SOLARA
     What are you going to do now?

                    ELI
     Same as always. Keep heading west.

                   SOLARA
     Why? I mean, you don't have the
     book any more.
```

ELI
But I still have my faith.

(*The Book of Eli*)

Before the New Testament was canonized, Christianity already existed. Before the New Testament was completed, Christianity already existed. Before the New Testament had even commenced, Christianity already existed. It is therefore both a historical and theoretical fact that Christianity can exist while no Bible exists. But if the Bible is not necessary for Christianity's existence, how would we know what it teaches without it? As it turns out, we can find out pretty much everything necessary from a multitude of extra-biblical historical sources. The Church's teaching can be found in a multitude of early sources such as catechetical instructions like the first-century *Didache*, sermon messages such as First and Second Clement (A.D. 95–97), and epistles like the *Letters of Ignatius* (A.D. 98–117). There are also baptismal confessions like the *Old Roman Creed* from the second and third centuries, Bible commentaries from the same period such as Theophilus' *Diatessaron*, and of course the ecumenical councils, canons, creeds, and definitions completed by the fifth century.[24]

The Argument from the Church

As you can see, proving Christianity and proving Scripture are two different things.[25] Saint Thomas Aquinas argued

[24] At minimum it is clear that the message that brought people into Christianity was from the very beginning that Jesus Christ was the Son of God, that he died, was buried, and rose again (e.g., Acts 2 and 1 Cor 15).

[25] None of the above should be taken to suggest that Christians abandon defense of the Bible. There is no need—for the evidential arguments for the reliability of the Bible are extremely strong. Rather, Christian apologists can

for the Church as the instrument God used to deliver the Bible. Perhaps surprisingly, Aquinas does not merely argue that miracles support the Church; he asserts that the Church itself is a miraculous confirmation of Christianity.

You see, even if we gave in to the skeptics' arguments concerning the Resurrection, they would then have to deal with historical facts that would now be even *more* difficult to explain. The very existence and success of the Church given its initial conditions seems miraculous—especially if the Resurrection did not occur! As Thomas Aquinas pointed out, "Either this was miraculous or not. If so, then the point is granted; if not, then I ask, what greater miracle than to convert so many without miracles?"[26]

Why should the existence of the Church be considered so miraculous? To quote Aquinas again:

> This so wonderful conversion of the world to the Christian faith is so certain a sign of past miracles, that they need no further reiteration, since they appear evidently in their effects. It would be more wonderful than all other miracles, if without miraculous signs the world had been induced by simple and low-born men to believe truths so arduous, to do works so difficult, to hope for reward so high.[27]

The Church's origin appears miraculous whether one takes the side of proven history or modern skeptics. It was founded on miraculous claims, and many people died for

benefit from a shift in apologetic focus: defending the entity that produced the Bible. This approach opens the door to even more clear, available, and accepted evidences and sidesteps issues of biblical transmission, inspiration, inerrancy, or infallibility.

[26] Thomas Aquinas, *Exposition of the Apostle's Creed*, prologue, in *Collected Works of Thomas Aquinas* (Hastings: Delphi Classics, 2000).

[27] Thomas Aquinas, *Summa Contra Gentiles* 1.6.

refusing to disavow the miracles they had experienced. The Church's birth, therefore, is harder to explain without miracles, because "there could not be a greater miracle than that the whole world should have been converted without miracles."[28]

Finally, as Aquinas points out, although not strictly necessary, "it is also a fact that, even in our own time, God does not cease to work miracles through His saints for the confirmation of the faith."[29] Even after its foundation, Christianity remained a religion of miracles.[30]

Coffee Shop Talk: Debating *The Da Vinci Code*

Nita and Mike continued dating throughout the semester. Renee and Bert were also growing quite close, and the two couples often went out together. When the semester finally drew to a close, the four friends were in their favorite corner of Café Veritas celebrating the coming break and spending the money they had made selling their old textbooks.

"Well, you two have become quite the little couple," Renee said, grinning at Mike and Nita. "After that first date, I thought you'd never make it!"

"Well," said Mike, "she finally wore me down." This brought laughter and knowing glances between the girls.

"Does this mean the relationship will last beyond the confines of fall semester?" Renee asked.

"Give them a break," Bert said. "It is not like they're going to get married or anything." At this, Mike and Nita

[28] Thomas Aquinas, *Exposition of the Apostle's Creed*.

[29] Thomas Aquinas, *Summa Contra Gentiles* 1.6.1.

[30] See Craig Keener, *Miracles: The Credibility of the New Testament Accounts* (Grand Rapids, MI: Baker Academic, 2011).

both tried to hide grins, but they did not escape Bert's notice. "Right?" he asked.

"Well ..." Nita began.

"Wait, what?" exclaimed Renee. "You had better not have gotten engaged without telling us!"

"No, no. Nothing like that," explained Nita. "But ... I won't say we haven't been talking about it." She squeezed closer to Mike.

"Get a room," Bert said happily. He turned toward Renee and raised his eyebrows.

"Don't even think about it, buddy," she said menacingly. "Speaking of marriages, Bert and I watched *The Da Vinci Code* this weekend." Renee smiled, knowing this was unlikely to be one of Mike's favorite movies.

Mike groaned inwardly. He had dealt with questions related to the *Da Vinci Code* for months after the book had become such a huge seller. He had read the book and actually enjoyed it, for the most part. But he knew the controversial material was what Renee was interested in discussing. Although he wished the ridiculous premises of the film were long forgotten by now, he decided to go with the flow and asked, "What did you think?"

"We both liked the book better, but the movie was fun," Renee answered for both of them. "One interesting thing, though—in the book the hero, Langdon, and the historian, Teabing, are completely in agreement with one another, and we are never given even a taste of contrary evidence or opposing theories. In the movie, however, Langdon is somewhat skeptical of the whole Grail legend. Further, Teabing is not portrayed as a master historian in the movie, but more of an eccentric old rich guy. At the end of the film, however, there's this dramatic conversion experience with Langdon kneeling before Mary Magdalene's tomb."

"Yeah, I appreciated that," Mike replied. "But it still bothered me that it allegedly presented facts that 'would devastate the very foundations of Christianity', Christianity was not founded on Jesus' celibacy but on his Resurrection! His disciples didn't die as martyrs because Jesus was single, but because he performed miracles! In fact, the very existence of the Church doesn't even make sense without them—"

Mike was about to launch into a sermon but was interrupted. "It was just a movie, Mike," Bert said, adding with his best Heath Ledger impersonation, "Why so serious?"

Mike reluctantly smiled and nodded with a sigh. He was only somewhat surprised to be hearing such objections after all this time. "Well, the problem is that although *The Da Vinci Code* story is put forth as fictional, the author claims its background is historical. People ignorant of the subject matter do not realize that the background is also fictional. The stuff the author puts forth as fact is a joke; virtually nothing in Brown's conspiracy theory is taken seriously by serious scholars, not even those at UC Berkeley."

"Like what, Mike?" asked Renee.

"Like the idea that the Bible has evolved through time and been selectively modified by the Church and corrupted by countless translations, additions, and revisions," Mike began. "This subject has been covered so comprehensively that Brown's misrepresentation of the facts is inexcusable. Knowledgeable textual critics would never make such assertions."

The others looked on, expecting more. So Mike delivered. "The trustworthiness of the Bible we have is so impressive that if we throw it out, we should be consistent and throw out all of ancient history—for none of it is recorded with more accuracy and multiplicity than the

Bible. When you look at the manuscripts, historical evidence, archeology—"

Bert interrupted before Mike could continue. "What about all the other gospels that were considered for the New Testament before it was finally collected by Constantine?" asked Bert.

"Complete fiction," answered Mike. "There were very few books of the New Testament that were involved in any dispute. The Church incorporated them in its worship very early on. The exact contents—what we call the canon—was not an issue until heretics began removing books from the accepted collection."

"What was Constantine's role?" asked Renee. "Brown makes it sound like Constantine basically invented the Church and made Christianity the religion of the empire."

"Well," Mike began, trying to remember the exact order of historical events. "Major Church councils could not occur before Christian persecution ended. It was Constantine who made Christianity legal, and he called on the Church to have a universal—what we call ecumenical—council to settle some doctrinal disputes although he had nothing to do with their outcomes. Now, this was at the Council of Nicaea in A.D. 325—fifty-five years before Emperor Theodosius I declared Christianity the state religion."

"So, the Bible's contents were decided at the Council of Nicaea?" Bert asked.

"No," Mike answered. "It wasn't even part of the discussion. The first council that officially laid out the biblical canon was at Rome years later—after Christianity became the state religion. More importantly though, the selection process The Da Vinci Code alludes to is complete fiction. Brown makes it sound like there were all these comparable writings lying around, and a few men simply picked their favorites."

"Does that include the Gnostic writings?" Bert asked. "Weren't they the closest competition?"

"Not really," Mike began, his memory now fully jogged, "although there was near universal acceptance of the four canonical Gospels—Matthew, Mark, Luke, and John—by the middle of the second century. This was long before the so-called Gnostic gospels had even been written and distributed. They weren't even on the table for consideration, much less as competition. But even if they had been, the character of the Gnostic writings is bizarrely off from the true Gospels; they wouldn't have stood a chance. In fact, *The Da Vinci Code* makes no mention of the most famous Gnostic writing, *The Gospel of Thomas*. There's a good reason for that: it ends with an admonition that women must become male in order to find salvation! Needless to say, this would not fit Brown's agenda of promoting the 'feminine divine'."

"Phew! Someone's been doing some studying!" Renee said, surprised and impressed with Mike's knowledge of the subject. Brown had seemed so convincing until now.

They all laughed, and then Mike continued. "The same goes for *The Da Vinci Code* claims regarding Jesus. Jesus' claims to deity, and his supernatural activity to prove those claims, are recorded in the earliest and best documents about his life. In fact, the earliest heresies were those that made Jesus out to be *merely* God! Nor was Christ's divinity a 'close call', as *The Da Vinci Code* states. Getting back to the Nicene Council, only two out of three hundred bishops did not sign the statement affirming the full divinity of Christ."

"OK, OK, we get it," Bert laughed.

"Just wait til I get going!" Mike said in an odd voice. Everyone laughed except Bert, who looked perplexed.

"It is from *The Princess Bride*, you cultural ignoramus," Renee scolded him.

"Correct," Mike replied, then continued. "And speaking of brides and 'mawwiage', Brown's belief that Jesus having a child would 'bring the church to its knees' betrays a serious misunderstanding regarding Jesus' nature—or rather, *natures*. There is no problem in affirming that Jesus, a complete human being, could procreate. Doing so would likely have caused practical problems, but it would in no way threaten his divine nature any more than his rising from the dead threatened his human nature."

"So, what about Jesus' 'mawwiage' to Mary Magdalene then?" Renee asked, winking at Nita, who just smiled and shook her head.

Mike rolled his eyes dramatically and laughed. "Yeah, about that. This is another area where *The Da Vinci Code* goes seriously wrong. Nothing in the New Testament or any other 'gospel' asserts that Jesus was married. *The Da Vinci Code* is committing the classic logical fallacy of arguing from ignorance. We should not affirm something as proved simply because it is not specifically denied. Mary Magdalene is never mentioned in Scripture with reference to any husband, much less Jesus! Jewish prophets and priests could be married, so it would not have caused any scandal—so why wouldn't Jesus' closest friends ever mention his wife or children?"

"But the book says that the royal bloodline of Jesus Christ has been established by scores of historians," Bert said. "That must make it true." He grinned, knowing that this was probably not the case.

Mike groaned. "There were only four sources listed in the book, and not one of them had an academic degree in history."

"Seriously?" Bert blurted, then unleashed the classic Bill Paxton whine, "It's game over, man!" Everyone laughed and started clearing their tables. That was enough for one night.

Renee expertly tossed a crumpled napkin into a nearby recycle bin. "Well, I enjoyed it, even if it is fictional."

At this, Nita chimed in. "Sure, everyone loves a good conspiracy theory, but *The Da Vinci Code* makes for a bigger problem. Too many people are forming their opinions about art, history, Jesus, and Christianity based on this novel. Faulty history and silly opinions about art are one thing, but lies about Jesus Christ are another."

Conclusion

As we have seen in the last few chapters, there are many popular movies that not only call Christianity into question, but also undermine foundational truths that Christianity is built upon. If the *Da Vinci Code* is correct, then history is basically a lie that has been used to control us rather than elegant testimony to the Christian faith. If *Contact* is accurate, we should be looking to find alien life on another planet rather than attain eternal life with God. And if *The Matrix* really(!) reflects reality, then truth is not—and cannot be—known for certain regardless of what evidence we may have at our disposal.

However, we can show philosophically that reality can be known and that it reveals a single, omnipotent, creator God, who verified his revelation with historically verifiable miracles. Because the means to communicate with human beings are reproducible by mere humans, God chose to confirm their divine origin with acts that no mere human could counterfeit—miracles. These "motives of credibility" do not force belief, however (e.g., Lk 16:31 or Jn 12:37). Rather, they give people the intellectual freedom to choose the faith without requiring blind consent.

Christianity, unlike most other religions, makes claims that are testable. Rather than reducing to a collection of

proverbs or a life philosophy, Christianity is rooted in historical events. Take away a sitting Buddha, and you can still have Buddhism. But take away a risen Christ, and Christianity is a sham (1 Cor 15:13–19). How many other religions open themselves up to this kind of investigation?

ACT THREE

APPLAUDING OR AVOIDING

Chapter 11

What Should We Then Watch?

Christians at the Movies

As has been mentioned throughout this book, not every movie is appropriate for every viewer. It is one thing to deem a movie "good" by objective cinematic standards. It takes different criteria to determine whether you should watch a given movie yourself or recommend it to your friends and family.

Ultimately, that decision is a personal one. Nevertheless, Christians often feel a great deal of pressure from one another regarding how they choose their entertainment. As we near the book's end, I would like to discuss some principles regarding the Christian's relationship with movie viewing in general that can be applied to choosing which movies to watch in particular.

Christian Entertainment Standards

Some people think that Christianity is against having fun. While Scripture does warn against seeking pleasure just to avoid more important things in life (Jer 15:17; Jas 4:8–10), one of the wisest people in the world, King Solomon, said that having fun once in a while is good for easing the strain

of a life of hard work (Eccles 8:15). Movies can provide enjoyable entertainment, but they can also distract us from more important things. So first we must make sure we have our priorities straight.

While we may watch movies for a variety of reasons, when watching movies for entertainment, we should seek movies whose enjoyment is glorifying to God (1 Cor 10:31). Because we are affected by what we see and hear, we need to be sure that our entertainment will not lead us or others into temptation (1 Cor 9; 10:23).

What constitutes a good movie choice? Philippians 4:8 lists several considerations that can help safeguard your choices: "Whatever is true, whatever is honorable, whatever is just, whatever is pure, whatever is lovely, whatever is gracious, if there is any excellence, if there is anything worthy of praise, think about these things." Because movies have such a strong impact on us (if they didn't, we wouldn't watch them!), we need to be careful that we do not set ourselves up to dwell on things that can lead us away from God.

"In" but Not "of" the World

In biblical terminology, "the world" often refers neither to planet Earth nor to its human population. Instead, in the context of being a disciple of Jesus, "the world" sometimes connotes the opposition to God that surrounds us. Jesus says Christians are no longer *of* this world, but we are to remain *in* it (Jn 17:6–20). We are to be set apart. Does that mean we should restrict ourselves to participating only in "Christian" groups and activities, attending only "Christian" movies, or listening only to "Christian" music? Certainly not. Just as Jesus was sent into the world but was

never "of it" so he sends us out to be in the world but not "of it". How Jesus lived his life while in the world is our model. As we discover from Jesus' example, there is an important difference between doing the good and ordinary things that people do in the world and sinning.

When trying to determine whether a certain behavior is sinful, it does us no good simply to point out that "the world does it." The world uses ballpoint pens, breathes air, and wears jeans. So may we. The question we must ask ourselves is whether we are conforming ourselves to Christ or, put another way, being transformed by Christ, as we go about our daily lives. As Saint Paul said, "Do not be conformed to this world but be transformed by the renewal of your mind, that you may prove what is the will of God, what is good and acceptable and perfect" (Rom 12:2). We need to be honest about ourselves, about the things that lead us away from Christ and the things that draw us closer to him. We must know our limits and the areas in which we struggle and make our choices accordingly.

I would advise you to check a movie's reviews before making plans to watch it, either alone or with others. There is nothing wrong with following your conscience; in fact you are morally obligated to do so. If you're not comfortable with a film, don't see it. But don't judge harshly those who do. Remember that not everyone shares your struggles. If you think a film is objectively evil, and therefore no one should watch it, be prepared to discuss your reasons for thinking that. They too should be objective

Abstaining from Every Form of Evil

Saint Paul writes in 1 Thessalonians 5:22 that we are to "abstain from every form of evil." This might seem to

include the evil portrayed or communicated by movies. However, both Jesus and Saint Paul provide examples of how someone can participate in culturally questionable activities without sinning. Jesus was known for irritating the religious establishment by hanging out with the "wrong crowd" and breaking man-made rules, yet he never sinned.[1] Saint Paul became all things to all men, meaning that he changed his behavior in ways that would help him best fit in with those to whom he was witnessing (1 Cor 9:22). He adapted to the culture as much as possible without overstepping Christian morality (e.g., Acts 16:3; cf. 1 Cor 7:18–19). Both Jesus and Saint Paul were free to act as they thought best when they were dealing with nonmoral issues.

What does this have to do with movie watching? Because many movies portray sinful actions, some Christians have been taught that movie viewing is evil—period. Yet to avoid all movies because of the bad ones is difficult to justify. The verse just before "abstain from every form of evil" actually says to "test everything; hold fast what is good." How can we do so by complete avoidance? Finally, while we want to avoid causing scandal or stumbling (see below), we are not responsible for how others judge our motives when we perform actions that are not sinful.

Stronger and Weaker Christians

There is also a lot of confusion in the Christian subculture regarding those whom the apostle Saint Paul refers to as "strong" and "weak" believers.[2] Christians often view

[1] Mt 12, 15; Mk 2; Lk 5:27–32, 7:36–50, 15:1–10, 19:1–10; Jn 12:1–7; 1 Pet 2:22.

[2] Rom 14 and 1 Cor 8–10.

more conservative believers as stronger—or at least more spiritual—but the opposite is often the case. Saint Paul defines the stronger believer as the one who rightly judges activities as moral (and thus desirable), immoral (and thus to be avoided), or nonmoral (and therefore matters of freedom). The weaker believer often puts nonmoral things into the "immoral" category.

When Saint Paul wrote his first letter to the Corinthians, Christians there were struggling to understand how to think about eating food that had been sacrificed to idols. Some correctly believed it was permissible to eat such food because "an idol is nothing" and could not, therefore, actually do anything to the food. Saint Paul describes those who believed that the food had become evil somehow as suffering from weak consciences due to ignorance. They thought they knew the truth of the situation but did not yet know to the degree that they needed to know. Saint Paul indicated that this situation was technically a nonmoral issue, for the people would be no better if they did not eat and no worse if they did. In other words, the weaker, more "conservative" believers were mistaken. They were more conservative only in the sense that they participated in fewer activities, not because they were less sinful.

Several problems can arise from confusion over this issue. First, the weaker believer may become judgmental of others, either stronger believers or unbelievers, who behave in ways that they wrongly consider to be immoral. Conversely, the strong believer may judge the weaker for his naïveté. Yet the stronger brother is not right for judging the weaker even though the weaker brother is in error, and the weaker is not right (or more spiritual) when he judges the stronger for his liberty. In nonmoral matters, both are accountable to God alone.

Another possibility is that the stronger believer may cause the weaker to stumble because of his actions.[3] "Stumbling" is another term that is often misunderstood. Strong believers are those who "possess knowledge" that has cleared their conscience and given them the liberty to act accordingly. A stumbling problem arises if a weaker believer sees the stronger acting in a way that the weaker mistakenly believes is sinful and decides to participate in the behavior solely on the basis of the stronger believer's actions. Saint Paul says that it is sinful for the weaker Christian to act against his conscience. For this reason, he commands the stronger believer not to behave in a way that will cause weaker believers to stumble in their actions.

What this means is that just because one believer does not like what another is doing, that person is not necessarily in danger of stumbling. There will always be people who have issues with nearly every action, so the only way to solve every potential stumbling problem would be to stop doing anything! After all, Jesus drank wine and John the Baptist did not, yet they were both accused of sin (Lk 7:33-35). Rather, true stumbling is knowingly causing weaker believers to act against their consciences even though what they are doing is not sinful in itself.

Furthermore, stronger believers are not expected to pretend that they agree with weaker believers, nor are they to affirm them in their error. Saint Paul says the stronger should not allow the weaker to speak evil of that which is not evil. He simply instructs them not to partake in the behavior in question in front of the weaker person, if it might cause them to join in and go against their conscience. But at some point, the weaker believers will have to be confronted with their error or they will

[3] Rom 14:13-23; cf. 1 Cor 8.

never mature and grow stronger in truth.[4] Thus, teaching someone the truth about the ethical status of a given activity is not the same thing as performing the action in front of them.

In areas of legitimate dispute, we must exercise charity. Charity does not keep mature believers in bondage to immature viewpoints, nor does it call good that which is evil. Charity also requires that when Christians discuss these matters, they do so with respect. Tensions resulting from the clash of opinions on nonmoral issues will be with us until Jesus returns. In the meantime, we need to allow each other freedom of conscience in disputable areas—including movie choices—while sharing our honest opinions with each other in a loving manner.

Desensitization

Desensitization is a concern, and the issue is a tricky one. Desensitization to things does seem to occur, at various levels and for various amounts of time, with repeated exposure (whether in real life or in media). With respect to movies, the question is, can watching lots of gratuitous immoral sex and violence desensitize people to the real injury these can cause? As Bart Simpson once warned his sister in The Simpsons, "If you don't watch the violence, you'll never get desensitized to it!"[5] But on a serious note, in Phoenix, Arizona, after some teenagers murdered an elderly neighbor, one of them said he had been surprised that the man was in so much pain and took so long to die, because "that's not how people die in the movies."

[4] Phil 1:9–11.
[5] The Simpsons, "Colonel Homer".

This is not the place for a lengthy survey of psycholog-
ical studies, but for the purposes of this book we can grant
the popular opinion that the dulling of our emotions can
happen. In some cases, this can be a good thing. Desensi-
tization therapy, for example, has been successful in curing
many cases of phobias and other hypersensitivities.

Becoming less sensitive is part of growing up. Strong
emotional reactions are often indicators of immaturity.
Overly emotional adults are referred to as "babies" for
a reason. Children react with far more emotion than is
acceptable in adult society, and we would think it a trag-
edy were the emotional reactions of a child not under bet-
ter control by adulthood. Maturity, then, seems to involve
a certain degree of "desensitization".

MONSIGNOR
Now we must all fear evil men. But
there is another kind of evil which
we must fear most. And that is the
indifference of good men.

(The Boondock Saints)

Certain individuals are arguably duty-bound to be
desensitized to things that many others are not. Law
enforcement officers, doctors, soldiers, ranchers, and oth-
ers could not function if their reaction to criminal behav-
ior, injury, nudity, violence, or death were the same as
most. Yet we do not consider them less morally upright
than anyone else for such desensitization. Quite the oppo-
site, in fact. However, it must be noted that the desensiti-
zation required by these professions can lead to something
worse. As the physician Sir Arthur Conan Doyle warned
through his character Sherlock Holmes, "When a doc-
tor goes wrong he is the first of criminals. He has nerve

and he has knowledge."[6] The reason for this deserves our attention.

God made us to desire what is good and to avoid what is evil. Our emotions (also called feelings or passions) are good when they contribute to a good action and evil when they contribute to an evil action. Thus "moral perfection consists in man's being moved to the good not by his will alone, but also by his sensitive appetite."[7] Our moral character depends upon our ability to govern our emotions such that we have the right emotion in the right amount to help with doing the right thing. So, desensitization should be considered a problem only if it hinders the intellect and the will from knowing and choosing what is good.[8]

Sin is an action of the will. And since my feelings and thoughts influence my will and can be governed by my will, what I do about them is a moral question. I am not responsible for my initial reactive feelings if I see a beautiful woman walking by—but if I indulge those feelings and then allow myself to fantasize about her sexually, then I have committed the sin of lust, just as Jesus said.

Here is another example from the Gospels worth considering: the parable of the Good Samaritan. The men who passed by the injured man by the side of the road did not suffer from too much of an emotional reaction, but too little. The Samaritan who helped him, however, had compassion, Jesus said, which is the ability to be moved by the pain of others such that we reach out to help them.

Merely moving from a high level of emotional reactivity to a lesser one is by itself neither good nor bad. But

[6] Arthur Conan Doyle, "The Adventure of the Speckled Band".

[7] *Catechism of the Catholic Church*, no. 1770.

[8] See the *Catechism of the Catholic Church* nos. 1762–75 for more on the passions and their relation to morality.

if it comes about that viewing certain kinds of films causes us to become uncaring or immoral, then we should give them up.

Big Screen Simulation and Simulacra

> SCREENSLAVER
> Superheroes are part of a brainless desire to replace true experience with simulation. You don't talk, you watch talk shows. You don't play games, you watch game shows. Travel, relationships, risk; every meaningful experience must be packaged and delivered to you to watch at a distance so that you can remain ever-sheltered, ever-passive, ever-ravenous consumers who can't free themselves to rise from their couches to break a sweat, never anticipate new life.... Grab your snacks, watch your screens, and see what happens. You are no longer in control.
>
> (*Incredibles 2*)

I wish to close with a brief note of warning. Regardless of where you stand on the overall morality or function of film as an art, movies present a kind of danger that, while present from the beginning, has grown to significant proportions in the twenty-first century. While it is rarely the point of focus in discussions of film and other activities that fall under the heading of "screen time", I believe this concern underlies many of the others. I am speaking of the

lure of alternate reality—and of the particular temptation to replace the *real* world with the *reel* world.

One problem is that digital re-presentation, regardless of technical sophistication, lacks the physicality of reality (i.e., its materiality). The reason matter matters is that we are material ourselves. We are embodied, physical beings designed to interact with other embodied, physical beings. There is no technology that can make the unreal real—that can replace *presence* with *re-present-ation*. It is one thing to accept the simulacra over reality as a necessary evil in modern life; it is quite another to embrace it as an improvement over reality in our lives. To do so is to commit to a sort of technological Gnosticism.

Gnosticism is an ancient heretical belief that the material world is evil—that only the soul counts and that salvation is the escape of the mind from the body through knowledge. This probably sounds very abstract and mystical, but in reality, Gnosticism is all around us in different forms today.[9] The modern infatuation with technology confuses immaterial information with the material world—elevating spirit over matter. Technological simulations of things (existent or nonexistent) can become the only reality we know.

God, however, did not make human souls and stick them into "earth suit" bodies for their worldly sojourn. Humans are embodied, physical beings designed to interact with other embodied, physical beings and things. We are not just minds—and therefore information transfer is not the whole story (an interesting treatment of this issue can be found in *Ex Machina* from 2014). As naturally

[9] Some Christian churches exhibit these sorts of Gnostic tendencies by making "the message" the sole focus of the church experience and substituting the beauty and physicality of sacred artwork with blank walls and empty altars.

embodied beings, we are meant to experience reality via our bodily senses, which fill our minds with the things of reality (not just information *about* things). Thus, our close physical/bodily contact with reality fulfills our soul's intellectual/spiritual yearning in a way that copies of reality cannot.

Some will ask whether delivery mechanisms matter. Isn't the information the same? In fact, isn't the experience of life made better when it is bigger, brighter, and brasher? No, it isn't. Indeed, it cannot be, for it is not reality that is being communicated—only (at best) information *about* reality, and, more and more often today, sometimes not even that. As Jean Baudrillard wrote in his critical review of modern technology, "The power of the virtual is merely virtual. This is why it can intensify in such a mind-boggling way and, moving ever further from the so-called 'real' world, itself lose hold of any reality principle"[10] It is one thing to accept technological representation as occasionally helpful—it is quite another to embrace it as an improvement over reality itself. Mere simulation removes us from the reality we are meant to live in. And as Plato warned, the resemblance is not the real.

Intuitive evidence for this fact is all around us. Why do live plays continue to draw crowds over a century after motion pictures were invented? Why are movie theaters still thriving after home video equipment has become ubiquitous? Why did paper sales increase dramatically after computers became commonplace? Despite our desire for order and obsession with sanitization, our very natures crave the physical, gritty material of reality (watch kids play before they learn that dirt is "bad"!).

[10] Jean Baudrillard, *Screened Out* (New York: Verso, 2002), 60.

Simulations make poor substitutes. We know this instinctively, but we are being told (implicitly if not explicitly) that second-rate technological simulacra are just as good (if not better!) than the reality they allegedly replace. They are not, nor can they ever be. Gnosticism is false, and so is the simulated life. The animalistic mud dance from *Matrix Reloaded* (2003) is a good demonstration of this fact—while sensual and (literally) dirty, it is more human than the sterilized world of the Matrix.

Beyond the obvious problem of simply spending too much of our real lives devoted to nonreality, there is also the danger of mistaking the two. Often technology is used not merely to *represent* reality, but to *replace* it. Technological simulations, then, can become the only reality many of us know. We do well to factor this danger into how we choose to spend our time.

> WADE WATTS
> People need to spend more time in the real world. 'Cause ... reality is the only thing that's real.
>
> (*Ready Player One*)

That's a Wrap

I sincerely hope that this book has helped you become a more thoughtful movie watcher and has equipped you to engage in movies without disengaging your faith. In fact, I hope you have learned that you can evaluate the message of movies with the help of your faith in order to find truth and communicate with others. I also hope that once you have internalized these basic principles, you will add to this working script and make it your own. As we have seen,

movies provide ample opportunity to engage in conversation about the claims of the gospel. To make the most of movies, then, keep the following principles in mind:

- Watch and enjoy movies for what they are before you begin your evaluations.
- Distinctly evaluate the style, story, suppositions, and message of the films you watch.
- Note any features that stand out as conversation points in each film (including biblical, theological, and philosophical issues).
- Prepare yourself to defend Christianity in areas where the film contradicts it.
- Bring up the film in conversation and ask questions that lead deeper into the film's message, so you can illuminate it with the gospel when appropriate.

Chapter 12

Denouement: An Analysis of
The Truman Show

Introduction

The Truman Show (1998) is one of my favorite films to use
as an example when teaching film analysis. For one thing,
it is a very good movie artistically: it is clever and well-
made in every way. Second, it is extremely entertaining
in both its writing and how that writing is brought to life
by its direction and stellar cast. Third, it's old enough that
most people have either seen it already or would never see
it if someone did not suggest it. Finally, several message
clues are just subtle enough to be missed but hard to ignore
when the film is watched critically.

If you've never seen the movie, I strongly encourage you
to stop reading and give it a viewing. Use the techniques
presented in this book to watch the movie *intentionally*—
enjoy it, but don't turn your brain off! When you've
thought it through, come back here and compare notes.

Summary

Act 1 opens with several key characters explaining that
The Truman Show is reality. Marlon, Truman's best

friend, sums the introduction well: "It's all true. It's all
real. Nothing here is fake. Nothing you see on this show
is fake. It's merely controlled." The audience is even-
tually let in on the whole story: *The Truman Show* (in
the movie) is a real-time reality show created by a man
named Christof (Messiah complex, anyone?) that follows
nearly every move of Truman Burbank (literally named
after the entertainment industry!). Burbank has unwit-
tingly spent his entire life in a fictional town controlled
by a TV station and populated by actors; he is the only
true man, or real person, in his world. The fact that
the actors spend so much script time saying that this fake
TV show is "real" is the first subtle clue that this movie
is doing more than just presenting a fictional story for
entertainment.

Very quickly Truman experiences what Syd Field called
an "inciting incident" (a plot point that helps launch the
story without introducing the main challenge). After a stu-
dio lighting fixture "star" falls from the "sky" and crashes
in front of his house, Truman runs into his father, who
Truman believes he saw drown when he was younger.
Several other revealing events—including a radio conver-
sation detailing his every move—pile up, causing Truman
to believe that either he is crazy or something just isn't
right about the town of Seahaven.

Welcome to Act 2! Truman becomes increasingly suspi-
cious as he begins testing the world around him. Although
everyone in town is trying to keep him from the truth
(including his alleged mother), he discovers more and
more clues.

One of the driving forces behind his search for answers
is his obsession with a woman he met and fell in love with
in college. She fell in love with him too, which was not
part of the script, and when she tried to tell him the truth

she was abruptly canceled from the show by her supposed move to Fiji. Serious problems develop (or are finally exposed) concerning Truman and his wife, and that tension builds until it comes very close to violence.

When Truman's father reappears in the show's desperate attempt to resolve Truman's doubts, he faces the final crisis of his "life" and enters Act 3. At first, it seems that Truman has chosen to accept this fake-but-safe life. He returns to his typical day-to-day routine and even buys the Elk rotary mower! Everything appears to be back to normal until his friend Marlon checks up on him. Truman is gone—he has chosen to lead an authentic life or die trying.

At the climax of the film, Truman faces his extreme hydrophobia, which had resulted from the staged drowning of his fake father and been nurtured ever since as a means to keep him from venturing very far. He hops in a boat to sail away from Seahaven. While on the "sea" Truman faces down the show's director, Christof, walks across the water, and ascends a staircase into the "sky"— finally escaping the world controlled by its manipulative creator to thunderous applause from the audience around the globe (who then begin channel surfing).

Christian Concerns

Viewers are meant to detest the show's personnel (and viewers) for what they've done to Truman. Clearly they are in the wrong for making a man into a plaything they can control or watch for the sake of entertainment. We want him to escape their clutches. Although Christof and some of the actors seem to think they have Truman's best interest in mind, no one wants to live in a world run by some

invisible all-powerful creator who rules and manipulates the world from beyond the sky ... *right?*

Or does that description perhaps sound a bit too familiar?

To many Christians who viewed *The Truman Show*, the message was clearly anti-religion and perhaps even anti-Christian. Christian screenwriter and author Brian Godawa, for example, concluded that the message behind *The Truman Show* was "submission to God leads to slavery."[1] If this sounds like a paranoid reading of the film, consider some of the details (remember, everything noticeable in a film matters!).

The director of the show is named *Christ*of, who calls himself the creator and acts like God by controlling the world, speaking invisibly from the sky ("Cue the sun!" cf. Gen 1:3, 14–15). The star of the show, Truman, is the "firstborn" (to the studio), feeds five thousand (cameras), walks on water, undergoes a baptism, crosses a stormy sea in a boat, takes up a crucifixion position, rises from the dead, and ascends into the sky. The challenge to Truman's ignorance begins when a studio light "star" named Sirius 9 Canus Major (aka "the morning star") falls from heaven (see Is 14:12–14), which leads the first man to seek knowledge—some of which he gets from his "first woman" (Sylvia, whose name is from the Latin word for forest or trees). There is simply too much biblical imagery here to ignore.

And it's not meant to be ignored, but there can be other interpretations from that of Godawa. Steven Greydanus notes that although "the imagery of the film's final act is suggestive [of] an anti-religious parable about rejecting

[1] Brian Godawa, *Hollywood Worldviews* (Downers Grove, IL: Intervarsity Press, 2009), 52.

God ... a fleeting climactic prayer to the *real* God offered on Truman's behalf suggests that the target is not God, but his presumptuous imitators."[2]

So which is it? Is *The Truman Show* a brilliantly subversive film attacking religion and the sovereignty of God, or is it rather celebrating the true God's gift of human freedom in its criticism of those who would take his place? Is there also the nonreligious lesson that life is a gift and an adventure and that those who try to use and control others for purposes of their own, through fear and manipulation, are not good but evil, however well-meaning they claim to be?

Ambiguous Analyses

It would have been easy to find a film with a more obvious message to use as an example, but I did not want to leave readers with the impression that the message behind the movie is always clear or that there is always a clear message. I do not get the impression that many filmmakers write scripts with a particular message in mind (unless a movie is being made for political or religious readings). Rather, the writer's worldview emerges as he presents the way he sees the world (even if he does not mean to).

As I pondered the meaning of this film, I realized that the reviewers I surveyed were not simply split over the interpretation of the religious elements of the movie—they fell into different religious categories themselves. The two major critics I found on the "anti-Christianity" side

[2] Steven Greydanus, "The Truman Show", Decent Films, http://decent films.com/reviews/trumanshow.

were both Reformed in their theology,[3] while the two "pro-Christian" views were from Catholic reviewers.[4] It does not seem to be a coincidence that those who lean farther to the "divine sovereignty side" see the film as subversive and anti-God, while those who find balance between God's sovereignty and human freedom see it as God-affirming.

To the degree that Christof seems like the kind of God Christians believe in (or that is attributed to their belief), interpretations of Truman's actions toward him will vary. And this is not simply the case for Christian viewers. Many atheists also took the "anti-Christianity" interpretation but spun it into a positive message of deliverance from oppressive religion.[5] Conversely, those who lean toward the "human freedom side" see Christof as a usurper trying to take the place of the true god. It seems, then, that one's theological presuppositions are coming into play.[6]

[3] Besides Godawa's mentioned above, the other was "Theology of The Truman Show" (https://reluctantfundie.wordpress.com/2010/10/03/theology-of-the-truman-show).

[4] Catholic reviewer Michael P. Foley wrote: "The New Zealand director and producer Andrew Niccol is not, as far as I have been able to determine, Catholic, yet two of his films, *Gattaca* (1997) and *The Truman Show* (1998), are astonishingly Catholic in meaning.... *The Truman Show*, on the other hand, is generally praised for upholding the 'right to privacy,' but this story about a man who unknowingly grows up as the star of a television show does far more than that: It retells Plato's Allegory of the Cave from a Catholic perspective." (https://www.crisismagazine.com/2007/four-and-a-half-kinds-of-catholic-films).

[5] One thread on Reddit begins with the assertion, "The Truman Show is IMO the best metaphor of what the religious experience is." ("Atheism, Theism, and The Truman Show", https://www.reddit.com/r/TrueAtheism/comments/53yne8/atheism_theism_and_the_truman_show).

[6] A self-professed "progressive Christian" saw the movie as "one mans [sic] journey towards self actualization, freedom, and finding a truer sense of liberation". Andy Gill, "What the Truman Show Says about Inner Religious Freedom", http://www.patheos.com/blogs/andygill/what-the-truman-show-says-about-inner-religious-freedom.

Truman's Typology

Good art communicates the artist's vision but leaves room for further interpretation and reflection; otherwise it is just pretty propaganda. The goal, then, is to bring objectivity to one's film analysis and to elevate judgment beyond merely subjective reactions. The viewer's own worldview presuppositions should be identified and mitigated as much as possible when assigning blame or praise to the movie's creator(s).

The primary themes of *The Truman Show* concern the false reality of modern media and the danger that it is over-controlling our lives. Even reviewers who disagree on its secondary meanings seem to acknowledge this. Interpretive disagreement arises from some of the means used to convey this primary idea. Here is where the viewer's own proclivities will come into play. Technophobes may see *The Truman Show* as a cautionary tale concerning technology's ever-increasing (and invasive) role in our lives. Philosophers might notice the story's re-packaging of Plato's allegory of the Cave or see the movie as promoting Sartrean existentialism.[7]

Christians, of course, will likely notice the biblical references being discussed here. Although these elements cannot safely be ignored, they should likely be seen more as allegorical *types* (figures that symbolically connect certain thematic generalities) rather than communicating a literal one-to-one correspondence with scriptural particulars.[8]

[7] For example, Christopher Falzon, "Peter Weir's The Truman Show and Sartrean Freedom", in *Existentialism and Contemporary Cinema: A Sartrean Perspective*, eds. Jean-Pierre Boulé and Enda McCaffrey (New York: Berghahn Books, 2014).

[8] We see this in Scripture with Moses' bronze serpent (Jn 3:14; cf. Num 21:8–9), Noah's ark (1 Pet 3:18–22), mountains (Gal 4:24), and the Virgin Mary

There is a sense, of course, in which Christof is a "God figure" (as all false gods must be!) and in which Truman is "saved" or "redeemed" (as protagonists are in most stories), and so the Christian symbolism attached to these characters is unsurprising. Such religious "Easter eggs" should not be pushed too far, though.[9] Is Truman supposed to be Adam (the firstborn, true man who gets knowledge of reality from a tree after Satan falls from heaven) or Jesus (who is baptized, walks on water, is crucified, rises from the dead, and ascends into the sky)? Is Christof a false God-the-Father or an anti-Christ? Is Lauren/Sylvia supposed to be Eve or the Church? If these references (or those from other sources) are taken too literally or too far, their allegorical function becomes so confused that it stops making sense.

Regardless of the film's nods to Plato, Jesus, or Sartre, the unambiguous and overarching message of *The Truman Show* is that reality is to be embraced and falsehood rejected as we take responsibility for the lives we are given. This is a message that Catholics, Protestants, and atheists alike can embrace.[10]

(see Steve Ray, "Mary, the Ark of the New Covenant", Catholic Answers, catholic.com/magazine/print-edition/mary-the-ark-of-the-new-covenant.

[9] The same can be said with regard to the Matrix trilogy, which includes many religious "Easter eggs".

[10] This interpretation is backed up by explicit statements from the movie's director, Peter Weir. For examples, see Karen Jaehne, "Peter Weir on 'The Truman Show'", www.filmscouts.com/scripts/interview.cfm?File=pet-wei, and "Peter Weir Retrospective: The Truman Show (1998)", www.flickering myth.com/2011/01/peter-weir-retrospective-truman-show.

CREDITS

CAST & CREW

Writer/Director	Douglas M. Beaumont
Executive Producer	Mark Brumley
Line Editors	Vivian Dudro, Abigail Tardiff, and Kate Adams
Production Assistant	Nathan Pierce
Director of Photography	DeLayna Kenney McCallum
Continuity Consultant	Lanny Wilson
Pre-Production Editor	Christina Woodside
Set Manager	Elaine Beaumont
Best Boys	Michael, Dante, and Jacob Beaumont
Best Girl	Ember Beaumont
Gaffers	Mike and Donna Beaumont
Key Grip	Joyce Peterson
Matte Artists	Brian and Connie McElhany
Stunts	Leroy and Janelle Lamar
Musical Direction	Matt and Kristin Barclay
Pyrotechnician	Eric Vözzy
Runner	Ben Dresser
Props/Costumes	Matt and Jill Graham
Foley Artists	Brandon and Andrea Dahm
Negative Cutters	Phil and Gini Hoff
Special Effects	Jason Reed
Choreographer	Richard Howe
Background Artist	Sonny Fleming
Focus Puller	Larry Lee
Mike Schonberg	Himself
Nita Wellborn	Tina Ortega
Renee	Sheree' Fisher
Bert	Brett Sackett
Dr. Matthews	Matthew Lawrence

RESOURCES

Art, Film, Story, and Culture

Abanes, Richard. *Fantasy and Your Family: Exploring The Lord of the Rings, Harry Potter and Modern Magick.* Camp Hill, PA: Christian Publications, 2002.

——. *The Truth Behind the Da Vinci Code: A Challenging Response to the Bestselling Novel.* Eugene, OR: Harvest House Publishers, 2004.

Anderson, Philip Longfellow. *The Gospel in Disney: Christian Values in the Early Animated Classics.* Minneapolis: Augsburg Books, 2004.

Baehr, Ted, and Pat Boone. *The Culture-Wise Family.* Ventura, CA: Regal, 2007.

Barsotti, Catherine M., and Robert K. Johnston. *Finding God in the Movies.* Grand Rapids, MI: Baker Books, 2004.

Boggs, Joseph M., and Dennis W. Petrie. *The Art of Watching Films.* 7th ed. Boston: McGraw Hill, 2008.

Bordwell, David, and Kristin Thompson. *Film Art: An Introduction.* 8th ed. Boston: McGraw Hill, 2008.

Bortolin, Matthew. *The Dharma of Star Wars.* Boston: Wisdom Publications, 2005.

Brown, Nancy Carpentier. *The Mystery of Harry Potter.* Huntingtin, IN: Our Sunday Visitor Publishing, 2007.

Buckland, Warren. *Film Studies.* London: Hodder and Stoughton, 1998.

Burns, Kevin, dir. *Playboy Presents Sex at 24 Frames per Second: The Ultimate Journey Through Sex In Cinema* [Documentary Film]. Prometheus Entertainment: 2003.

Campbell, Joseph. *The Hero with a Thousand Faces*. 2nd ed. Princeton: Princeton University Press, 1973.

Campbell, Joseph, with Bill Moyers. *The Power of Myth*. Edited by Betty Sue Flowers. New York: Anchor Books-Doubleday, 1988.

Christian Spotlight on Entertainment. Christian Answers .Net. http://christiananswers.net/spotlight/.

Clover, Joshua. *The Matrix*. London: British Film Institute, 2004.

Comfort, Ray. *Hollywood Be Thy Name*. Orlando, FL: Bridge-Logos, 2007.

———. *What Hollywood Believes*. Bartlesville, OK: Genesis Publishing Group, 2004.

Decent Films. http://decentfilms.com.

Decker, Kevin, and Jason T. Eberl. *Star Wars and Philosophy*. Chicago and La Salle, IL: Open Court, 2005.

Detweiler, Craig. *Into the Dark: Seeing the Sacred in the Top Films of the 21st Century*. Grand Rapids, MI: Baker Academic, 2008.

Dyer, Richard. *Seven*. London: British Film Institute, 2005.

Eco, Umberto. *The Aesthetics of Thomas Aquinas*. Translated by Hugh Bredin. Cambridge, MA: Harvard University Press, 1988.

Elsaesser, Thomas, and Warren Buckland. *Studying Contemporary American Film: A Guide to Movie Analysis*. New York: Oxford University Press, 2002.

Field, Syd. *Screenplay: The Foundations of Screenwriting*. New York: Delta, 2005.

Focus on the Family. Plugged In. https://www.pluggedin .com.

Geisler, Norman, and J. Yutaka Amano. *Religion of the Force*. Dallas, Quest Publications, 1983.

Geivett, R. Douglas, and James S. Spiegel. *Faith, Film and Philosophy: Big Ideas on the Big Screen*. Downers Grove, IL: IVP Academic, 2007.

Giannetti, Louis. *Understanding Movies*. 6th ed. Englewood Cliffs, NJ: Prentice Hall, 1993.

Gilson, Etienne. *The Arts of the Beautiful*. Champaign, IL: Dalkey Archive Press, 2000.

―――. *Forms and Substances in the Arts*. Translated by Salvator Attansio. Champaign, IL: Dalkey Archive Press, 2001.

Godawa, Brian. *Hollywood Worldviews: Watching Films with Wisdom and Discernment*. Downers Grove, IL: InterVarsity Press, 2009.

Hibbs, Thomas S. *Shows About Nothing: Nihilism in Popular Culture from the Exorcist to Seinfeld*. Dallas: Spence Publishing Company, 1999.

Hofstadter, Albert, and Richard Kuhns. *Philosophies of Art and Beauty*. Chicago: University of Chicago Press, 1976.

Internet Movie Database. https://www.imbd.com.

Internet Movie Script Database. https://imsdb.com.

Johnston, Robert K. *Reel Spirituality: Theology and Film in Dialogue*. Grand Rapids, MI: Baker Academic, 2006.

Johnston, Robert K., ed. *Reframing Theology and Film: New Focus for an Emerging Discipline*. Grand Rapids, MI: Baker Academic, 2007.

Kermode, Mark. *The Exorcist*. Rev. 2nd ed. London: British Film Institute, 2005.

Kuritz, Paul. *The Fiery Serpent: A Christian Theory of Film and Theater*. Enumclaw, WA: Pleasant Word, 2006.

Lawhead, Stephen. *Turn Back the Night: A Christian Response to Popular Culture*. Westchester, IL: Crossway Books-Good News Publishers, 1985.

Lewerenz, Spencer, and Barbara Nicolosi. *Behind the Screen: Hollywood Insiders on Faith, Film, and Culture.* Grand Rapids, MI: Baker Books, 2005.

Lowry, Eugene. *The Homiletical Plot: The Sermon as Narrative Art Form.* Louisville, KY: Westminster John Knox Press, 2000.

Lubin, David M. *Titanic.* London: British Film Institute, 1999.

Maritain, Jacques. *The Responsibility of the Artist.* Staten Island, NY: Gordian Press, 1972.

Mattingly, Terry. *Pop Goes Religion: Faith in Popular Culture.* Nashville, TN: W Publishing Group, 2005.

McKee, Robert. *Story: Substance, Structure, Style, and the Principles of Screenwriting.* New York: ReganBooks/HarperCollins,1997.

Medved, Michael. *Hollywood vs. America.* New York: HarperCollins-HarperPerennial, 1992.

Monaco, James. *How to Read a Film: The Art, Technology, Language, History, and Theory of Film and Media.* New York: Oxford University Press, 1981.

Moore, T.M. *Culture Matters: A Call for Consensus on Christian Cultural Engagement.* Grand Rapids, MI: Brazos Press, 2007.

———. *Redeeming Pop Culture: A Kingdom Approach.* Phillipsburg, NJ: P&R Publishing, 2003.

Nicolosi, Barbara R., and Vicki Peterson. *Notes to Screenwriters: Advancing Your Story, Screenplay, and Career with Whatever Hollywood Throws at You.* Studio City, CA: Michael Wiese Productions, 2015.

Phillips, Patrick. *Understanding Film Texts: Meaning and Experience.* London: British Film Institute, 2000.

Pollock, Dale. *Skywalking: The Life and Films of George Lucas.* New York: Da Capo Press, 1999.

Reinhartz, Adele. *Jesus of Hollywood*. Oxford: Oxford University Press, 2007.

Romanowski, William D. *Eyes Wide Open: Looking for God in Popular Culture*. Grand Rapids, MI: Brazos Press, 2007.

Rosenstand, Nina. *The Moral of the Story: An Introduction to Ethics*. 5th ed. Boston: McGraw Hill, 2006.

Rotten Tomatoes. https://www.rottentomatoes.com.

Sanders, Steven, ed. *The Philosophy of Science Fiction Film*. Lexington, KY: The University Press of Kentucky, 2008.

Schaeffer, Franky. *Sham Pearls for Real Swine*. Brentwood, TN: Wolgemuth and Hyatt Publishers, 1990.

Skal, David J. *The Monster Show: A Cultural History of Horror*. New York: Faber and Faber, 1993.

Solomon, Jerry, ed. *Arts, Entertainment, and Christian Values: Probing the Headlines That Impact Your Family*. Grand Rapids, MI: Kregel Publications, 2000.

Stam, Robert. *Film Theory: An Introduction*. Malden, MA: Blackwell, 2000.

Tasker, Yvonne. *The Silence of the Lambs*. London: British Film Institute, 2002.

Vogler, Christopher. *The Writer's Journey: Mythic Structure for Writers*. 2nd ed. Studio City, CA: Michael Wiese Productions, 1998.

Wharton, David, and Jeremy Grant. *Teaching Analysis of Film Language*. London: British Film Institute, 2007.

Whedbee, J. William. *The Bible and the Comic Vision*. Minneapolis: Fortress Press, 2002.

Wood, Ralph C. *The Gospel According to Tolkien: Visions of the Kingdom in Middle-Earth*. Louisville: Westminster John Knox Press, 2003.

Philosophy, Theology, Ethics, Evangelism, History, and Apologetics

Albright, William F. *Archaeology and the Religion of Israel.* Baltimore: The Johns Hopkins Press, 1953.

―――. *The Archaeology of Palestine.* Baltimore: Penguin, 1949.

Aldrich, Joe. *Lifestyle Evangelism.* Sisters, OR: Multnomah Publishers, 1993.

Aquinas, Thomas. *Summa Contra Gentiles.* Translated by Anton Pegis. New York: Image Books, 1955.

―――. *Summa Theologiæ.* English Dominican Province Translation. Cincinnati: Benzinger Brothers, 1947.

Aristotle. *The Basic Works of Aristotle.* Edited by Richard McKeon. New York: Random House, 1941.

Barnett, Paul. *Is the New Testament Reliable?* 2nd ed. Downers Grove, IL: InterVarsity Press, 2005.

Beckwith, Francis J., and Gregory Koukl. *Relativism: Feet Firmly Planted in Mid-Air.* Grand Rapids, MI: Baker Books, 1998.

Black, David Alan. *Why Four Gospels?: The Historical Origins of the Gospels.* Grand Rapids, MI: Kregel Academic & Professional, 2001.

Bruce, F. F. *The New Testament Documents: Are They Reliable?* Grand Rapids, MI: Eerdmans, 2003.

Budziszewski, J. *Written on the Heart: The Case for Natural Law.* Downers Grove, IL: InterVarsity Press, 1997.

Comfort, Ray. *Hell's Best Kept Secret.* New Kensington, PA: Whitaker House, 1989.

Copan, Paul. *"That's Just Your Interpretation": Responding to Skeptics Who Challenge Your Faith.* Grand Rapids, MI: Baker Books, 2001.

Craig, William Lane. *The Kalām Cosmological Argument.* Eugene, OR: Wipf and Stock Publishers, 2000.

————. *Reasonable Faith*. Wheaton, IL: Crossway Books, 1994.

Dillow, Joseph C. *Solomon on Sex: The Biblical Guide to Married Love*. Nashville, TN: Thomas Nelson, 1977.

Downs, Tim. *Finding Common Ground: How to Communicate with Those Outside the Christian Community ... While We Still Can*. Chicago: Moody Press, 1999.

Foreman, Mark. *Christianity and Bioethics—Confronting Clinical Issues*. Joplin, MS: College Press Publishing Company, 1999.

Geisler, Norman, and Frank S. Turek III. *I Don't Have Enough Faith to be An Atheist*. Westchester, IL: Crossway Books-Good News Publishers, 2004.

Geivett, R. Douglas, and Gary R. Habermas, eds. *In Defense of Miracles: A Comprehensive Case for God's Action in History*. Downers Grove, IL: IVP Academic, 1997.

Gilson, Etienne. *God and Philosophy*. New Haven, CT: Yale Note Bene, 2002.

————. *The Unity of Philosophical Experience*. San Francisco: Ignatius, 1964.

Habermas, Gary R. *The Historical Jesus*. Joplin, MO: College Press, 1996.

Habermas, Gary R., and Michael R. Licona. *The Case for the Resurrection of Jesus*. Grand Rapids, MI: Kregel: 2004.

Howe, Thomas. *Objectivity in Biblical Hermeneutics*. Altamonte Springs, FL: Advantage Inspirational, 2005.

Jastrow, Robert. *God and the Astronomers*. New York: W. W. Norton & Company, 2000.

Keener, Craig. *Miracles: The Credibility of the New Testament Accounts*. Grand Rapids, MI: Baker Academic, 2011.

Kreeft, Peter. *A Refutation of Moral Relativism*. San Francisco: Ignatius Press, 1999.

————. *The Unaborted Socrates*. Downers Grove, IL: InterVarsity Press, 1983.

Lawrence, Matt. *Like a Splinter in Your Mind: The Philosophy Behind the Matrix*. Malden, MA: Blackwell Publishing, 2004.

Lewis, C. S. *Mere Christianity*. New York: Macmillan Publishing Co., 1953.

———. *Miracles*. New York: Touchstone, 1996.

———. *The Problem of Pain*. New York: Touchstone, 1996.

Little, Paul. *How to Give Away Your Faith*. Downers Grove, IL: InterVarsity Press, 1966.

McDowell, Josh. *The New Evidence That Demands a Verdict*. Nashville, TN: Thomas Nelson, 1999.

Metzger, Will. *Tell the Truth: The Whole Gospel to the Whole Person by Whole People*. 3rd ed. Downers Grove, IL: InterVarsity Press, 2002.

Miller, L., and Jon Jensen, eds. *Questions That Matter: An Invitation to Philosophy*. Boston: McGraw Hill, 2006.

Moreland, J. P. *Love Your God with All Your Mind: The Role of Reason in the Life of the Soul*. Colorado Springs: Navpress, 1997.

———. *Scaling the Secular City*. Grand Rapids, MI: Baker Book House, 1987.

Naugle, Jr., David K. *Worldview: The History of a Concept*. Grand Rapids, MI: William B. Eerdmans, 2002.

Porter, Burton F. *Philosophy through Fiction and Film*. Upper Saddle River, NJ: Pearson, 2004.

Ramsay, Sir William. *St. Paul the Traveler and the Roman Citizen*. New York: G. P. Putnam's Sons, 1896.

Rosenstand, Nina. *The Moral of the Story*. 6th ed. Boston, MA: McGraw Hill, 2009.

Schaeffer, Francis. *The God Who Is There*. Downers Grove, IL: InterVarsity Press: 1998.

Sherwin-White, A. N. *Roman Society and Roman Law in the New Testament: The Sarum Lectures 1960–1961*. Eugene, OR: Wipf and Stock Publishers, 2004.

Sire, James. *The Universe Next Door: A Basic Worldview Catalog*. Downers Grove, IL: InterVarsity Press, 2004.

Sullivan, Daniel J. *An Introduction to Philosophy: The Perennial Principles of the Classical Realist Tradition*. Rockford, IL: Tan Books, 1992.